MW00575258

The SOLOTYPE CATALOG

of

4,147 DISPLAY TYPEFACES

Dan X. Solo

Dover Publications, Inc. • New York

Copyright © 1992 by Dan X. Solo.
All rights reserved under Pan American and International Copyright
Conventions.

Published in Canada by General Publishing Company, Ltd., 30 Lesmill Road,
Don Mills, Toronto, Ontario.
Published in the United Kingdom by Constable and Company, Ltd., 3 The
Lanchesters, 162–164 Fulham Palace Road, London W6 9ER.

The Solotype Catalog of 4,147 Display Typefaces is a new work, first published
by Dover Publications, Inc., in 1992.

DOVER *Pictorial Archive* SERIES

This book belongs to the Dover Pictorial Archive Series. You may use the letters
in these alphabets for graphics and crafts applications, free and without special
permission, provided that you include no more than six words composed from them
in the same publication or project. (For any more extensive use, write directly to
Solotype Typographers, 298 Crestmont Drive, Oakland, California 94619, who
have the facilities to typeset extensively in varying sizes and according to specifica-
tions.) Certain elements displayed on pages 32, 56, 65, 79, 87, 107, 118, 122, 145,
168, 188 and pages 204 through 230 are trademarks and must not be reproduced
without the trademark holder's permission.

However, republication or reproduction of any letters by any other graphic
service whether it be in a book or in any other design resource is strictly prohibited.

Manufactured in the United States of America
Dover Publications, Inc., 31 East 2nd Street, Mineola, N.Y. 11501

Library of Congress Cataloging-in-Publication Data

Solo, Dan X.
 The solotype catalog of 4,147 display typefaces / Dan X. Solo.
 p. cm. — (Dover pictorial archive series)
 Includes index.
 ISBN 0-486-27169-2 (pbk.)
 1. Type and type-founding—Display type. 2. Printing—Specimens. 3.
Alphabets. I. Title. II. Title: Solotype catalog of four thousand one hundred
forty-seven display typefaces. III. Series.
Z250.5.D57S654 1992
686.2'24—dc20 91–37947
 CIP

America's only "monster" type shop

Oh! sacred shades of Moxon and Van Dijke, of Baskerville and Bodoni! what would ye have said of the typographic monstrosities here exhibited?

It was 1825 when London printer Thomas Hansard penned that protest against the rapidly changing field of typography. For 350 years, printing had subsisted almost entirely on romans, italics and blackletters. Then quite suddenly, as the century turned to the 1800s, decorative and display types of every conceivable variation began to appear. By 1900, everything that could be designed had been, leaving to the twentieth century only the task of refinement.

Nineteenth century types were long forgotten when we began collecting in 1942. We thought then, as we do now, that types that aren't being used are more interesting than those that are. We like the vibrant energy of these faces.

Hansard may have considered decorative and display types "monstrosities," but we think they are all that keeps typography today from being dreadfully dull. In the end, it is the graphic artist with good design sense and the resources of a shop like Solotype who will successfully fight the look-alike curse.

In this catalog you will find an excellent selection of new and old display types, many of which would be hard-to-find elsewhere. We hope you will delight in their use as we do.

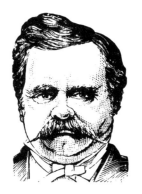

If you read the next two pages and still want to deal with us, we were meant for each other.

SOLOTYPE

SOLOTYPE TYPOGRAPHERS

Hard-to-find Display Types and Optical Special Effects

298 Crestmont Drive · Oakland, California 94619

Phone (510) 531-0353 · Fax (510) 531-6946

"Always closed in October"

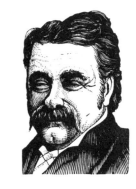

3½ Reasons You May Not Want to Deal With Solotype.

1. We are not a full service type shop. No body type and very few production services. Just good headlines and a big bag of special effects tricks.

2. Orders are taken in turn. No one else's work is ever pushed in ahead of yours. Works both ways though. When the shop is fully booked you may have to wait an extra day.

3. Because our work is produced optically rather than by computer, there are no instant revisions. Those who know what they want are usually pleased, but those who want to make "little" changes until they "see something they like" will have to go to the end of the line.

3½. Our focus is national. Local customers must deal with us on the same basis as everyone else. No over-the-counter orders ever.

On the next 200 pages we offer more than 4,000 reasons you may want to deal with us — a great collection of hard-to-find headline type.

A word about quality.

Laser printouts of modern computer types are wonderfully clean, with flawless edges and sharp corners.

By contrast, our hard-to-find faces are from original sources, not computers, and show occasional hiccups and heartbeats.

Some customers find this unacceptable.

So, if perfection of edge quality is more important than the interesting letterforms we offer, please don't order from us.

We wouldn't want you to be disappointed.

Who we are, what we do, and who we do it to.

We are a small band of dedicated craftspeople whose entire focus is good headline typography and special effects. Nothing more, and certainly nothing less.

We work the old way, optically, without computers. This gives us access to a remarkable archive of hard-to-find types gathered from all over the world during our annual October type hunts.

We work best for those who try to understand our limitations and our strengths. We're good but we're not perfect. Dedicated nit-pickers and the chronically unhappy should probably seek elsewhere.

We've been collecting type for half a century, and providing headlines and special effects for most of that time. Hundreds of type buyers use us regularly with complete satisfaction. We hope this catalog will encourage you to join them, if you haven't already.

Sincerely,

Dan X. Solo, on behalf of a great cast of characters.

MEMO FROM DAN X. SOLO, PROPRIETOR:

Solotype is always closed for the month of October.

Solotype is probably the only type shop in the world that shuts down for an entire month each year to hunt for more type.

Every October we head out to some part of the world that we believe may have interesting types in hiding. Do we find them? You bet we do! Literally hundreds of the revivals on the market today are directly traceable to our efforts.

We hope you will agree that the inconvenience of our October closing is worth the result.

Credit Policy

Send us your orders. We will ship open account immediately and follow with an invoice payable within 30 days. We will ship to a post office box, but must have your street address and phone number for our billing records. Yes, we do take steps to collect past due accounts. Yes, we do exchange credit information with others in the trade. And yes, we do become grouchy when someone takes advantage of us.

Shipping

Because our orders come from all over the United States and a handful of foreign countries, overnight express is the most practical means of quick delivery. The charges for this are added to your invoice, and explained in detail in our price list. We will ship by U.S. Mail if you specifically request it, but will not under any circumstances accept responsibility for delays.

No Over-the-Counter Business

Because our customer base is national, local customers must deal with us by phone, fax, overnight express or mail just like everyone else. We never allow anyone to place an order over the counter.

Legal Notices

Solotype Typographers is a sole proprietorship. Federal tax identification number 94-1645171. The name Solotype is a federally registered service mark belonging exclusively to us. The terms Solosphere, Soloflex and Elastograph are trademarks we use to identify certain types of optical modifications.

Placing your order is easy...

Most orders reach us by fax or phone, and the rest by overnight express or mail. Local customers note: No over-the-counter orders, no exceptions.

Turn-around time is fast...

Orders for a headline or two reaching us by noon our time (3 p.m. on the east coast) will normally go out the same day. Large orders will go out the next working day. Optical effects usually go out the next working day, but could take longer. We try to keep you informed of delivery schedules.

Rush work...

Taking orders in turn is practically a religion with us. No amount of pleading or threatening will cause us to put anyone else's order in ahead of yours. When rush service is needed (and this isn't always possible), we have to put someone on overtime. This doubles your price. Is it really worth it?

A bit of history

Just to let you know we've been at this for a while and haven't spent all our time in the pool halls, here are some dates: First printing produced 1935. First new type acquired in 1938. First antique types acquired in 1942. First photo-lettering experiments 1945. First type hunt out of state in 1953. First commercial typography in 1959. Solotype established in 1962. First optical special effects produced in 1963. First original typeface designed 1964. Altergraph optical modifier patented 1973. First Dover display alphabet book produced 1976. First type hunt in Europe 1978. First type hunt in Orient 1989. Matro-circle machine invented 1978. Circle Arc machine invented 1980.

When ordering type . . .

Point size includes everything from the top of the cap letters to the bottom of the lowercase descenders.

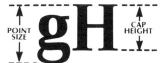

Cap height does not include the lowercase descenders, just the full caps from the top to the base.

Be sure to tell us whether you are specifying "point size" or "cap height" as differentiated in the diagram above. Cap height may be specified in inches or millimeters as well as printer's points, so be sure to tell us which system you are using.

Standard point sizes at Solotype . . .

12 14 16 18 20 24 30 36
Hm! Hm! Hm! Hm! Hm! Hm! Hm! Hm!

All intermediate sizes available.

72 60 48
Hm! Hm! Hm!

Examples of spacing...

How do you like your type, tight or loose or in-between? The examples below should help you tell us how to do it. We feel there is a "comfortable" norm for each alphabet design, and in the absence of specific instructions we will use this norm.

Touching
TIGHT or loose?

Very Tight
TIGHT or loose?

Tight
TIGHT or loose?

Normal
TIGHT or loose?

Loose
TIGHT or loose?

Touching
TIGHT or loose?

Very Tight
TIGHT or loose?

Tight
TIGHT or loose?

Normal
TIGHT or loose?

Loose
TIGHT or loose?

SOLOTYPE
Typographers

298 Crestmont Drive · Oakland, California 94619
Phone: (510) 531-0353 · Fax: (510) 531-6946
Hours: 8 AM - 4:30 PM · Always closed in October

Contents

No secrets about our prices.

★

An up-to-date price list is yours for the asking.

First, we'll show you some hard-to-find condensed faces...

Spire with lowercase

GIANT REDWOOD trees threatened too

Ransahoff

CONGRATULATIONS are in order today with

Latin Noir Etroit

GRAND CANYON tours by airplane

Bellery Elongated

RETRACTABLE statements made

American Narrow

ELEVATORS Heaven bound express

Binner Gothic

GIGANTIC SEA creatures underneath

Newport

BEACH FRONT properties for

Phenix

CANDLELIGHT dinner and dance

Emporia Gothic

FANTASTIC FOUR crime fighter comix

Onyx

ROCKETING to the moon at

Onyx Inline
NEW TYPOGRAPHIC VARIATIONS

Spire Shaded
SENSATIONAL SOLOTYPE

Slimline with lowercase
Student Gymnastic Activity To

Raymundo Shaded
RAYMUNDO IS A REGAL TYPE

Slimline Classic Caps
SLIMLINE CLASSIC DISPLAY

Moderna
MODERNE STYLE IN ARCHITEC

Slimline Moderne Caps
SLIMLINE MODERN DISPLAY

Empire with lowercase
PREMIUM WINES grown in valley region

Huxley Vertical
STREAMLINE AGE TYPES IN

Empire Caps
DESERT LAND OF LIGHT AND SHADOW

Huxley Vertical Bold
MELODIES PLAYED SOFTLY

Empire Medium Caps
STREAMLINE DESIGN TYPOGRAPHY

Huxley Vertical Bold Extended
BRAVE NEW WORLD NOW

Empire Bold Caps
THE EMPIRE STRIKES BACK BOLDLY

Designer Raleigh
Cruise Down The River Daily

Haas Ideal with lowercase
Don't Shoot the Typogra

Research Light
GARDEN DELIGHTS from yesterday

Haas Ideal Caps
IDEAL SWISS TYPE SHOP

Mechano
WALLS and ceilings gave

Herold Extra Condensed
CONDENSED TYPE always popul

Klingon
DESTROY klingon empire

GLAMOUR TYPOGRAPHY FOR SALE

Raymundo

When you're tired of the ordinary, it's time for Solotype!

Slimblack

BUILD A SKYSCRAPER OF

Onyx

MONSTER rally tonight!

Onyx Italic

QUALITY typographers

Onyx Ten

CONDENSED typefaces needed

Mannequin

STORE window models

Miehle Condensed

ORANGUTAN dance part

Maharaja

SULTAN OF SWAT HOM

Marla

MARVELOUS MARLA TO

Bacardi Condensed

EARTHQUAKES aftershocks

Bordeaux Shaded

CAKE & ALE served perfectly in

Bordeaux

DECORATE homes with color

Rainbow

RAINBOWS decorating in sky

Caslon Super Condensed

CONDENSED milk saves spac

Caslon Extra Condensed

SHARK fin soup served

Caslon Extra Condensed Swash

Buy An Elephant Today

LeBarron

DEFINITIONS revised by

Century Ten

ROCKS and minerals for

Bernhard Bold Extra Condensed

THIRD row away from

8 SOLOTYPE

Assay Rimmed

OLD TIME FAVORITES

Katherine Bold

Old World Travel In

Orbit Antique

GREAT old typef

Sturdy

VIEW the doze

Fredricksburg

CIVIL WAR MUSEUM

Arbuckle

BLACK HORSE MOUNTAIN HOME

Grandmother Condensed

HOW IT MADE THE PROFIT!

Grandmother

TRUNDLE BEDS FOR

Nonesuch

OLD MAN RIVER GO

Assay Condensed

BOXER punch in

Assay

DUNKS dough

Assay Extra Extended

BE ints

Olympia Extended

GAMBLES pay dividends

Rubens

FACTORIES displaying industrialized

Rubens Extended

MAGICAL disportment show

Rubens Wide Wood

RUBENS by numbers in

Morningside

MARCONI signals girdle the globe w

Concave Extra Condensed

COUNTY HISTORICAL TRUST

Concave Condensed

SOFTER MUSIC SING

Concave

TEMPERANCE

Concave Extended

MUSICAL TO

Hibernian

DUBLIN theatre walk

Commonwealth

Great Day in the M

Olympia

GOLD ore mined

Specialists in Antique, Ornamental & Exotic Typography

Asteroid
METEOR named for Russian sky wat

Lafayette
MELODY of bird songs recor

Campanili
MUSICAL receives standing o

Makart
VARIOUS theatrical events oper

Acantha
PARTY lines ask for

Century Boston
LOVES designing by het

Bowl
ARTS festival on

Fantail
MORNING coffee shop he

Art Gothic
PARLOR makes waves per

Art Gothic Bold
GRANDIOSE schemes hat

Peerless
IDEAL Printers have m

Donaldina
POET announes pe

Gauloises
MEZZO soprano sings

Champion
MARKS symbols and

Victorian Clarendon
ENGLISH PAINTINGS

Edwardian Clarendon
PATIO table umb

THE CREATORS OF THE
HARVEST FESTIVAL
PRESENT
THE FIFTH
AMERICAN
FOLK ARTS
FESTIVAL
FROM ALL OVER AMERICA MORE THAN
500 FINE CRAFTSMEN
ALL IN 19th CENTURY COSTUME
DEMONSTRATING & SELLING THEIR WARES
HEARTY FOOD & DRINK
PLENTY OF NICE PEOPLE & A HIGH OL' TIME!!!
THE FABULOUS FRISCO FOLLIES
A CONTINUOUS STAGE REVIEW
EARLY AMERICAN FOLK SONGS & DANCES
FOOT STOMPIN' BLUE GRASS MUSICIANS
MELODRAMAS • JUGGLERS • FORTUNE TELLERS
EXPOUNDERS OF TALL TALES
APRIL 27 · 28 · 29
$2.50 ADULT • $1.00 CHILDREN
FRI 5 PM 10 PM • SAT 10 AM 10 PM • SUN 10 AM 8 PM
BROOKS HALL · CIVIC CENTER
SAN FRANCISCO

Pacific
UNIQUE music hall show

Ryan Jackson
COMEDY skits produced

Flirt
GIRLS given traing

Typo Antique
TRAVELS with my aunt and her

Ancient Text
The New Rich Spas

Spiral
Song and Dance Man

Zorba Half Solid
Zorba Half Solid top

Quincy Backslant
RADIOS tuned to stations

Battery
Ranch Opens in Great Sout

Alfereta
The Great American P

Pisa
Salt Meats from Jewish

Smoke
TRAVELS with my aunts in

Tandem
BICYCLES built for two b

Sometimes it really is a dirty job.

Rumaging in the basement of an old printshop in San Francisco, we came across a cigar box full of worn type. Paid a whole dollar for it, took it home and sorted it out. Wow! What a find. Turned out to be the font shown below, which we call Glorietta. Its actual name was Columbian, but we already had two other faces by that name, so we changed it. Type hunting can be a dirty, time-consuming and back-breaking job, but a type like Glorietta makes it all worth while.

Glorietta
ABCDEFGHIJKLM
NOPQRSTUVWXYZ
abcdefffghijklmnnopqrsttt
uvwxyz &!? 1234567890

Glorietta
Secrets Among Moonlit Stones

Cardinal
Kings and Queens stay in

Pansy
PRINT Supply House

Iroquois Condensed
STUDIO remaking ea

Congress
Pretty Maidens in Budding Spring

Prang Litho No. 1
Advanced Courses in Sheer

Obelisk
NORTH and South encircled by fla

Alpine
FROST due by Thursday

Kismet
INSIDE passenger

Renaissant
PRINTER on display today a

Cross Gothic
CRAZY quilts sewn by m

Chaucer
ADAGE teaches imp

Olympian
FARIES play games

Randall
PROUD to present

Ringlet
PRINTS auctioned for

Cirrous
FROGS to princes in no tim

Brevet
EARLY artisans never m

Pamela
Lydia the Tattooed Lady
Fancy initials are built up of parts.

Bijou
FLOAT coats for boating

Signet
CHIMES tell time and som

Gutenberg
NEITHER rain nor dark

Karnak
MUSIC charms beast

Hogarth
INDIAN medicine cures

Raphael
MYSTIC rites held for

Inside Solotype by Golly

Like a well-oiled machine, the staff
functions smoothly at all times.

Romanesque
Album of HEART SONGS and Poems

St. Clair
Careful HEADLINE Designs

Fancy Celtic
Victorian ARCHITECTURE on Display

Tivoli
Welcome to TIVOLI GARDENS Amusements

WHERE HAVE ALL THE FLOWERS GONE?

Playtime at Solotype

Sentinel
FOREST DESIGN TAUGHT

Angular Text
AFTER hours dining by the pot

Anglo
TOURS arranged for

Banquet
PARIS perfumes alluring

Aesthetic Caps and Small Caps
MUSIC PROGRAM SOI

Gladiate
YOUNG GIRLS KNIT

Aesthetic
EASTERN CULTURE

Heather Lightface
ORNAMENT decorated house

Monastic
GRAND NATIONAL RODEO

Aesthetic alphabet
AABCDEEFGHH
IJKKLMMNOP
QRSTUUVWX
YZ& ✺❀❁❋❃❀
AABCDEFGHIJKLM
MNOPQRSTUVWX
YZ 1234567890

Gazelle
Her New Spring Fashions

Dainty
TRAVEL in San Francis

Rococo
The Big Gold Rush And

Houghton
New York Brownstone Hut

SOLOTYPE 13

All Solotype headlines are edited by hand for even color.

Phidian
HORSELESS CARRIAGE ASSOCIATION
Annual Rally & Exhibition Scheduled

Tangier
African CITY Visited

Algonquin Shaded
FLASHY new automobiles

Ripple
BROWN paper bag wrap

Gingerbread
Birdcage Theatre Variety Shows

Soutache
GAMES organized by the boss

Goldwin
GOLDEN ventures

Sentinel
Fairy Tale Story Hour

Argent Open
REGAL characteristics requis

Argent
Bird In The Hand Is Worthy

Aeolean Black
ABCDEFG abcdefghijklmnopqrs

Aeolean
Sings Mother Nature's Lullaby

Tedesca
HERBS packaged in bulk

Ferdinand
The Bitter Pursuit of the Dollar

Oakwood
FAIRY tale monks

Nymphic Caps with Initials
CAN BE USEFUL FOR

Nymphic
GRAPHIC enterprise in S

Nymphic with Swash Caps
A B C D E F G H I J
K L M N O P Q R S
T U V W X Y Z

ABCDEFGHIJKLMNOPQRST
UVWXYZ 1234567890 (&;+$)
abcdefghijklmnopqrstuvwxyz

Belmont
TRACE YOUR STEPS

Mystic
MYSTIC SEA PORT

Cocktail
UPRIGHT AND STEADFAST

Southern Cross
SOUTHERN CROSSES

Angel
DAISY BELLE RIDES

Safari
VICTORIAN DELIGHT

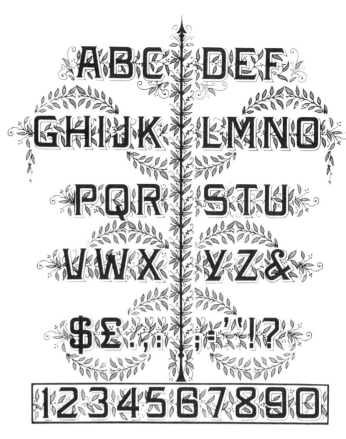

ABC DEF
GHIJK LMNO
PQR STU
VWX YZ&
$£.,:;‚‘–="!?
1234567890

Border Combo 250

Campanile
JOEY McKENZIE
OLD-TIME FIDDLING

Arboret
LIVING TREE

Fashion
HIDEOUS FASHION HOW

Fashion Ornamented
FANCY SOPHISTICATED

Templar
GREAT WHITE WAY

Wave
OVERHANG TYPES

Arcade
ARCADE THE

Epitaph Open
WHITEWASHED ROOM

Victoria Central
NATURE FREAKS

Epitaph
PASTA BOWLS FULL

Atlanta
RHINE WINS

Sesame
SESAME BUNS

Tuscan Floral

DECORATIVE VICTORIANS

Tuscan Ronde

HORSES RUN ON TI

Barndance

TONSORIAL SHOP

Tallyrand

TRAVELING MEDICINE SHOW AN

Barndance Wide

BARNDANCE

Armenian

BRIGHT FESTIVE BRUNCH

Trocadero

OLD TIME MOVIE

Stereopticon

STEREOPTICON SHOW

Chorus Girl

CLOWN COSTUMES

Romantic No. 4

THE PARISIAN FOLLIES

San Francisco

BARBARY COAST SALO

Ringmaster

ANIMAL SHOWS NEV

Julie

WANT: OUTLAW

Roulette

EXERCISES AT GROVE

Joseph

CHIVALROUS GENTLE

Gentry

FANCY CEMENT ON

Soule Poster

THE SARSPARILLAS

Sideshow

SIDESHOW ACTS

Miss Kitty

MELODY LINGERS

Soubrette

FEATURES MUSIC

Broadside

CIRCUS PARADE

Thunderbird

SHOWBOAT TIM

Banknote Italic
TEXAS MORGAN

Florist
FRILLS CAN MAKE

Penelope
PROGRAMME TODAY

If we couldn't work with great old types like these, we wouldn't want to be in the business.

Van Horn
CARNIVAL SIDE SHOWS

Jim Crow
STEAMBOAT DOCKING

Van Horn Shaded No. 1
HISTORICAL MOVIES

Ancient Gothic Shaded
ANCIENT GOTHIC SHADE

Martini Shaded
VODKA MARTINI STIRR

Rosella
ROCKY MOUNTAIN

Broadcast
BLACK HORSE INN

Cameo Antique
OLD RESERVE

Circus (Rome)
CISCO TOWERS

Nightshade
CHECK POWER

Doublet
POSTER of dancehall girls

Belgian
ROMANS touring other citie

Caxtonian
PATIOS designed brilliantly

Galena
GREAT migration

Big Cat
GRAND OPEN

Broadgauge Ornamented
BROAD COMEDY

Bruce Mikita
SUMO WRESTLERS

Elmo Outline

CURIER AND IVES

Joplin Rag
GREAT PIANO MAN

Elmo Solid
FINE ART PRINTS

Moorish
DEMONS AND IM

Cabalistic
RELIGIOUS DISORDER

Snowbird
SNOWBIRDS FLY AWAY

Glyptic Bold Shaded
PHARMACY RUG

Marble Heart
PONY EXPRESS DELIVERY

PUBLIC OUTRAGE!

~ DAWSON'S ~
BARBARY COAST SALOON
OPENS MAY FIFTH

Bohemian Actors & Flamboyant Actresses

PERFORMING
UNINHIBITED THEATRICALS
IN AUDIENCE'S MIDST!

☞ PATRONS SERVED BY ☜
UNREPENTENT SINGERS!

A RELENTLESS DISPLAY
& COMESTIBLES & POTABLES

*Crab, Shrimp, Oysters, Sourdough Sandwiches
and Traditional tavern fare. Beer / Wine / Spirits*

INDECENT HOURS!
TUES. THRU SAT. - 7 PM TO 2 AM

Soule Poster
WORDS ARE THE WINGS

Heraldic
MUSICAL NITE

Cruikshank
GENERAL OFFICE OF PUNS

Oxford No. 3
OLD DAYS REVISITED

Old Bowery
OLD NEIGHBORS GO

Claret
WINE SHOP

Dresden
BEAUTIFUL O

Harlequin
CELEBRITY W

Courtier Italic
WINE THIEF

June
FRENCH PERFUM

Tuscan Grail
HUNT EASTER EG

Fargo
STAGECOACH IN

Spangle
CLUB LIDO IN FRANCE!

Gypsy
GALA CLOTHING FOR EVER

Jeffrey
FOLIAGE GROWS BEST

Abramesque
COUNTY FAIR HOT F

Lattice
JEWELS OF FIRE ON DI

Fry's Ornamented
ENGLISH TOUR

Algerian
NEW CUSTOMERS

Old Vic No. 1

MAGIC HERBS

Old Vic No. 2
MAGIC HERBS

Old Vic No. 3
MAGIC HERBS

Old Vic No. 4
MAGIC HERBS

Old Vic No. 5
MAGIC HERBS

Old Vic No. 6
MAGIC HERBS

Diamond Inlay
CHARM CLASS

Chronicle
BARN DANCE TO

CALIFORNIA STATE RAILROAD MUSEUM
MILEPOST 1
Pacific Coast Chapter
Railway & Locomotive Historical Society, Inc., Prop.
QUALITY RAILROAD GOODS
GIFTS · JEWELRY · PHOTOGRAPHS · BOOKS
115 I STREET · TELEPHONE 916 447-9665
OLD SACRAMENTO, CALIFORNIA 95814

Every October, we shut up shop to hunt for more type.

Monastic Condensed
THE AMAZING STORY OF IVORY JOE

Mural
PAINTINGS ON A WALL

Cabinet
CABINET PHOTO

Moxon
JACK IN THE BOX!

Dangerfield
JACK RIPPER'S

Eccentric
ECCENTRICALLY SPEAKIN

Crusader
RICH THE LYING

Lantern
SAMURAI SWORDS

Jumbo
PACKS TRUNKS

Vulcan Antique
SAINT ALBAN

Spearhead
WROUGHT IRONS

Solar
ROUGH SUBURB USE

Santa Claus Open
A FLYING REINDEER

Santa Claus
EASTERN WATERS

CABLE CAR
MAP
GENERAL INFORMATION
HISTORY
HOW IT WORKS
HOW TO USE THEM
ETC., ETC., ETC.

Castle Wide
SWIM THE BAY

Castle
HABITS GET WORSE A

Telephone Gothic
THE LOST WEEKEND

Grant Antique
GREAT FISHING IN ALASKA

Grant Antique Wide
PRINTERS GUIDES

VICTORIAN AMERICA

Barndance Wide

LIVES ON AT SOLOTYPE

Daisy Rimmed Plain

PLAIN VERSION I

Daisy Rimmed Fancy

FANCY VERSION I

FRESH BAKED

Daisy Delight

DELIGHTFUL CONT

Alternate Letters

ABDFhKLNPRSTUVY

✷ ✲ ✸ ✤
1 2 3 4

Orleans Open

STREET FAIR HELD

Gold Rush

ARTS & CRAF

Washington Antique Open

GREATEST SHOW

Washington Antique

EMERGENCY MO

Cavalcade

HOPEFULS

Steamboat Shaded

STEAMBOAT

Ambelyn

KEEP REFRIGERATED HAM

Ambelyn Shaded

POCKET WATCH WINDS

Ambelyn Shaded Italic

MIDSUMMER NIGHT IN

Hyde

THAT PRINTER OF UDELL'S

Jagged

OCELOT RUN WILD

Brenda

THE ROAD TO SALISBURY

Buffalo Bill

PERFORMERS

New Orleans

PARIS REVISITED

Cleft Gothic

CLEFT GOTHIC

Ullmer

VAMPIRES FLY HOM

Bizarre

CANNIBAL RITE

Vaudeville
MODERN VICTORIAN TYPEFACES

Monterey
BEAUTY & MEN

Rajah
CIRCUS PARADE HE

Monterey Wide
DECORATIVE

Roulette
HALLOWEEN PARTY

Canterburry Initials
TEN LARGE BOND

Rhett
FRANKLY SCARLET I

Lexington
LEXINGTONIA

Scarlett
SOUTHERN BEAUTY

Molle Folliate
SILK THREADS

Gone With The Wind
AS ATLANTA BURNS

Fontanesi
MADE OF WOO

Damsel
THE DAMSEL FLY

Springtime
EXCELLENT DESIGN AC

Ornata
ORNATE typeface

Cristal
STEREO SOUND

Davida Bold Shaded
NEW YEAR PARTIE

Saphir
CHALET STYLE

Davida Bold Outline
HOLIDAY DECORS

Duo Solid
TWIN BUILDING

Davida Bold
TAQUERIA SPECIAL

Boulder Ornate
PICCARDYS

Gypsy Rose
MAGIC HERBS

Boulder Solid
SOUTHERN

Twirl
TWIRL ROPE

Crayon
Good Old Boys Dance Tomorrow

Crayonette
Get Rich Quick Association

Komet
STUDIO dramatic show

Cabinet No. 2
FROGS croaking loudly

Delight No. 2
DELIGHT the audience

Rafael
RAFAEL paints houses

Koster with Fancy Caps
Call the Wind Maria

Koster
To Be Or What It Be!

Koster with Swash Caps
A A B B C C D D E E F F
G G H H I I J K K L L M M
N N O Ö P P Q Q R R S S
T T U U V V W W X X Y
Y Z Z 1234567890 (&;!?'~$)
abcdefghijklmnopqrstuvwxyz

Erbar Initial
ENCYCLOPEDIA

Monopol
CRAB AND LOBST

Recherche
D'Arceau-
Limoges,
le fabricant.

Geometric
EXACT particulars

Geometric Italic
TWINS open gift bal

Allegro
You Are Invited to a Mus

Tango
Bristol Rose Cafe Menu

Crazy Eights
Once Upon a Midnight Dreary

Crazy Nines
Fall Of The House Of Usher

Funhouse
LAUGHING LADY HOWLS

Minsky Shaded No. 1
GRAPHIC tutti frutti avai

Minsky
HELPING hands offering fr

Minsky Shaded No. 2
BUNDLE up for the badn

Mansard
GREAT INDIAN CHIE

Mansard Outline
GREAT ARCHITECTS

Mansard Rimmed
SULTRY SLAVE GIR

MIXED NUTS
Elastograph Special Effect EL-1

Rigney
DECK THE HALLS WITH BOUGI

Oregon
LEWIS AND CLARK EXPEDIT

Silverado
GUEST FINDS VAL

Midway Ornate
FUN HOUS

Mona
REWARD I

Hidalgo
NEW ALMADEN QUICKSILVI

Sutro
CHRISTMAS TREE FARM IS SWEET

Bullfrog Extended
BULLFROG SINGS

Bullfrog
GOLDEN MOMENT CH

Wampum
INDIAN PAWN TUR

Coachline
COACH LINES

Delwin
PIANO RECITAL FEATURES C

Warlord
WARTHOGS running amuck now

Wigwam
CABIN dorms for braves

Rodeo
BANK closed for

Helven
CHEERS VICT

Helven Ornate
BEAUTY AND

Barnum Condensed Caps

CIRCUS DAYS
MEADOWBROOK CARTS

Call it French Clarendon (the Americans did), or Italienne (the French did), or American (the Italians did) — it will always be Barnum to most of us. The basic style was first seen in the United States about 1830; reissued and renamed Barnum in the 1930s.

P. T. Barnum

MASTER presentation

Pointed Barnum

THESPIC playhouse taug

Cartwright

HOP SING woks proudly

Barnum Square

MODERN version of earl

Old Town

VALUABLE player award tl

Shaded Barnum

CIRCUS recalled exh

Pardee

SLIDES mutual improvemen

Cirque

THE BEAST performed by local ballet co

Western

WESTERN movie star

Playbill

BLOOMING bargain days begi

P. T. Barnum
American Showman
1810 – 1891

Dado

FESTIVAL ends succ

Magnet

MAGNETIC influences thou

Dime Museum

BANG from guns

Italianate Barnum

HIDEA homes island

Italianate Barnum Lined

PLATE EFFECT

Nubian Antique

LIGHT of the ne

Corral

THOUSANDS mourn man's inl

Lanefixt
DELIGHTFUL

Bracelet
PARISIAN

Grandiose
GRANDIOSE PLA

Lavinia
BLESS YOU, VINNIE!

Tuscan Tri-level
TUSCAN

Romantic No. 4
FRANÇAISE

Status
BUILDING AGE

Scott Gothic
SCOTT GOTHIC FOR

Carillon Condensed
THE BUILDINGS

Gardenia
FLOWERS

Calliope
MUSIC BOXES

INDEX BEGINS ON PAGE 232

Cinderella Text
Cinderella

Laurel
DELIGHT

Gazette No. 5
CITRON VERT

Mozart
FIRESIGN

Cane Gothic
GRANDIOSE PLAN

Paris Ronde

Hard-to-find Display Types from Solotype

Ruby

GREAT WOOD TYPES

Grecian Extra Condensed

GROUND COVERS PLANTED WITH

Eureka

CIRCUS PARADE TODAY

Madison

MADISON TO GO

Daniel Webster

DANIEL WEBSTER PLEA

Arcadian

MUSEUM SHOP

Visitor Wood

JUDGED

Burlesque Rimmed

CARNIVAL

Palladium

PIANO PLAYER SHOT BY

Landsby

FAMILY REVEALS

Antietam

THE BEST ONES

Antimony

HIGHWAYS TO NEW YORK

Broadway Philosophers 89

Juniper

MIRACLE THINGS

Crackers

FOREIGN CRISIS A

Clementine

WATER BABIES

Landslide

LANDSLIDE

Milepost

FATS

Zebulon (Wood No. 112)
HARVEST FESTIVAL

Dawson
GREATEST SHOW ON EARTH

Runkle Roman
GRAPE JAMS

Chikamauga
MARKET FRESH

Ragtime
MOUSTACHE PETE'S

Usherette
MAGICAL MOMENTS THE

Bohemia
BUTTONS & NEEDLES GALORE

Bonanza
DEMONSTRATION OF DECEPTIVE

Begonia
MOUNTAIN HOUSE

Hopkins
LIPS THAT TOUCH LIQ

Clown Alley
MUSICAL EVENTS

Farringdon Outline
FARRINGDON MACHINE

Farringdon
OLD ENGLISH FOLK SONG

Brenda
THE ROAD TO SALISBURY

Jason Wood
YIDDISH FOLKTALES TO

Curiosity
INDIAN ARTIFACTS SH

Snowdon
ROUSTABOUT RELAXES

Cooktent
FRONTIER VILLAGE

Gilbey
JUNIPER BERRY REFR

Nogales

PROGRAM NOTES

Heather

THE STARLIGHT RIDE

Aster Wood

HORSE RANCHES

Excelsis

THE BEST TEACHER BU

Mahoney

UNION SQUARE

Orchid

SNAKE CHARMER

Redwood

NORTH BOUND A

Grecian

THE FORBIDDEN ISLAND

Wood No. 6

THE WALTONS

Page Peerless Antique

COACH LINES

Egiziano Wood

ELEPHANTS

★★★★★ FIRST ANNUAL ★★★★★
ROARING CAMP
HANDCAR RACES AND
STEAM
FESTIVAL

🖝 RIDE 🖝
1899 Heisler Steam Train
1912 Shay Steam Train
🖝 SEE 🖝
1897 Baldwin Locomotive
1870 Donkey Steam Powered Saw Mill
Plus other historic equipment
🖝 CHEER 🖝
Railroad Handcar teams to victory
— RACING EACH DAY —

SATURDAY, SUNDAY & MONDAY
LABOR DAY WEEKEND
August 31 and September 1 & 2

🖝 Board the Authentic Steam Trains of the **ROARING CAMP & BIG TREES R.R.** for a **HISTORIC & SCENIC EXCURSION** through **MAGNIFICENT REDWOOD FORESTS!** Partake of a Delicious **CHUCKWAGON STEAK BAR-B-Q** served beneath the trees! Enjoy Genuine Country Music with **FIDDLER & BAND!**

ADMISSION TO ROARING CAMP $3.00 PER PERSON
(Credited to each Steam Train ticket purchased.)

Handcar Teams must register in advance.
For further information telephone (408) 335-4484

ROARING CAMP
& BIG TREES RAILROAD
Felton, Santa Cruz County, California

Nickel Wood

RIOT SQUADS

Kent Wood

SANTA FE STAGELINE

United Gothic

OUT AND JOIN TH

Nugget

DIMENSION TH

Daisy Wood

DAILY NEWS

Mona

REWARD I

Rose Egyptian

GARDEN

Balderdash

REQUIEM for a heavy

Balderdash No. 4

FOURTEEN YEARS

Balderdash No. 2

LAW IN THE WEST!

Balderdash Tablet

BALDERDASH TABLET

Carnival Open

VICTORIANS

DREADFUL TYPOGRAPHY

$500 REWARD	$25,000 REWARD JESSE JAMES DEAD OR ALIVE
For the Arrest and Conviction of	$15,000 REWARD FOR FRANK JAMES
JESSE JAMES	$5000 Reward for any Known Member of the James Band
St. Louis Midland Railroad	SIGNED: ST. LOUIS MIDLAND RAILROAD

The two posters shown above have been widely reproduced by historians as "the real thing," but they are not. Any competent period typographer would dismiss them as a fraud without a second glance. The layout is ridiculous, the punctuation usual to the time is missing, and—most dreadful of all— two of the typefaces used weren't designed until at least fifteen years after Jesse James died. There's no rule that says old type has to be used authentically, but if the job does call for an authentic look, give us a call. Solotype knows how.

Kevin

AUSTRALIA'S CUP
Official First Race Photos

Mousehole

RUNAWAY WITH THE CIRCUS

Latin Condensed Wood

NEW YORK TIMES HEADLINE TYPE

Staccato Wood

SALOON CL

Pyramid Shaded

PHAROAH WARS

Fearless

HONEST IDEAS

Jackpot

MONSTER SHE

Crosstie

HORIZONTAL

Byron

PRINTMAKER

Cheapjack

CHEAPEST

Wood 47

RODEO

Page Ionic (Wood No. 22)

EARL'S COURT

Argosy

STOLE XMAS

Jolly Josephine

THE FAT LADY SINGS

Primula

ROASTED NUTS

Firehouse Gothic

BUFFALO PASS & SCALPI

Chabot

FRAME maker discove

Minnesota

RANGE finders

Alcazar

Circus Arts School

Alcazar

S·T·E·A·M P·R·I·N·T·I·N·G

Railroad Gothic

POPULAR GOTHIC STY

Jubilee Wood

THE DISTANT DRUMS

Bindweed

MASTER CRAFTS

Hometown

HOME TOWN X

Rover Boys

GLADIATORS TRIBE

Mandy

CHRISTMAS CANDY

Don't wait 'til the last cat's hung to place your order.

Backhand Script

The Eating Place

Walter Wood

GREATEST show on earth

Kildare

DOCTORS repeat golfin

Valjean

GUIDES hired from

Tungsten Solid
CHINA TREASURE

Woodboat
FARMER'S PRODUCE MARKET

Tungsten
TUNGSTEN MEDICAL

Antique Triple Condensed
SIPPING POISON FROM A CUP OF OOLONG

Panjandrum
HOME CLUBS

Antique Double Condensed
WHISTLESTOP CAMPAIGN TRAIL

Nesbitt Fat Face
ROCKET SCIENTIST

Bootjack
MY CHINATOWN

Klondike Wood
KLONDIKE discovery reveals

Bamberg
WANTED FOR CRIMES OF PASSION

Antique Condensed Humbert
FRENCH roasted coffee has

Rondell
ROUND HORSE

Caswell Condensed
JOHN appleseed grows

Round Gothic
BABES IND

Goodfellow
BLACK horse can

Rhett Shadow
SLEEPY TIMES

Jake Tablet
ON OUR STAGE

Carnival
CIRCUS DAY

Marquette
PHOTOGRAPHS BY PATRICIA

Camelia Wood
FLOWERS & HERBS

Sutro Wood
LADIES & GENTLEMEN

Primrose
VICTORIAN AUTHOR

Frolic
ANNUAL FROLICS

Grecian Extra Condensed
JEFFERSON AND MONTICELLO

Grecian Condensed Fineline
OLD TIMERS DANCE

Shimmer
OUR BEST DEALS

Rosemary
GAS LIGHT DAYS!

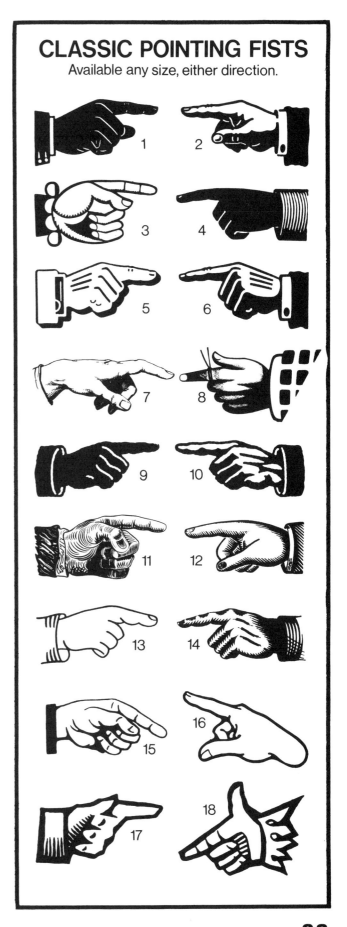

CLASSIC POINTING FISTS
Available any size, either direction.

Nesbitt Fatface
GREAT poster types

Amberg
CHALK drawings

Cirque
HALF A LOAF is better than

Pardee
KITES checked for

Richmond Wood
MISTER and missus ito

Rhodium
THROWING the fight for money

Van Horn
RETAIL GAMES

Torpedo
DAMN THE TORPEDOES

Patriot
CIRCUS DAY

Eureka
NEEDLECRAFTS

Tombola
ISLAND EMPIRES

Vacation Helpers

Wood 104
HOLDING?

Wood 18
TARPS!

Puffin
MUSIC VIDEO

Wood No. 2
QUIET ONE

Rustic Inline
RUSTIC WAYS

Nottingham
NOTTINGHAM GATE

Caldwell No. 2
WILD WEST RODEO

Gettysburg
GREAT CRIMINALS OF

Wood Block Grotesk
BATMAN & ROBIN AT

Juanita
GENERAL MASTER

Title Gothic No. 11
METER READERS

Caldwell
POPCORN GARLANDS IN

Fiona
OLDE VICTORY

Humbert
OUTLAWED MUSIC PLAY

Railroad Gothic
SOUTHERN PACIF

Wood No. 16
MAGIC

Quartz Black
CREATIVE

Quartz Shaded
RAILWAYS

Morgan Gothic
WILLARD & SONS

Wood No. 20
DRINK MORE

Grecian No. 6
NO SMOKING HERE!!

WILCOX INITIALS

ABCDEFGH
IJKLMNOPQRS
TUVWXYZ&

Dahlia

BARNUM'S CIRCUS

Rodeo Condensed

WILD COUNTRY

Tuscan Dotted

CELEBRATION TON

Narrow Gauge

CARNIVALS & GAMBLING

Coffee Can Initials

OPENING GAL

Vanderburg Pointed

HIGHLAND GAMES

Verbina

LEMON VERBINA SQUASH

Grubstake Open

DEFINITIONS

Grubstake Black

ROME PHONE

Xavier

XAVIER MAGICS

Sadie Hawkins

SADIE HAWKINS

California Clarendon

CALIFORNIA GOLDEN

Antique Condensed Boston

BEAN COUNTER BOSTON

Express

THEATRICAL VENTURE

Golden Era

THE GILDED CAGE

Mimosa

ROY AND TRIGGER

Grecian Shaded

APPLE JACK SCRATCH

Facade Bold

SARTORIAL ELOQUENCE & STYLE

Our unlimited selection of type enables us to produce tightly-fitted work like this from your rough layout. Be prepared to pay for trial settings and 'stats to size, which are always necessary in this work.

Templar Wood
RAZOR CUT

Pansy Wood
GREAT DAYS

Patsy
ENTERTAIN ROYALS

BARBARY COAST
DAYS

Vanadium
Guaranteed Fresh

Vanadium
GUN SHOW OPEN

Edna
HIS song

Rhoda
Drag Racers

Rhoda
RED SKIES

Chickamauga
FUNDING

Solotype does make a difference. Try it and see.

Kid Ory B
BUTCH AND SUNDANCE RIDE

Octic Extra Condensed Wood
BACKGAMMON PLAYERS

Juanita Plain
TUXEDO JUNCTIONS

Serena
MAGICAL MYSTERIES

Antimony
GLADIATORS at the Colisseum in Rome

Carnation Wood
MANEATING FISH eaten by gourmet

Tulip Wood

BOXED FRUIT

Ishpeming
BLACKEST

Rodeo Tablet

GREAT MEALS

Dime Museum

BANG from guns

Southland

New Circus Band

Roxy

ROUGH estimates given

Sans Serif Condensed No. 1

HOT RECORDS STOLEN BY

★★★

☞ **CITIZENS ARISE!** ☜

★★★★ **THE CALIFORNIA** ★★★★

CIVIL WAR

★★★★★ **ASSOCIATION** ★★★★★

WILL HOLD ITS SECOND ANNUAL CIVIL WAR

BATTLES & ENCAMPMENT

SATURDAY, SUNDAY & MONDAY

MEMORIAL DAY WEEKEND

★★★★★★ **MAY 28, 29 & 30, AT** ★★★★★★

ROARING CAMP

& BIG TREES RAILROAD

FELTON, SANTA CRUZ COUNTY

☞ *See Union and Confederate Troops in*
Authentic Battle Re-enactments Featuring

INFANTRY, ARTILLERY & CAVALRY UNITS

3 BATTLES A DAY 3

☞ Board the Authentic Steam Trains of the
ROARING CAMP & BIG TREES R.R. for a
HISTORIC & SCENIC EXCURSION through
MAGNIFICENT REDWOOD FORESTS! Partake
of a Delicious **CHUCKWAGON STEAK BAR-B-Q**
served beneath the trees! Enjoy Genuine Country
Music with **FIDDLER & BAND!**

ADMISSION TO ROARING CAMP
$3.00 PER PERSON

☞ Steam Train Excursion and Bar-B-Q Extra.
An Admission Ticket will be refunded with the
purchase of a Steam Train Excursion Ticket.

COME ONE, COME ALL!

★★★

Dahlia Wood

ELECTION DAY, BALL OF CONFUSION

Daniel Webster

DELUXE ACCOMODATIONS IN TOWN

Verbena

IT'S IMPOSSIBLE TO STICK A CADILLAC UP

Mayo

FIRST BANK

Marchtime

BOND PRACTICE

Grand Wood

ONE GRAND

Palm Wood

HOT DOGS

Zinc Wood

PISTOL

Grecian Extra Wide

TROMBONIST

Wampum

INDIAN PAWN TUR

Cheops Wood

RUSTIC

Gothic Tuscan Condensed Wilcox

GOLD RUSH ART!

Carboy Bold

GENERAL SON

Aspenwall

THE GIFT OF MAGIC

Square Barnum Condensed

DEPORTED PROMS

Rally Scotch

RALLY 'ROUND THE

Wharfdale

TUNICS

INDEX BEGINS ON PAGE 232

Carter Egyptian Extra Condensed

DOWN AMONG THE SHELTI

Haymarket

MIGHTY casey has struck out

Digest Roman Extra Condensed

DEFINITION quotations

Digest Roman Condensed

JUNQUE cellars

Digest Roman

REST easier

Digest Roman Extended

BRAZEN

Carter Egyptian Bold Condensed

SPHINGES revisited

Pinewood

PIN strip

Keystone

BANGLES!

Rubens Wood

ROMAN honkers

Rubens Wood Caps

HANDSOME FRO

Omicron Wood Gothic

DELIGHTFUL TIES

COME ONE! COME ALL!
TO THE
SIXTH ANNUAL
PIEDMONT ARTS
FESTIVAL
SUNDAY, SEPT.
25
AT PIEDMONT PARK
HEAR
MAESTRO
CARMEN DRAGON
CONDUCT
THE ARTS FESTIVAL ORCHESTRA
SAN FRANCISCO SYMPHONY MEMBERS & OTHER BAY AREA SYMPHONIES
ENJOY
DUO PIANISTS
BOGAS & GIANOPOULOS
Roy Bogas, Tchaikovsky Competition Laureate, and Dino Ginopoulos, Virtuoso
PERFORMING WITH THE FULL SYMPHONY ORCHESTRA
CAMILLE SAINT SAENS
THE CARNIVAL OF THE ANIMALS
VERSES BY THAT GREAT WIT OGDEN NASH
DRAMATICALLY PRESENTED BY

WRITE FOR A COPY OF OUR
FREE CATALOGUE
MORE THAN 700
RAILROAD
BOOKS
ALWAYS IN STOCK
CARRY AN EXTENSIVE
LINE OF QUALITY
RAILROAD MERCHANDISE
GIFTS & JEWELRY
FINE SELECTION OF
LITHOGRAPHS
IN STOCK TOY TRAINS
STORE OF THE CALIFORNIA
STATE RAILROAD MUSEUM
WHISTLEPOST 1
STREET · (916) 447-9665
SACRAMENTO, CA 95814

EASTERN
Bristol,
NAVIGATION

RETURN TO THE
GOOD OLDE DAYS
WHEN
BANKING
WAS FUN!

THE
GREAT BRITAIN
Largest Steamship
in the World,
SAILING
FOR
PIER 49
SAILING
FOR
SAN FRANCISCO, CALIFORNIA,
May 28, 1849.

ANNUAL SACRAMENTO
HARVEST FESTIVAL
& COUNTRY CRAFTS MARKET

FROM ALL
ACROSS AMERICA
OVER 700 FINE CRAFTS
ALL IN 19TH CENTURY COSTUME, DEMONSTRATING AND S

CONTINUOUS STAGE
ENTERTAINMENT
MARVELOUS MELODRAMA

Early American
Folk Songs & Dances
TOE-TAPPING BLUE GRASS MUSIC

PLENTY OF NICE PEOPLE · ALWAY
Your One Great Opportunity to Purchase Origina

OCTOBER 7, 8, 9
Fri. Noon-10 PM / Sat. 10 AM-10 PM / Sun.

SACRAMENTO COMMUNITY / CONVEN
Entrance on J St. near 14th

TICKETS: $2.00 at door — Children 50¢ — Grou

ANNIVERSARY BALL
A TRADITIONAL FIREMAN'S BALL
JOIN THE
ST. FRANCIS HOOK & LADDER SOCIETY
& THE SAN FRANCISCO FIRE DEPARTMENT
FOR A
GALA 20TH OBSERVANCE
OF THE 1906 EARTHQUAKE AND FIRE.
SPECIAL EFFECTS AND GRAND MARCH
COMPLIMENTARY
Champagne, Wine, Beer, Hors D'Oeuvres
MUSIC BY
PRIDE & JOY AND THE ROYAL SOCIETY JAZZ ORCHESTRA
AND FEATURING THE RED HOT REDHEAD
COMEDIENNE LINDA HILL
HONORARY CHAIRPERSONS
MAYOR DIANNE FEINSTEIN AND CHIEF EMMET CONDON, SFFD
SATURDAY
APRIL 19
8:00 P.M.–1:30 A.M.
S.F. CITY HALL ROTUNDA
(Polk and McAllister Streets)
TAX DEDUCTIBLE DONATION
$25
PER PERSON

ATTENDANCE LIMITED

BARBARY
COAST
DAYS
JUNE
27·28·29
9 A.M. – 4 P.M.

Charlie Chaplin liked the Parsons types for his silent movie titles.

MILLION singing comedians

Auriol Italic

Listen My Children

Auriol

ESP festival staged

Auriol Outline

SHARE your hil

Auriol Condensed

WOOD OIL used in flavorin

Parsons Light Initials

ABCDEFGHIJK
LMNOPQRSTUVWYZ

Parsons Bold Initials

ABCDEFGHIJK
LMNOPQRSTUVWYZ

Parsons Initials
Parsons Initials

Berolina Bold

BALANCING
ACT

Parsons Light

RADIO revived on

Berolina

WATERS for health and

Parsons Bold

DARIN cooking t

Berolina Bold

EUROPE inspiration cl

Hobo light

PISTOL SHOT rang through th

Hobo Bold

LONG TIME until the return of

Hobo Outline

VAGRANCY laws enforced

Hobo Black

RUMBLE SEAT was fun in go

Inside Solotype by Golly

Modern, compact typesetting
equipment speeds production.

Godiva

Art Nouveau Favorites

 Art Nouveau began as an architectural movement in the late nineteenth century. Its snaky, flowing lines and naturalistic motifs soon found their way into furniture, art objects, clothing and -inevitably- type designs.

Godiva
CASES of liquor arriving by C

Livonia
PROOF of the pudding is in the

Interlaken
SKIRT of bright flowered mat

Iron Gate
FLAKY bran muffin mixes sell

Salem
FOGGY nights on the

Argos George
BLACK hearted pirat

Emperor
HOLIDAY into darkest rea

Siegfried
JOURNEY immortalized by R

Thalia
CLASSICAL references ofter

Tip Top
JAPANESE presented trad

Danube
CHANCE meetings

Fantasie Artistique
CAST aside fears th

Culdee
CALIPH in grand proce

Cleopatra
TABLES of houses and

Please to remember...

We are always closed during the entire month of October for our annual type hunt.

SOLOTYPE

A most unusual type shop.

Virile
SEPTEMBER upon the earthl

Virile Open
FAVORITE art nouveau perio

Erratick
EAGLE watchers I

Erratick Light
ENJOY game of

Erratick Outline
BUYING houses

Bambus Grotesk
CLOWN'S big red nose

Jackson
SHADOW interlopers i

Jackson Wide
AUGHT of early revo

Tintoretto
MUSIC event of

Murillo
Arthurian Legend

Utrillo
PLACE answers in

Baldur
WHIST party arrange

Flemish Wide
MUSICAL program sold

Teutonia
GREAT morning events

Ophelia
The Faust Legend Exami

Ebony
SMILE on sunshine of

Art Sans Half Solid
SEMI-sweet chocolates

Constantia
BASKET makers of

Negrita Outline
POINT out benefits

Negrita Light
SWING into Spring at

Negrita
HATS for any time

Inside Solotype by Golly

Our operators are standing by to assist you weekdays from 8 a.m. to 4:30 p.m.

Primitive
Primates Displayed Today

Cordova
Change Type For Effect Today

Art Gothic
BEAUTY PARLOR makes waves per

Art Gothic Bold
GRANDIOSE schemes hatched too

Harlech
MENUS include soup an

Childs
BANDS invade states

Griswold
MEXICAN pyramids at Sar

Elefanta
THORN trees plan the

Skjald
NORTH provide nig

Excelsior
UNION troops mecha

Abbott Oldstyle
FRIAR takes vows

Columbus Initials
Quaint Scene
BCEFKLQ
RSTVW

Mira
WATER plays Carneg

Franconia
BREAK with our gre

Titania
OCEAN liner trips

Columbus
CRISP and crunch

Branchwater
PUBLIC opinion st

Columbus Outline
FRESH fish today

Temperance
BARNS are often

Columbus Bold
SHIP of fools sail

A line or two from Solotype will jazz up any job.

Bocklin Bold

Art Nouveau!

Bocklin

ABCDEFGHIJKLMN
OPQRSTUVWXYZ
abcdefghijklmnopqrf
stuvwxyz 123456789

Student

GIRLS wanted for extra

Hercules

PLANT shop flowers as

Fingal's Cave

CREATE novel heads

Herold

MIGRATION of vacationers th

Elefante Outline (Domingo)

MASQUE tonight at the ol

Elefante (Marshall)

FREEDOM characterizes n

Medea

MONSTER mashed potatoheads

Romany

MODERN romance

Bocklin

MEN demonstra

Bocklin Bold

BIKE trail guide

Roberta

CIRCUS elephants co

Roberta Outline

ROBERTA in outline

Neptune

EXOTIC from the briney

Bishop

LONGER journey into t

Pretoria

CREW sought v

Every type shown will be used someplace, sometime.

Secession Medium
CHARIOT races tonight

Oceana
FENWICK rules the entire

Hohenzollern
TARRY awhile in luxury as

Eckmann Schrift
CAUGHT red-handed

Charleston
HONEY crackers and

Rogers
King Arthur by

Abbey English
BLENDS created from

Chantry
EARTHLY delights questione

Jubilee
STYX river fishing

Carmen
CARMEN operetta stage

Boomerang (Hansa)
Wallabies Jumping For Joy

Boomerang Italic (Hansa Cursive)
Writers Begin Conference

Boomerang Bold (Regina Cursive)
A Modest Proposal to

DeVinne Ornamented
CABLE television

DeVinne Ornamented Italic
SMOKE another by

Giraldon
SOAPY lost dwarf

Giraldon Italic
MAGIC awards show

Giraldon Bold
BEST from europe

Une Nuit
— dans —
Le Vieux
· Paris ·

Tiroléan
SHAPE your daily work

Huntsman
KRAFT papers and fin

Fantasie Noire
WORDS and more w

Ambrosia

THEY GO WILD, SIMPLY WILD, OVER THESE

Isadora

HOLLYWOOD FILMS

Calcutta Solid

HOLY COW ELS

Kerry's Titling

EARTHWORMS IN

Calcutta

ANTIQUE FURNI

Limbo

CEREMONIAL SWORD

Calcutta Bold

HEATHEN VINE

Desdemona (Quaint Black)

THE LITTLE LOST BEAR

Calcutta Rimmed

LA BELLE EPOCH

Quaint Open

ENTER THIS CONTEST

Pigalle

HUNCHBACK OF NOTRE DAME

Jagged

OVER THE JAGGED

Spencer

IMPORTED WINES A

Spencer Bold

MOUNTAIN GROWN

Rollo (Foster Gothic)

CARTWRIGHT'S LAND

Multiform No. 4

EMPLOY MOTLEY

Multiform No. 1

METAL DETECTOR

Multiform No. 1 Bold

SCIENCE FICTION

DREADFUL TYPOGRAPHY

TINTORETTO
TINTORETTO
BOCKLIN
BOCKLIN

You see it often in graphics, the peculiar letter I that looks like a J. It's found in German decorative types, and there's a reason: The Germans, in days gone by, didn't set their display lines in all-caps. The peculiar I works well when used as the first letter in a line of lowercase, but is dreadful when seen in an all-caps setting. The makers of fonts and dry-transfer lettering, who sometimes appear not to know much about type, seem content to ignore the problem. At Solotype, however, we always redesign an appropriate letter I for all-caps use. Another sneaky way we avoid dreadful typography.

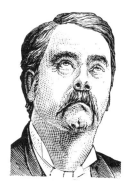

Most Art Deco types aren't!

Most Art Deco types are actually latter day creations. The original period was short—1925 to 1935—and over half of it was plagued by the Great Depression of the 30s. Most printers simply couldn't afford to buy the new Art Deco types. By the late 30s when the economy began to improve, we had moved on to the Streamline Age with types like Huxley Vertical and Empire. Only a few of the original Art Deco faces, notably Broadway and Futura Black, achieved lasting popularity. New designs in the style proliferated in the 60s and 70s when photolettering came into its own.

Dellmond Rimmed Black
RIMMED SHADOW

Dellmond
TRICKY SHADOWS

Veronica
ARCHIE'S GIRLFIEND

Veronica Open
TICKET SALE FROM

Mania No. 1
HIGH STYLE TYPE

Mania No. 4
CONTEST JUDGE

Mania No. 3
CHOKING CAN HURT

Mania No. 2
PENNY ANTE POKER

Dynamic Deco
BLACK HORSE

Guggenheim
CODED SIGNALS

Guggenheim Shaded
VIDEOS PAC MEN

Blunt Highlight
CARWASH BLUES

Bobo Bold
CLOWN ALLEY

Harmony
THREE PARTS

Mindy Highlight
CHROME LOOK

Baby Teeth
BOY BITES MONK

Cubist
DANCING IN

Joyce Black
HEAVYWEIGHT

Pickfair
SPACE BLACK HOL

Fat Cat
ARTS & CRAFT

Theda Bara
SILENT FILM VAM

Ticktock Wide
THE WARS!

Porky
PORK AND BEANS

Ticktock
CRUISE control sw

Eclipse
URANUS MOON

Parasol
SHOWERS of Hollywood Stars g

Clyde
MANUSCRIPTS

Parisian
FRENCH poodle kiss and tell

Alex
DOUGHNUT HOLE

Ricky Tick
OBTUSE geometrics

Capitol
RIVIERA HOTEL AA

Plaza Suite
POKER face play

Grock
ORIGINAL DESIGNS

Futura Black Outline
MOCK turtle soup

Roco
NIGHTCLUB SWAP

Futura Black
BLOCKS of butcher

Boul Mich
COCKTAIL ART

Manhattan
UPTOWN subways

Broadway Engraved
TIMES squared

Broadway Bold
ROADWAY sensation

Inside Solotype by Golly

Broadway
WEST SIDE story re

Braggadocio
GOLDEN spike rails

Profit and loss statements are
received weakly.

Modernique
GREAT DAYS are comi

SOLOTYPE **49**

Glass Art
GREAT TYPOGRAPHY

Kailey
SHUTTLE craft dock

Carlotta
CARLOTTA LIVES

Fanfare
PANORAMA OF THE WORLD'S

Castaway
LEAVING ON SH

Branding
ORIENT EXPRESS

Kobe Open
WINTER BLUNDERLAND SKI

Lute Light
LITTLE STRINGER

Nadall
ARTHUR'S COURT

Lute Medium
RADIO MUSICAL

Eccentric
ECCENTRICALLY SPEAKIN

Lute Bold
CAGEY COUSINS

Galadrielle
ASPIC-COVERED POULTRY

Circus Wagon
TONIGHT ON STAGE

Frednel
ALMIGHTY DOLLAR COST

Neuland Inline
LAST OF THE HOT

Tanglewood
MYSTERIOUS ISLANDER

Neuland
MOHAWK DRUMS

Tanglewood Condensed
MADE FROM FINE HAND LOOMED WOOL

Ashley Crawford
DEVIL'S MAILBOX

Chloris
EARLY TO RISE MAKE TIRED

Ashley Inline
SECRET AGENT

Sheeba
COME BACK HOME TO

Phosphor
WATER SHORTAGES

Checkmate
PAWNS used to

Pan Bold
Jupiter, what a f

Eleanora
CAJUN ZYDECO FESTIVAL TIME

Round Rosie
TRAP GERMS KILL AD

Rosie
SAVE the whales blubb

Precis Bold
BAKED beans in Bastania

Gismonda
NAMES given to cop

Publicity Gothic
CRUST for baking

Balloonogram
CHILI sauce sensation

Sheet Steel
REFLECT telescope

Bust
HOUSE detective

Wild Bill
PRESTIGE cultural society forming

Avon
AVON LADY CALS

If there are types that are harder to read, we don't know where they are.

The rock concert and ballroom posters of the 1960s inspired a number of far out faces whose life was mercifully short. We show them below because they are occasionally used in layouts reflecting that period. We have always considered them hard to read.

Zephyr
WIND across th

Dudley Narrow
FAIR PLAY IS A JEWEL PRECIOUS

Urban
UNDERGROUND PRESS IN

True Grit
TYPES known tl

Zany
Rock Concerds

Inkwell Black
BLARE forth with i

Hoopla
BALLOON demonstra

Tulo
COLUMBIAN musical ins

Rhythm
EXQUISITE jewelry is

Brawley
MOVIE house hit

Venture
VENTURE capitalist

Patricia Bold
POWER typographers

Adriana
CORN festive

Adriana Italic
JETS all the

Vero Fat Antiqua
DIRT for sale

Monogram
DEPTH f finders

Polly
STORMY WET ON

Bullseye
TARGET PRAE

East Side
NIGHTS MAKE DAY

Sikkim
GOLDEN BROWN

Kubla Khan
CONQUERS

Zanzibar
ROAD TO ZA

Anonymous
KITCHEN APPLIANCES?

Anonymous Shadow
AESOP WAS FABULOUS IN

Anonymous Outline
ANONYMOUS OUTLINE

Crust
BAKERY SHOP

Wood Grotesk
CARVED wooden idols sold

Basso
EQUESTRIAN REVIEWS

Basso Outline
CAMCORDER SHOTS

Bees Knees
POWERFUL IDEAS

Sundown
THE JERRY SUN SHOW AT

Alpha Midday
LUNCH TIMERS

Alpha Sunrise
TEQUILA SUNRISER

Alpha Twilight
TWILIGHT ZONE

Alpha Midnight
MIDNIGHT TOUR

Margit
POLICE DEPARTMENT

Theatre
THEATRICALS

Ragtime
NAWLINS MUSICIAN

Grange
HOME ON GRANGE

Decorette Fancy
ROMANTIC DATE

Decorette Plain
FUN AND GAMS

Horndon
FINE CAVENDISH TOBAC

Lunch & Dinner

Spartana
HAND CARVED MAS

Spartana Outline
FACES OF THE PA

Spartana Shaded
BLADES OF STEE

Spartana Bold
LATEST COMEDY

Fantastic
PARIS SHOWTIME

Wings
ARLEN IN WINGS

Metropolitan
GENTRIFICATION UP

Hoffman
EAT NOT A BRAN

Nightclub
CATS MELODIES

Elefont
TAKEOUTS DROP IN

Wood Grotesque
DANGER explosives in use thro

Flemish Condensed
DIRECTOR QUITS

Dante Baily
DANTE'S INFER

Ringo
DOUBT IS

Aki Lines
SOLOTYPE IS THE PLACE

Piccadilly
GAS LIGHTING

Hotline
STOCK CAR DRIVERS

Neon
GAS LIGHT LOUNGE

Joanna
CAPONE'S organization

Prisma
RATS RUN MAZES

Festival
BRITISH BROADCASTING

Prisma Shaded
SPITFIRE BOMBING VE

Electra Clara
ELECTRA inline contours

Prismania A
LIGHTS GLOW NE

Prismania P
FUMBLE fingers reti

Prismania M
MAGIC HERBS FIX

Oxford
psychic foolishness

Prismania C
CREATIVE WORKS

Matra (Bifur)
RADIO IN THE THIR

Prismania K
KILTMAKING LAID

Beverly Hills
MOVIE STAR HOME

Prismania D
DRAKE CLUB DUC

Atlas
MACHINE DIES

Prismania G
GRATE POTATOES

Shady Deal
SAVING AND LOA

Prismania F
SPECIAL KIND OF X

Perky
STAND OUT FROM

Prismania B
BRANDIED FRUIT LY

Blackline
SWINGERS KEY

Boxley
MOVIE PALACES!

Acier Noir
PARTIAL ECLIPSED

Giraffe Condensed
FRAGRANT ORANGES BLOOMING

Really, now, isn't this a grand collection of type?

Giraffe Wide
BAGELS & LOX

Modernistic
DECO DESIGN

Seventh Avenue
BARGAINS GALORE TO

Saxony
CHARLIE PARKER BLUES

Oliver
BEAUTIFUL PRINT

Colorama
RICH FALL COLORS MI

Eclair
WOODCOCK & JIM

Chic
CLEAR THESIS

Vesta
WOVEN BLANK

Silver Screen
SILVER SCREEN

Bertie
OLD NAVAJO RUG

Paris Flash
GOLDEN DREAM

Boogie
DANCING IN THE ST

Atrax
TRACE THE COU

Lion
TIPPED CANOE

Gallia
CABLE CAR TR

Sinaloa
MEXICAN TOUR

Gallia No. 2
LIONS & TIGERS

Rialto
MODISH & BRIGHT

Squid
THE SQUID

Break the Look-alike Headline Habit!

INFORMATION ON SPECIAL EFFECTS STARTS ON PAGE 203

RUN for the SUN

strong • absorbent

HOLLYWOOD
and the
SUPERNATURAL

SHERRY HANSEN STEIGER
AND BRAD STEIGER

GOLDEN BRANDS
BEVERAGE DISTRIBUTORS

QUEEN'S MACHINE!

3-D POCKET DRIVER

GOT A QUESTION? GIVE A CALL.
PHONE (510) 531-0353 8 AM-4:30 PM
24-HOUR FAX LINE: (510) 531-6946

THE ENDS OF THE EARTH

SYSTEM FOCUS

DOWNHILL CHALLENGE

VACATION VIDEO

FREE GIFT INSIDE—
FROM DOMINO'S PIZZA!

Archie
SUPER bold type

Dynamo Shadow
MAGIC and myths

Dynamo
FUDGE brownies

Dolmen Decorated
SHAKE DICE

Dolmen
READ stories!

Sintex No. 1
HOPYARD condominium

Groovey
MARKETS open earlier?

Company
WATER company dry

Berliner Grotesk
GHOST of a chance to

Berliner Grotesk Bold
STONEface gargoyle

Block Condensed
GERMAN typographic st

Block Schwer
BLOCK form the

Block Outline Shadow
STOP watching

Super Dooper
FRAME maker form

Quartet
GROUP of quads

Antique No. 14
VALUE money of

Olden
OLDEN days visited

Bernhard Bold Extra Condensed
Bernhard Bold Extra Condensed

Bernhard Bold Condensed
STABLE hand wanted for

Forester
SIGNPAINTERS

Bernardo
JUKE BOX

Fanfare
BUGLE fanfare at

Affiche Modern
LARGE smile betwe

Brooklyn Face No. 3
WOKS TO WORK

Brooklyn Face No. 1
BLUES JAMZ IN

Brooklyn Face No. 2
BLACK HERD

 ...SOLOTYPE HAS THESE GREAT TYPES, TOO!

Bravour Kayo Light
ABCDE abcdefg

Bravour Kayo Medium
GHIJKL abcde

Bravour Kayo Bold
MNOPR abcdef

 GOT A QUESTION? GIVE A CALL.
PHONE (510) 531-0353 8 AM-4:30 PM
24-HOUR FAX LINE: (510) 531-6946

Gumball Bold
ABCDEFG abcdefghijk

Parkhurst Light
ABCDEG abcdefghijkn

Parkhurst Medium
ABCDEF abcdefghin

Parkhurst Bold
ABCDE abcdefghij

Chancel Mod
ABCDEFG abcdefghijklm

Horseshoe Light
ABCDEFG abcdefghijkln

Horseshoe Medium
ABCDEFG abcdefghijk

Horseshoe Bold
ABCDEFG abcdefghij

Churchward Brush Italic
ABCDEG abcdefghi

Churchward Brush
ABCDEG abcdefghijk

Time Script
ABCDE abcdefg

Time Script Medium
ABCDE abcdefg

Time Script Bold
ABCDE abcdefgh

Adverscript
ABCDEF abcdefghi

Lo-type Medium Italic
ABCDEF abcdefghi

Lo-type Light
ABCDE abcdefghijkl

Lo-type Regular
ABCDEF abcdefghij

Lo-type Medium
ABCDEF abcdefgh

Lo-type Bold Condensed
ABCDEF abcdefgl

Lotype Bold
ABCDE abcdefg

Illusion

EUROPEAN DESIGN

Startime
HOLIDAYS

Hollywood Stars
LAST PICTURE

Ascott Lights
DOTTY sings the a

Needlepoint
SEWING circle meets to

Rivets
NEWS ABOUT TYPE

Needlepoint Roughcut
COLONY settled by seafa

Hollywood Lights
VAUDEVILLE TONIGHT!

Sampler
CANDIES candygrams

Necktie Striped
CHRISTMAS

Necktie Plain
IS AT OUR THROATS AGAIN!

Posture
POSTURE IMPROVING

Direction
DIRECTION INDICATED

Focus (Process)
FOCUS FAULTS

Arcadian
ETCHED IN STONE AND

Soulsby
PINBALL WIZARDS

Bubbles
ROUND AND FAT

Barb
SPIKED PUN

Shatter
CRASH program for

Tonight
TONIGHT WON'T

Wings
WINGS ALOFT &

Showtime
HEADLINES THAT SPARKLE

Splash Water

Splash Oil

THE OIL SPILL

The "splashes" shown above can be applied to any type, but obviously will work better with bold, simple faces like the ones we have used.

Static

CHINA'S ELECTRIC I

Malibu

THE AMERICA'S CUP

Firebug

SIZZLING SUMMER SAVINGS!

Raindrops

RAINDROPS & SUCH

Icicle

HOT ices melt

Season

JACK FROST VISI

Snowcone

SNOWCONES MELT

Igloo Outline

ALASKA MORGAN I

Igloo Solid

TEMPERATURE UP

Earthquake

EARTHQUAKE

Sparks

ELECTRICITY

Sparkle

MAGIC SPECIALS

Explosion

VALUE EXPLOSION

Flamo

GRAND CASINO

Burst

BURST EFFECT

Doppler

DOPPLER ABC

Tension

STRESSED OUT? WHO ME?

Radio

RADIO DAYS REVISITED

Typhoon

GET SWEPT AWAY

Slipstream

CRASH COURSE

Speedo

GLIDE silently

Instant typographic fun with topical alphabets.

Cartoon Snowcap
CROSS COUNTRY EVENT

Cartoon Snowcap Open
SIERRA NEVADA LODGE

Cartoon Mexicana
TIN DANCES

Cartoon Snowcap Wide
WINTER DAY

Newsbeat Condensed
FRIDAY FISH RAP

Cartoon Snowcap Wide Open
SNOW BANK

Fata Morgana
FATA MORGANA EXPLORED BY

Cartoon Holly Days
HOLLY DAYS

Hurdy Gurdy
CASPIAN CAVIAR

Cartoon Party Time
PARTY TIME

Wood Relief
CARVE SIGN

Cartoon Tepee Open Condensed
INDIAN MUSEUM OPENS

Fieldstone
FIELD ON

Cartoon Tepee Condensed
EXHIBITING ART TODAY

Azure
CURIOS

Cartoon Tepee Open
RESERVATION

Sausage
THE WURST

Cartoon Tepee
INDIAN CAMP

Inside Solotype — by Golly

The day we showed a profit.

Ticket Roman
MONEY TROUBLE

Kolibree No. 2
SCOTCH OVER

Kolibree
BLANK VERS

Kolibree No. 3
ARGOSY SHIP

Cheque
CALIFORNIA

Banknote Italic
MONEY TROUBLE

Aquatint
MONEY makes their

Treasury Open
Bonds Listed on the Ex

Treasury Black
Stocks & Bonds Recalled

Steelplate Text Shaded
The Bank San Franci

Halftone
Ben Day Effects Pro

Century Litho Shaded
LOTTERY tickets printed f

Argent
Banking Company of Honest

Merlot
MERLOT ARGENT

Greystoke
PLACE D'ARGENT LOT

Symbol
MONETARY PLAN

Select
COLLECTIBLES

Engravers Bold Shaded
MINT COIN

SAM'S INCREDIBLE SHRINKING GREENBACKS
WATCH THEM VANISH, ONE BY ONE, BEFORE YOUR VERY EYES!

Certificate
BANKRUPT!

Certificate Open
STOCK BUY

Radiant Antique
MUNICIPAL BOND

Garfield Special
COUPON EVENT

Garfield Condensed
FREE GIFT OFFER

Garfield
IF MONEY WAS

Garfield Wide
BANK NOTE

Bankers Roman Open Condensed
WITHDRAWAL

Bankers Roman Open
MONEY MART

Bankers Roman Open Extended
DEPOSITS

Bankers Roman Condensed
BANKING JOB

Bankers Roman
RAILROADS

Bankers Roman Extended
SILVERED

Banknote Roman
$20 VALUE

Banknote Roman Fineline
BIG MONEY

Garfield No. 3
BONDS ISSUE

Garfield No. 4
MONEY TALKS

Bond Open Condensed
CERTIFICATION

Bond Open
FAKE ESTATE

Bond Extended
INVESTORS

Bond Black Condensed
FEDERAL RESER

Bond Black
GOD WE TRUST

Bond Black Extended
GREAT SEAL

Bond Shaded Condensed
WHAT ME WORRY

Bond Shaded
GOVERNMENT

Bond Shaded Extended
GUARANTEE

We can stretch, squeeze and curve type to your specifications.

THE FIRST DOLLAR WE EVER MADE.

Engravers Roman
BOND FRAUDS

Charter Roman
MONEY FOR WORK IS

Engravers Roman Extended
THE OLDER

Rimmed Roman
LOST WAGES NE

Engravers Roman Bold
THE ARTISTS

Marchtime
BANKING PRACTICE

Martini Shaded
VODKA MARTINI STIRR

Map Roman
BANKERS WE

Bond Roman with Penline Flourishes

TOBACCONISTS

Copley
THE BIG SHOWS

Parma Horizontal
MASTER HIT

Mercantile
MERRY GRINS

Parma Vertical
COLLEGIATE

Debenture
CHECKS

Auroral
GUARANTEE

Skyline

PROPERTY DEVELOPMENT

Solotype Really Does Make a Difference!

INFORMATION ON SPECIAL EFFECTS STARTS ON PAGE 203

FutureVision

FutureVision

UNDERWATER RESCUE!

HOW MANY DIVERS CAN YOU SAVE BEFORE SURFACING?

GOT A QUESTION? GIVE A CALL.
PHONE (510) 531-0353 8 AM-4:30 PM
24-HOUR FAX LINE: (510) 531-6946

HOT CHOCOLATE

OFFSHORE

The Grapevine

apshots American Snapshots American Snapshots America
n Snapshots American Snapshots American Snapshots Am
apshots American Snapshots American Snapshots America
n Snapshots American Snapshots American Snapshots Am
apshots American Snapshots American Snapshots America
n Snapshots American Snapshots American Snapshots Am
apshots American Snapshots American Snapshots America
n Snapshots American Snapshots American Snapshots Am
apshots American Snapshots American Snapshots America
n Snapshots American Snapshots American Snapshots Am
apshots American Snapshots American Snapshots America
n Snapshots American Snapshots American Snapshots Am
apshots American Snapshots American Snapshots America
n Snapshots American Snapshots American Snapshots Am
apshots American Snapshots American Snapshots America
n Snapshots American Snapshots American Snapshots Am
apshots American Snapshots American Snapshots America
n Snapshots American Snapshots American Snapshots Am
apshots American Snapshots American Snapshots America
n Snapshots American Snapshots American Snapshots Am
apshots American Snapshots American Snapshots America
n Snapshots American Snapshots American Snapshots Am
apshots American Snapshots American Snapshots America

Daisyland

FLOWERY SOLOTYPE

Calypso Initials

DIMENSION

Shoemaker Sans

CRAFTERS

Tartan

HIGHLAND

Rope Initials

SEAHORSES

Chains

LINK RING

Springtime

SPRING FEVER

Pencils

MAKE POINT!

Candy Cane

candy sticks

Hollywood Stars

HOLLYWOOD IN

Jiminy Christmas

JIMINY DAY!

Links

CHAIN LINKS

Holiday Wish

HOLIDAY WISH

Stamps

POSTAGES

Perspective No. 1

PROSPECTS

Giftwrap

GIFTWRAP

Houdini Lights

GAMESHOW HOST

Stonewall

STONEWALL

Sleighbell

CHRISTMAS

Daisies Forever

GREAT TYPE!

The forest primeval for sale at Solotype.

Oliva

Tenderleaf

Snowtime
SNOWTIME

Eve Initials

Hedgerow
STONE LOWE

Garland
SPRINGTIME

Linden
JUNGLES

Confucius
TEA HOUSE HUT

Alderwood
ALDER SHOP AN

Jungle Hut
JUNGLE HUT

Driftwood
OUR SEASHORE

Fenceline
FRONTIERS

Campfire
CAMPFIRE SO

Slapstick
MEND FENCES

Rustic
SMOKEHOUSE

Shantytown
ORPHAN

Rustic Whiteshadow
EXPLORING

Floriad

Kelly's Travel

AAABCCDDDEFFGG̃HIJKLM
NOPQRSTTUVWXYZ&$
1234567890I0¢%/.,:;"''!?¿--°()

Go Fish!

ABCDEFGHIJKLMNOPQRSTUV
WXYZ&.,~!?$¢() abcdefghijklmn
opqrstuvwxyz 1234567890

Kelly's Gourmet

ABCDEFGHIJJ
KKLLLMNOPPQRSS
TTUUVWXYZ.,'!?£$12345
67890¢

Tarantella

ABCDEFGHIJKLMNOPQRS
TUVWXYZ&.;!?$¢£()abcdef
ghijklmnopqrstuvwxyz1234
567890

Grog

MONSTER TYPE

Vampire

NIGHTWORK

Spook

FRIGHT WIGS

Spooks Alive

Midnight Show

Headhunter

HEAD HUNTER

Spooks Alive Outline

Haunting Tune

Dracula

TRANSYLVANIA

Spooks Alive Shaded

Weird Events

Frankenstein

SPARE PARTS TO

Hellhouse Two

Count Diablo

Monster Outline

HOUSE VISIT

Rocky Horror

MONSTERS MARCH

Cartoon Ghost Narrow Outline

SPOOKY OCCURRENCES

Cartoon Ghost Narrow

MIDNIGHT FESTIVITIES

Cartoon Ghost Wide Outline

GHOST SHOW

Cartoon Ghost Wide

POLTERGEIST

High Tech

Types for the electronic age from Solotype.

Electronic **CALCULATOR DESIGNER**	Automation Outline **NEW INTEGRATED CI**
Electronic Italic *MACHINES TAKING OVER*	Automation Rimmed **THE EARTH STOOD D**
Calculator Light *THE TIME MACHINE*	Automation Shaded **ROBOTS TAKE OVER**
Calculator Bold *GREAT INVENTORS OF*	Automation **AUTOMATIC MONIES**
Silicon *SILICON FACTORY*	Data 70 **SPORT** score phones
Russell Square Italic *CALCULATE FORMS*	Countdown **NATIONAL** computer
Russell Square **YEARS** of computers	Moore Computer **PUNCH THOSE KEYS**
Capacitor **NEW VIRAL STRAIN**	Amelia **COMPUTER** opens br
Printout **COMPUTER PRINTO**	Decade Computer **BRAINS** and bran
Quicksilver **NEON SIGN TYPES**	Synchro **SCREEN PREVUE**
Chromium One **CHROMIUM ONE**	Steve **TRIM** and stitch a

Credit Card Gothic
WINTER WINDS COMING AL

Credit Card Figures A
1234567890

Credit Card Figures B
1234567890

Stipple Typewriter
MONEY talks loud

Typewriter Squeezed
NARROWEST typewriter styled

Teletype
TELETYPE MESSAGE

Radiogram
MARCONI IS ALIV

OCR Type
COUNTDOWN 5,4,3,2,

Inkjet
GROCERIES AND LIQUORS

Pinball
ORATIONS speak loud

Pixel
ORDER TODAY PROMPTLY

Scoreboard
NEWS EVERY HOU

Polonia
MACHINE MAG

Bulletin Typewriter Bold
LETTER must be

Bulletin Typewriter
GROUND newspap

Fractured Typewriter
SCORE one for the

Ribbonfaced Typewriter
HEALTH stores a

Ribbonfaced TYPEWRITER for letters!

American Typewriter Outline
GONE foreverm

American Typewriter Light Condensed
STOCKS and bonds m

American Typewriter Medium Condensed
HOMES opened today

American Typewriter Bold Condensed
QUICK meals served

American Typewriter Light
FLUTE & clarinet

American Typewriter Medium
GREAT ideas roi

American Typewriter Bold
STAGE delicate

Ramen
RAMEN RECIPES EN

Japanette
EARLIEST form writi

Susie Wong
WANCHAI DISTRICT

Chin Chin
JOURNEY with MAP

Moon Gate
ORIENTAL MYSTERY

Mandarin
CHINESE GARDEN

Mandarin Outline
JUST HOLLOW M

Mandarin Shaded
SHADOW PLAY

Shanghai
GUIDED TOUR OF HO

Tokyo
ORIENTAL WISDOM

Ideograph
IMPERIAL WAY

Fantan
GINSENG FLAVORS

Sukiyaki
UNREADABLE

Civilite
Low Rents of Arabian homes

Legende
Nepal City Organization

Pekin
CHINATOWN when your li

MAH JONGG
The gift of the East to the West

Bamboo
CHINA contemplated l

Little Egypt
ORIENT travel books

Cathay
HARBOR great values i

Chopstick
MORSELS of delicious foo

Hong Kong
SHADOW new year fe

Chinatown
BANQUET from your

ORIENT TYPE

INDEX BEGINS ON PAGE 232

solotype talks your language!

Used in the right place, a few words in an exotic type can make an ordinary layout into something special. Most of these fonts have variant characters which we use to insure maximum readability.

Timbuctu
mysterious travel!

Khayyam
Omar Khayyam's New M

Siamese
the siamese twins

Shalimar
light experiences

Persian
The Legend of Camel o

Samoa
EXOTIC island huts

Harquil
TAKE pride in your a

Croissant
PUNCH recipes for

Harem
Abduction From Seragli

Trinity
THE IRISH COUNTRY

Shamrock
IRISH dances and music

Le Golf
MENUS featuring ac

Artistik
NORTH championship

Limehouse
FOLK concerts for

Manila
Manila and Environs

Pagoda
TOKYO transit autl

Appian
COMPOSURE OF DEFF

Acropolis
MOTIFS ARE REQUIRED TO B

Xerxes
GREEK ISLANDS VISITED BY

Pericles
GREEK PASTRIES IN

Chippendale
CABLE AND CHAI

Maccabee
LANGUAGE SKILLS ESSENTIAL IN OUR

Proverb
LAND TOURS being organize

Moses Condensed
FIVE MEN OF FRANKFORT BY

Sholom
CHICKEN SOUP

Arrowhead
SILVER arrowheads

Arrowhead Shaded
IMAGE sharpened of

Azteca Condensed
MEXICAN ARTISANS

Azteca
ANCIENT RUG

Herb Shop
HERBAL TREAT

Temple
PHILOSOPHIC

Russian Egyptian
THE RUSSIAN REVOLUTIÜÑ

Russian Clarendon
ARMY OF REDS

Sinbad
ARABIAN NIGHT FEVER

Early Egyptian Eye Chart
as imagined by Solotype

Scimitar
EXOTIC CLIMATES

Novella
MYSTERIOUS

National Gothic

CELEBRATIONS

Salute Stars

Liberty and Justice

Stars & Stripes

STARS & STRIPES

Moore Liberty

HOLIDAY EVENTS

Old Glory

LIBERTARIAN

Campaign

VOTERS

Town Hall Two

TOWN HALL TWO

Yankee Doodle

PARADE ROUTES

Fatima

PATRIOTICS

Banner Stars

FLAG DAY

National Spirit

CHAMPIONS

These types look red, white and blue even in black and white.

Old Glory Rimmed

THE PARADES

Cartoon Bunting Narrow

PATRIOTIC POLITICIANS

Cartoon Bunting Wide

CELEBRATION

Ad Lib Bunting

FLAGPOLE

Mystic Flag

MYSTIC FLAG 90

Flag Initials

CARNIVAL

American Assay

HEROICS

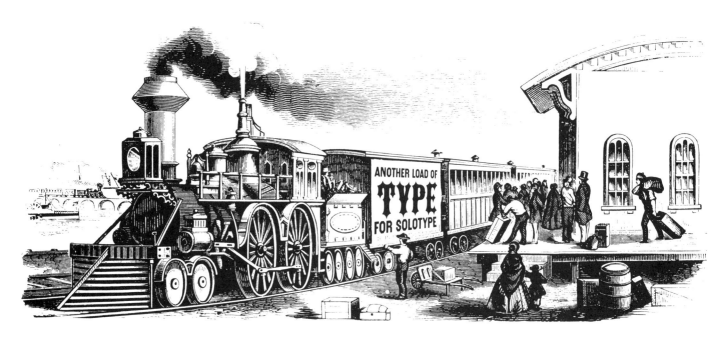

☞ Authentic Railroad Car Sign Painters' Styles ☜

Railroad No. 21

BRIDGE

Railroad No. 13

NOVEL BOYS

Railroad Car Figures

1234567890

Railroad No. 6

BUILDER

Railroad No. 23

TELEGRAPHING

Railroad No. 9

GROCERY STOCKS

Railroad No. 12

RAIL FARES

Railroad No. 8

FISH MARKET

Railroad No. 19

RAILS

Railroad No. 27

FRUITS

Railroad No. 15

ELECTRIC TRAIN

Railroad No. 7

SOUTHERN ROAD

Railroad No. 4

PRIVATE CAR

Stephen Ornate (Ends #1)

Stephen Ornate (Ends #2)

Stephen Ornate (Ends #3)

Stephen Ornate (Ends #4)

There is no premium for the use of these ribbon types, but the end pieces, center ornaments and spacing sections are charged as additional characters. Trading Stamp and Campaign were originated at Solotype. Film is a French style of the 1930s. The others are nineteenth century styles.

Film

Trading Stamp

Dimension 3

Tableau (Ends #1)

Campaign

Tableau (Ends #2) Tableau (Ends #3)

Ribbonette

Fillet (Ends #1)

Stipple

Fillet (Ends #2) Fillet (Ends #3)

Arborette

Fanfold

Arborette No. 2

Camille

Relievo (Ends #1)

Relievo (Ends #2)

Relievo (Ends #3)

Comic Book

COMIC BOOK PARADE

Clown Around

CARTOON CONVENTION

Yippie Narrow

JAUNTY WRANGLERS

Clown Around Open

GREAT AMERICAN FOOD

Yippie Narrow Outline

HAPPY COWPUNCHER

Bodie Bounce

CHARACTERS

Yippie

THE COWBOY

Bodie Bounce Open

TRADITIONS

Yippie Open

GRUBSTAKER

Country Barnum

SOUP KITCHEN

Scintillate Open Condensed

ASTRONOMICAL PRICES

Scintillate Solid Condensed

BRILLIANT TYPOGRAPHY

Scintillate Open

SCINTILLATE

Scintillate Solid

SPARKLE FUN

Texture No. 2

MUSHROOMS

DREADFUL TYPOGRAPHY

SOLOTYPE IS ALIVE!

(That's why the heartbeats
occasionally show.)

Some folks see image quality as the measure
of typographic quality. The letterforms may
be beautiful and exquisitely spaced, but if the
edges show hiccups or heartbeats, the job is
considered to be unacceptable.

We think this is sad, because many of our fine
old types come from original sources, not
computers, and sometimes lack the perfection
of the more common modern faces. Our types
are far from dreadful in quality, and most
users find them quite acceptable. But if your
standards put edge quality above all else,
perhaps we're not the best source for you.

Art's perfect forms no moral need,
And beauty is its own excuse.
— Whittier.

Your Ideas and Our Type — Wow!

INFORMATION ON SPECIAL EFFECTS STARTS ON PAGE 203

ONCE-A-YEAR EVENT!

K.C. Masterpiece

GOT A QUESTION? GIVE A CALL.
PHONE (510) 531-0353 8 AM-4:30 PM
24-HOUR FAX LINE: (510) 531-6946

MERCHANDISING

DEVIL'S ISLAND

California

THE UPTOWN WINE CELLAR

WILD BIRD FOOD

SAILING

MAZEMAKER

SUMMIT LANDSCAPE DEVELOPMENT

FAMOUS BRANDS

★ FIVE ★
★ STARS ★
STRONG

SEND US WORK – OR ELSE!

Ransom Note Reversed

TYPOGRAPHICAL teRRORISM!

Queen Casual

FEMALE monarc

Layout Gothic

LAYOUTS FAST

Quaker Inline

QUAKER cat makers

Dry Brush Gothic

DRY Brush Effect

Studio

ENCORE performan

Project

PROJECT IMAGE

Studio Bold

FINER work place

Tumbleweed

RETURN tomorrow and

Kartoon K

BRINGING UP FATHERS

Astur

QUESTING for intere

Kartoon Bold K

KATZENJAMMER KID

Pen Print Bold

CRUDE but forceful in

Cartoon C

TRAVEL THE EASY

Schooldaze

SIDEWALK GRAPHS

Cartoon Bold C

FREE PAMPHLETS

Notation

ROMEO loves Juliet

Cartoon Bold Shaded C

OCTOBER TRAVEL

Quarry Shaded

OBJECTS of desirability

Agitator

STOP THE WAR

Quest Shaded

QUEST for firelogs

Protest

THE MARCH D

Quota

QUOTA systems

Wormwood

SOLOTYPE MAKES HEADLINES
The Great American Headline Machine

INDEX
BEGINS ON
PAGE 232

At least half of the types on this page
came from an old newspaper shop in
Nevada many years ago. They were
so deliciously distressed that we
decided to leave them that way. Here
is instant old age at no extra charge!

Distressed Stencil
DISTRESSED ONE

Smuggler
THE LUMBER INDUSTRY REPORTER

Lotta Crabtree
ENGINES installed to pow

Daniel Boone
ROAD right way of

French Kate
BOAT on the old

Pony Boy
LIVERYI

NOTICE.
CLAIM JUMPERS
WILL BE SHOT ON SIGHT.
JNO. R. KINCAID, Gen'l Supt.
RUBY HILL MINING COMP'Y

Rubber Stamp DeVinne
OLDER letter and

Rubber Stamp Bold Condensed
STAMPS manufactured

Wood Grotesk No. 21
GROTESQUE FORMS

Skeleton Antique
SKELETON found by old miner

Calamity Jane
GROUND to be protected and pre

Annie Oakley
MOUSE traps sold today

Lola Montez
HOT numbers

Buffalo Girl
MINE claims so

Tombstone
TOMBSTONE EPITAI

Lyons Egyptian
WILD WEST EXTRAVAGANZA

Rocky Road
MOUNTAINS I

Scalplock
WILD SID

ABCDEFGHIJKLMNOP
QRSTUVWXYZ&
abcdefghijklmnopqrst
UVWXYZ1234567890

Old but true:
Good ads
start with
good headlines.

Gotham City
FAMOUS REMARK

Woodcut
PAUL'S bunion toe

Flintstone
PREHISTORIC ROCK

Woodcut Fineline
Woodcut Finelin

Parable
STORIES OF THE

Woodcut Shaded Initials
SHADED INITIAL

Parable Bold
PROMISE KEPT

Grab Bag
SHOW TIME USA

Trading Post
PUT WAMPUM IN YO

Yahoo
RED GAP SALOON

Trading Post Bold
TRADING CARAVAN

Chalkboard Block
BLACK LETTERING

Split
FARMER JOHN

Sarah Elizabeth
STARLIGHT DANCE

Split Wide
MAGICAL

Origami Contour
ORIGAMI PAPER

Hacker
STONE AGE ROCK

Hacker Outline
COUNTRY BUMP

Blade Display
THE EDGE OF SANITY

Mod Casual
FLYING SQUIRRELS

Valhalla
END OF THE TRAIL

Vladimir
TOWN OF BEDROCK

Dancer
CAVE OF BATS

China Brush
GHOSTLY LIGHTS

Stuntman
JUNKY YARDS A

Estro
SHAKING and quaking

Stuyvesant
CHARGE audacious ed

Tomahawk
KNIGHTHOOD presented by

Broken Bow
GERONIMO leaders

Jabberwocky
JABBERWOCKY

Tyler
MOSAIC EFFECT

Whimsey
WHIMSICAL STORIES

Elefont
SIGNS OF DANGER

Interlock
PLAYLAND AT THE BEACH

Scraffito
STRANGE BOOK

Lobby Art
DARK HOUSES

Lydia
ICHABOD CRANE

Black Casual
BACKYARDS

Inside Solotype by Golly

The efficiency of our order department
staggers the imagination.

Shepherd
BROWN cows made grey

Poor Richard
TELLER tells all in exc

Nicholas Cochin
TABLE and chairs mad

Nicholas Cochin Italic
GREAT early types lim

Nicholas Cochin Bold
KITES flying high

Greco Bold
GRECO bold and

Greco Bold Italic
CAFE and shop op

Greco Adornado
SUNSET ROAD

Alhambra Condensed (Ohio Bold Cond.)
QUIET in the study

Alhambra (Ohio Bold)
GATE closed pu

Quaint Roman Condensed
PATZCUARO craft guild

Quaint Roman
FILMS displayed

Airedale
BUMPS all in a ro

Jugenstil
BARK louder

Ben Franklin
LAKES open for fis

BEN. FRANKLIN
AUXILIARIES
—
The the Dr. of and To

Ben Franklin Open
GREAT earth feature

Ben Franklin Condensed
MEETINGS Central labor al

Roycroft
MADE appearance l

Post Oldstyle Italic
EARTH tractor sold

Post Oldstyle No. 2 Italic
QUIET storm warn

Post Oldstyle Condensed
GUARD typograph

Plymouth
WEST lives again

Plymouth Italic
TAME lion for se

Plymouth Bold
MINES closed

Colonial Dame Shaded
COLONIAL DAME
Reflecting the feeling of 1776

☞ The useful & neceſſary "long ſ" is included in this ſtyle.

You can be an instant genius with Solotype.

Colonial Dame
PAUL'S midnight ride

Colonial Dame Italic
MYTH revised and up

Colonial Dame Bold
REASON men will of

Colonial Dame Bold Italic
EXPLORE return wi

Caslon Antique
BROWN cow knolls how

Caslon Extra Antique
KITES designed for

Caslon Extra Antique Italic
BARNS raised ord

Freedom 200
YANKS gone back up

Chalk Roman
FAILED vision tester

Blanchard
METAL workers 1

Blanchard Bold Italic
EQUAL birth is a

Artcraft Bold
MAGIC mountains

Puritan
CLEAN thoughts

Powell
NOVEL typeface for

Pabst Oldstyle
QUIET zones define

Dominican
TOMBS opened fro

Nantucket Italic
MINUTE men hold

Naudin (Mayflower)
Fifty Dollar Reward Po

Naudin Italic (Mayflower Italic)
Patch Work and Special

Hearst Italic
WINES served at ro

Hearst
BOATS launche

 ...SOLOTYPE HAS THESE GREAT TYPES, TOO!

Tortilla Light
ABCDEF abcdefghijklm

Tortilla Bold
ABCDEF abcdefghijkln

Davenport Light
ABCDEF abcdefghijklo

Davenport Medium
ABCDEF abcdefghijk

Davenport Bold
ABCDEF abcdefghijl

Joker Light
ABCDEF abcdefghij

Joker Medium
ABCDEF abcdefgh

Joker Bold
ABCDE abcdefghi

Vox Pop
ABCDEG abcdefghi

Barker Script
ABCDEFG abcdefghijk

Barker Script Bold
ABCDEG abcdefghij

Gridiron Script
ABCDEF abcdefgh

Ebor Script
ABCDE abcdefghi

Weineman Script
ABCDE abcdefgh

Punchline
ABCDEG abcdefgh

Glossy Script Light
ABCDEF abcde

Glossy Script Bold
MNOPQklmn

Poster Script
ABCDE abcdefghijl

Poster Script Condensed
ABCDEF abcdefghijkl

Rage Italic
Rapper's Jam Sessions

Rage Bold Italic
Outrage And Anger

Lasalle Script
Open Door Policies

Bronx Script
Spraycan Art

Break the Boredom with Solotype!

INFORMATION ON SPECIAL EFFECTS STARTS ON PAGE 203

SuperTrim

WILD
SPOKE-WHEEL
ACTION!

COOL!

ROUND TABLE PRESENTS
— HOW THE PIZZA WAS WON —

FOR $2.00 OFF

FEEL LIKE A
MILLION
SAVINGS SWEEPSTAKES

MISTER GHICHKA

GOVERNMENT WARNING: (1) ACCORDING TO THE SURGEON GENERAL, WOMEN SHOULD NOT DRINK ALCOHOLIC BEVERAGES DURING PREGNANCY BECAUSE OF THE RISK OF BIRTH DEFECTS. (2) CONSUMPTION OF ALCOHOLIC BEVERAGES IMPAIRS YOUR ABILITY TO DRIVE A CAR OR OPERATE MACHINERY, AND MAY CAUSE HEALTH PROBLEMS.

YOUR
CHOICE

CHARLIE DANIELS BAND

 GOT A QUESTION? GIVE A CALL.
PHONE (510) 531-0353 8 AM-4:30 PM
24-HOUR FAX LINE: (510) 531-6946

Unless you say otherwise, we send all work by overnight express.

Athens
LETTERING Styles Created for You by Solotype wit

Ace
LETTERING Styles Created for You by So

Action Brush
LETTERING Styles Created for You l

Alert Casual
LETTERING Styles Created for You by

Arthur
LETTERING Styles Created for You

Atlas Overweight
LETTERING Styles Created fo

Adonis Handletter
LETTERING Styles Created f

Amber Casual
LETTERING Styles Created

Bunny Demibold
LETTERING Styles Create

Agate
LETTERING Styles Created for Y

April Handletter
LETTERING Styles Created for

Acme Brush
LETTERING Styles Created for

Anita Lightface
LETTERING Styles Created for You

Arcade Slim
LETTERING Styles Created for You by

Abbey
LETTERING Styles Created for You b

Ally Upright
LETTERING Styles Created for You by

Adam
LETTERING Styles Created fo

Aragon
LETTERING Styles Created f

Andy
LETTERING Styles Created

Arab Brushstroke
LETTERING Styles Created

Armada
LETTERING Styles Created

Ark Casual
LETTERING Styles Created f

Balloon Drop Shadow

BALLOON DROP SHADOW

Austin
LETTERING Styles Created for You

Arizona
LETTERING Styles Created for Y

Arbor Casual
LETTERING Styles Created f

Arena
LETTERING Styles Created

Arctic
LETTERING Styles Create

Accent
LETTERING Styles Creat

Army
LETTERING Styles Cr

Army Extended
LETTER Styles C

We were hunting for type designs at the Patent Office in Washington one day when we happened across a category devoted to barber poles. Couldn't resist copying a few to share with you. These were all designed in the 1920s, though the one on the left looks very Victorian. With the advent of the super-snip franchises, the barber pole seems to be vanishing from the scene. Better start collecting now.

IF YOU LEAVE
THE SHOP
YOU LOSE
YOUR TURN.

Sign in our local barber shop.

Canary
LETTERING Styles Created for You by Solotype w

Caravan
LETTERING Styles Created for

Candid
LETTERING Styles Created for You

Dancer Ace
LETTERING Styles Created for

Calico
LETTERING Styles Created for You by Solo

Card Casual
LETTERING Styles Created for You

Dart
LETTERING Styles Created for You by Solo

Cargo Brush
LETTERING Styles Created for You

SOLOTYPE **89**

Cameo Casual with Special Effects Shadow added

SOLOTYPE MAKES YOU LOOK GOOD!

Cocoa Medium

LETTERING Styles Created for

Avon Casual

LETTERING Styles Created for

Capri

LETTERING Styles Creat

Apache

LETTERING Styles Created fo

Cactus

LETTERING Styles Created

Border Bounce

LETTERING Styles Created for

Cameo Casual

LETTERING Styles Created

August

LETTER Styles Created

Comet Slope

LETTER Styles Creat

Arrow Handletter

LETTER Styles Crea

Conga

LETTER Styles Create

Beaver

LETTER Styles Cre

Cast

LETTER Style sr

Beaver Extended

LETTER Style C

Cadet

LETTERING Styles Created for You

Carmen Handletter

LETTER Styles Created

Carolina

LETTERING Styles Created for

Cane

LETTER Styles Created for You

Courtland

LETTERING Styles Created for

Checker

LETTER Styles Created for Y

Crest

LETTERING Styles Created for

Cutlass

LETTER Styles for

Marvel
Distinctive HEADINGS for Nicer DESIGNS

Navy
HEADINGS for Nicer Distinctive S

Musket
HEADINGS for Nicer Distinctive I

Misty
HEADINGS for Nicer Distinctive I

Modern Bounce
HEADINGS for Nicer Distinct

Morton
HEADINGS for Nicer Distinc

Mink
HEADINGS for Nicer Distin

Major
HEADING for Nicer Dist

Milton
HEADS for Distinc

Metro
HEADINGS for Nicer Disti

Pueblo
HEADINGS for Nicer Distin

Power
HEADINGS for Nicer Dis

Portly
HEADINGS for Nice

Nero
HEADS for Nicer Distincti

Nobel
HEADS for Nicer Distin

Prima
HEADS for Nicer Distin

Macbeth
HEADS for Distinctive

Melody
HEADS for Distinctiv

Polar
HEADS for Distincti

Trade your humdrum headlines for headlines that hum!

Inside Solotype by Golly

BANK

Our bank manager knows us well.

Pastel Bounce
HEADINGS for Nicer Distinctive

Parker
HEADINGS for Nicer Distinctive D

Prince
HEADINGS for Nicer Distinc

Pine
HEADINGS for Nicer Distinctive D

Parrot Casual
HEADINGS for Nicer Dist

Pacific Bounce
HEADINGS for Nicer Distinctiv

Monroe
HEADING for Nicer Distin

Puritan Bounce
HEADINGS for Nicer Distincti

Presto
HEADING for Nicer Dist

Pike
HEADS for Nicer Dist

Orlando
HEADING for Nicer Dist

Parade Bounce
HEADS for Nicer Di

Petunia Bounce
HEADS for Nicer D

Panama
HEADS for Nicer Di

Mars Bounce
HEADS for Nicer D

Palace Bounce
HEADS for Nicer D

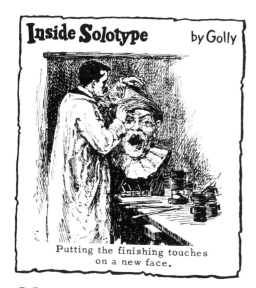

Inside Solotype by Golly

Putting the finishing touches
on a new face.

Pearl
HEADINGS for Nicer Distinctive D

Pixie
HEADINGS for Nicer Distinc

Panda
HEADINGS for Distinctive

Peter
HEADS for Disti

Casual types need special care. Solotype does it right.

Metric Extra Italic
HEADINGS for Nicer Distinctive

Metric
HEADINGS for Nicer Distinctive S

McCoy
HEADINGS for Nicer Distin

Milan Ace
HEADS for Nicer Di

Nina
HEADS for Nicer

Tenor Extra Italic
DESIGNS in Demand FOR Better TYPOGR

Tenor
DESIGNS in Demand FOR Better TYPOGR

Treasure
DESIGNS in Demand FOR Better

Tulip
DESIGNS in Demand FOR Better T

Topic Ace
DESIGNS in Demand FOR Be

Travel
DESIGNS in Demand FOR B

Tailor
DESIGNS in Demand F

Tempo Ace
DESIGNS in Demand

Troy
SIGN in and

GOT A QUESTION? GIVE A CALL.
PHONE (510) 531-0353 8 AM-4:30 PM
24-HOUR FAX LINE: (510) 531-6946

Plymouth Ace
HEADINGS for Distinc

Patent
HEADINGS for Nicer Dis

Maypole
HEADS for Nicer i

Norman
HEADINGS for Nicer Disti

Morocco Ace
HEADINGS for Nicer Di

Anvil
SOLOTYPE

We take
all work in turn,
so order early.

Edrick
MUSICAL instruments

Polo
EVERY Sunday plays

Calico
CALICO cats have mini paws at forty

Dom Casual
BUYER wanted for local bas

Dom Diagonal
SLANT for many commercia

Dom Bold
FIRST sale day tremendou

Flash
FLASHED in the pancreas

Flash Bold
PARTY favors given to

Graffito Outline
CAMP sites foun

Graffito Bold
WORK of art how

Van Dijk
Rapid Headline Servic

Van Dijk Bold
Energy Comes First

Cocoa
SOAPY film removed

Brooklyn Casual
OSCAR presentation from a

Architect Light
STIX AND BRICKS FORM

Lithos Light
STACCATO SONG

Lithos Regular
WRITE ON STONE

Lithos Medium
LITHOGRAPHS PR

Lithos Bold
STONE CUTTERS

Lithos Black
INK THE PLATE

Balloon Light
MARCH PLANNED HAS BE

Balloon Bold
PAPER DELIVERY FOR ST

Balloon Extra Bold
BIG SAIL AT YACHT

Album Script Extended

Write Like This!
Don't You Wish You Could!

Album Script

Old Photo Album Found In Basement

Zoom Script

Wine Grape Harvest At New Level

Zurich

Win A Trip to Switzerland and Have Fun Yo

Zeal Script

You Can Lead a Horse to Water Ho

Zeppelin Script

Count von Zeppelin Is Alive and Well

Snell Roundhand

A Guide to Special Effects and

Dianna Light

Brand Names Are Essential To

Dianna Medium

Kind Hearts And Coronets With

Dianna Bold

Happy Times In Sunny Playin

Zither Script

Design With Solotype For Gre

Zircon Script

The Proper Study of Man in

Banker's Signatures

In our archive is a century-old trade magazine called "Rhodes Journal of Banking." One of its features was an "identify the signature" contest. Here are the three scrawls offered:

"A bank cashier."

"A prominent businessman."

"A factory treasurer."

Alas, we'll never know if you have read them correctly, as the answers were in a subsequent issue, not in our possession.

Elsewhere in the issue, a reader writes:

"Is there any good reason why a banker's signature should be illegible? It would seem that the plainly-written signature would be much more difficult to counterfeit." We understand that most document experts today concur. Plain signatures are harder to fake.

Inside Solotype by Golly

All staff members must learn the entire alphabet by heart.

Spencerian Script
American Harvest Event

Latino
Lady Of Spain Serenade Quietly

Elegance
Eat Hot Apple Pie

Belvedere Light
Wisdom Of Many And The Wit Of One

Carpenter Script
Wide & Handsome

Steelplate Script
You Deserve The Very Best

Lady Script
All This For A Song an

Excelsior Script
Boston Cream Pie Made Fr

Excelsior Script Semibold
Harvest Cabernet Sauvignon

Typo Script Extended
Blend of Choice Whiskies

Bank Script
Banking House of Rufus

Commercial Script
Stories For Young R

Nestor Script
Beautiful Nestor Script A

Jiffy Script
Modern Alphabets In

Yukon Script
Yonder Lies The Castle How

Hallmark Script
Modern Alphabets Increase the Res

Hilton Script
Modern Alphabets Increase

York Script
Express Yourself Forcefully!

Zenith Script
Alphabets Increase the Modern

Zanzibar Script
Modern Alphabets Increase the R

Zephyr Script
Ship Of Fools Sail Around Noon

Zurich Script
Win A Trip to Switzerland and H

96 SOLOTYPE

Centennial Script Fancy

A Century of Progress

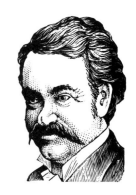

This beautiful script was designed to commemorate the United States centennial of 1876.

Centennial Script Plain

United States of America

Bolina Script Condensed

Beautiful Dreamer Wakes Up

Typo Upright

Tonight Irma La Douce Witl

Engrossing Script

Prenuptial Agreement Written in

Hispania Script

Cinco De Mayo Festivals

Novelty Script

Exodus From Jazz Pop

Script Text

Metropolitan Grand Opera

Pantagraph Script

Dinner Theater Presents Musicals for

Pantagraph Script No. 2

California Food Market Opens

Pantagraph Script No. 3

Contra-Italics Sometimes Wor

Spinner Script

Lady Sits in Her Parlour

Chopin Light

History of the French Renaissance in 4 volumes

Chopin Bold

Greater East Bay Folk Dance Council

Some of the flourishes on the capitals of this script will interlace with the adjacent letters, giving the effect of a hand-drawn script.

A A B C C D D E E F G H I I J K L L

M M N O P P 2 R R S T T U V W X Y Z E

a b b c d e f f f f g h h i j k k l l m n o p q r s t t u v w x y z t

Circular Cursive

Look to Solotype for the Unusual!

Murray Hill

Design of Quality Printing Types

Amazone

Great Balloon Esca

Murray Hill Bold

Curtain of Night Swiftly Darken

Boulevard

Tennis Club Now Ope

e k m n t z

Hanover

Fancy Handy Dan

Virtuoso Bold

The Chicago Home Ne

Liberty

Graceful Design From Other

Virtuoso Light

They Have A World To Win

Bernhard Cursive Bold

A Hero In a Golden Cage

Stradivarius

Boundless Energy Displayed

Zipper

You Are Invited For Dinner

Bernhard Tango

You Are Invited To A Seder

Trafton

Dance Theatre Rehearsal Begins

Bernhard Tango with Swash Caps

Bring Your Own Food

Coronet

Moe, Larry, Curly Underated Acts

Coronet Bold

The World's Best Advertising

Bernhard Tango Swash Caps

A B C D E F G
H I J K L M N
O P Q R S T U
V W X Y Z

Park Avenue

Stylish Type for Invita

Madisonian

Dolly Madison And

Roundhand

He Who Laughs Last Didn't

Arabella Favorit

Solotype For Headlines

Phyllis

Fortune Smiles Upon All

Personality Script

Then And Now With A

Phyllis Initials

A B C D E F G
H I J K L M N
O P Q R S T
U V W X Y Z

Champion Script

Champ Loses The Bouts

Gloria

Martin's New York

Charme Light

High Definition For

Gabriele

Gabriele Type Design B

Charme Bold

European Songfest

Ariston Light

Light And Beautiful

Ariston Bold

British Film Review

GOT A QUESTION? GIVE A CALL.
PHONE (510) 531-0353 8 AM-4:30 PM
24-HOUR FAX LINE: (510) 531-6946

Arkona

Great Steam Journey

Troubadour Script

Vanilla Bean Whiskey

Astaire

DANCE scheduled

Troubadour Light

Mail Order Catalog To

Adastra Black

La Hermitage Studio

Shelley Andante

Music Program Tonigh

Adastra Royal

Wine Maker Shows

Shelley Allegro

Champ Wins Easily At

Mardi Gras

Baron Emerson, Magic

Shelley Volante

Feliz Año Nuevo W

Gong
The Encyclopedia of Sidewalk Graffiti

Charcoal
The Art & Science Club

Lariat
Ranch Help Wanted Driv

Mistral
The Winds Of Change B

Nevison Casual
Have you seen buffalo

Bazaar Casual
SHARE a bit of humor

Greeting Card Casual
SQUARE and upright is our

Fox
Riding To Hounds Is Unspeak

Compliment
Compliment Wife

Backhand Script
Backhand Script Type

Figaro
Free Style Pen Scripts

Holly
Modern Alphabets Increa

Romany Script
Romany Beautiful

Bravo
Many Scripts Revived For

Gillies Gothic Light
The Enchanted Life of Colette

Bolide
HOPES and glories with

Gillies Gothic
The Streamlined Diner

Choc Outline
GHOST stories abound

Kaufman Light
Best New Type Design For

Choc Open Shade
TREES that hide flow

Kaufman Bold
Yachts River Journey

Choc Grey Shade
YOUTH groups come ab

Brush
Cooling Pacific Breezes

Choc
FRENCH signpainters

Mandate
Most People Enjoy S

Unless you say otherwise, we send all work by overnight express.

Flex Ribbon
Row Your Boat Gently!

Keynote
Last of the Red Hot Lovers

Cigno
Festival Music Contest

Derby
Help The Work Forc

Hauser Script
Hunting With The Camera

Balzac
Hemlock Pills Cure Your

Impulse
Deduct Business Expenses

Holla
Holiday Bargain Selections

Fanal Script
Candy Making Technique H

Inserat Cursive
The Prophet of Profits

Bonaire
Parks Enjoyed By Old And

Bold Script 332
Gifts For Every Occasion

Fulton Sign Script
Baked Dietary Goods

Laclede
Railroad Magnate Hires

Pragefest
Lace Festival Antwerp

Hawarden Italic
Printing Types From E

Label Script
Prize Money Lost

Kaligraphia
The Chapel Roses An

Zorba
Time Machine Sho

Futura Script
Future Schlock Now

Brandy Script
Renew Your Faith During

Julia Script
The Rich Are Here

Gaston
Display Type Price List

Maxime

Paris Tour Now Av

Cascade

Quiet Storm Blows Over

Express

Express Mail Services

Bison

Bison Roaming The East

Courier

Courier For Overseas

Quill Script

Every Movement Has A

Kusterman Script

New York Berger F

Contact Script

Contact Us Quick

Forte

For Better Importing

Swingalong

SWING brightly

Papageno

TRIPS organized

Bronstein Bold

Best Foods Mayonn

Lazybones

Half A Loaf Is Bet

Nobody else's work gets pushed in ahead of yours at Solotype.

Elite

Crisp Type Style

Salto

Love Induces Homey Atm

Kingsland (Gloriosky)

Ironclad Guarantee Pre

Boutique

COLORFUL jungles of the trop

Parrot

PEACE on earth and good

Fortunata Italic

Great Fortunes To

Fortunata

Bronze Statue Dedic

Aegean

Great Day Coming So

Octopus

The Great Sea Voyc

Swinger

World of Type Aw

Rusinol

Elect A New Slate Now

Reiner Script

Spidery Letterforms Designed by Imre Reiner

Cassandra

STUDIO REPRESENTED

Oscar

THINK it over caref

Loose New Roman

PROGRAM chairman e

Hippie

SELDOM lacking som

Tambo

Tambo Scrip

Zebra

Zebra Ranch

Zero

Zero Dive Bomber Hits Today

Minstrel Man

HEADINGS for Nicer Distinctive I

Peruvian

HEADINGS for Nicer Distinctive DESIGN

Party

HEADINGS for Nicer Distinc

Plato

HEADING for Nicer D

Mercurius

FLASH saves day

Lilith

Military Academy

Fulton Sign Script

Baseball Team Shirts

Brody

Old Comic Books Worth Al

Jolly Roger

The Pirates of Oak

Jolly Roger Outline

PRICES remain high

Jolly Roger Whiteshade

COLOUR processes

Dynamic Script

Decision to Consider a

Elvira Bold Italic

Elvira Bold Ita

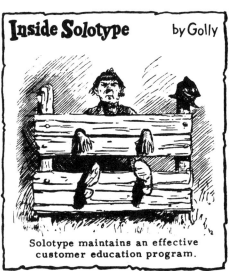

Inside Solotype by Golly

Solotype maintains an effective
customer education program.

When you're ready
to put the fun
into typography,
think of Solotype!

Jewell Script
Modern Alphabets Increase the Results

Houston Script
Modern Alphabets Increase the Result

Honey Script Light
Modern Alphabets Increase the Res

Jade Script
Modern Alphabets Increase the Res

Jester Script
Modern Alphabets Increase the R

Jamboree Script
Modern Alphabets Increase the

Highland Script
Modern Alphabets Increase the

Hornet Script
Modern Alphabets Increase the

Hamlet Script
Modern Alphabets Increase the

Historic Script
Modern Alphabets Increase the

Hickory Script
Modern Alphabets Increase t

Harmony Script
Modern Alphabets Increas

Hostess Script
Modern Alphabets Increase

Jupiter Script
Modern Alphabets Increase the

Hunter Script
Modern Alphabets Incre

Havana Script
Modern Alphabets Increase the R

Horizon Script
Modern Alphabets Increa

Harper Script
Modern Alphabets Increase the Resu

Hogan Script
Modern Alphabets Increase th

Hemlock Script
Modern Alphabets Increa

Hercules Brush Script
Modern Alphabets Increa

Husky Script
Modern Alphabets Increa

Homer Script
Modern Alphabets In

104 SOLOTYPE

Halo Script
Modern Alphabets In

Howard Script
Modern Alphabets Inc

Hardy Script
Modern Alphabets Inc

Hudson Script
Modern Alphabets Inc

Hawk Script
Modern Alphabets In

Hindu Script
Modern Alphabet I

Japan Script
Modern Alphabets

Humboldt Script
Modern Alphabet I

Haywood Script
Modern Alphabet

Hillside Script
Modern Alphabets In

Hampton Script
Modern Alphab

Harvard Script
Modern Alphabets

Harlem Script
Modern Alphabets In

Kentucky Script
Modern Alphabets Increase the Results

Louise Script
Modern Alphabets Increase the Resul

Liberty Ace Script
Modern Alphabets Increase the R

Linda Script
Modern Alphabets Increase tl

Jefferson Script
Modern Alphabets Increase th

Lilac Script
Modern Alphabets Increase t

Husky
Lord Greystoke's
JUNGLE
TOURS

Lark Script
Modern Alphabets Increase th

Kansas Script
Modern Alphabets Increase the R

Lion Script
Modern Alphabets Increase t

Headline Script
Modern Alphabet I

Lester Script

Modern Alphabets Increase

Kingston Script

Modern Alphabets Increas

Korea Script

Modern Alphabets Inc

Jackson Script

Modern Alphabets Increase

Lincoln Script

Ask "Why" and you'll buy

Kipling Script

Modern Alphabets Increase t

Kent Script

Modern Alphabets Increase t

Lancaster Script

Modern Alphabets Incre

Kellog Script

Modern Alphabets In

Keynote Casual Script

Modern Alphabets Inc

Lakeside Script

Modern Alphabets Increas

Ledger Script

Modern Alphabets Increase t

Latino Script

Modern Alphabets In

Lasso Script

Modern Alphabets Incr

LaCrosse Script

Modern Alphabets Incr

Kinzie Script

Modern Alphabets Increase t

Kitten Brush

Modern Alphabets Increase

Leader Script

Modern Alphabets Increas

Lasalle Script

Modern Alphabets In

Lotus Brush Script

Modern Alphabets In

Lucky Script

Modern Alphabets Inc

Luzon Script

Modern Alphabe

Lancer Script

Modern Alphabets In

Lincoln Script

Modern Alphabets I

Dreams Become Reality at Solotype!

INFORMATION ON SPECIAL EFFECTS STARTS ON PAGE 203

WE'RE LEADING THE WAY

GRAND MASTER

BLUE JEANS

FINEST JEANS

SUMMERTIME

SWEEPERSTAKES!

ADVENTURES

PROTEIN SOURCE

ADVENTURE GARDEN

PREMIUMS

GOT A QUESTION? GIVE A CALL.
PHONE (510) 531-0353 8 AM–4:30 PM
24-HOUR FAX LINE: (510) 531-6946

TRIPLE SLOTTO-DRAW

MT. TAM PALE ALE

Inside Solotype by Golly

Our reproportioning facilities are at your service.

Black Ornamented
Solotype Elegance

Lady Text Mixed A
Mixed Blessing

Lady Text Mixed B
Mixed Blessing

Lady Text
Here Comes The Bride Dressed

Lady Text Black
Wedding Reception Ball Room

Goudy Text
Gothic Arms Displayed

Zahner Text
Gothic Decorative Arms

Society Text
Pray for Peace Vigil tomor

Hansa Gothic
Hansa Gothic From M

Engravers Text
Engrave Beautiful Thought

Guttenberg Gothic
Guttenberg Bibles

Antique Black (Distressed)
Antique Deals For

Westminster Gothic
Westminster Abbey

Steelplate Text Open
Engraver's Style Fou

Durer Gothic
Durer Engraving

Steelplate Text Shaded
Knots and Splices of

Memorial Open
Bless The Moment whic

Steelplate Text Black
Joh. Sebastian Bach

Memorial Deepshadow
Harmony in Our Lives

American Text Compressed
Stained Glass Windows Are A Pain

Memorial
CRAFT faire pleasures alm

American Text
SUNDAY sunrise service

Medieval
Praise the Lord for maki

Kanzlie Light

Youth Program S

Kanzlie Bold

A Black Forest Cake

Academy Text

Academic Festival O

Washington Text

The Garlands Fadea

Offenbach

Paris Conservatory Theat

Faust Text

FAUST opera for be

This lusty dark bread originated in Schleswig Holstein, a region in N.W. Germany bordering Denmark. It is a whole meal bread, "vollkornbrot," deliciously crunchy owing to the coarse rye meal that's blended in with the finely ground rye and whole wheat flours. A robust yeast and a little salt complete the flavor. Try this traditional old-country bread for sandwiches made with good coldcuts and brushed with hot mustard. Sehr gut! ❧ ❧ ❧ ❧

New Deutsch

DEMAND quality when

Bradley Outline

CHRISTMAS magazine co

Bradley

PURPLE painting the foot

Kimberley Initials

The FRIENDS Invite U

Kimberley

CHRISTMAS cards of the

Kimberley Outline

Return Of The King From

Eros Text

BEERS from bavaria

Continental Text

MAGIC herbs growing c

Behrens Schrift

BEAMS of light spreadi

Dublin Text

Upstairs Window Nee

Castlemar

CHARGE of the huns

Tannenberg

NOTHING ventured in

Zapata

FLOWER arrangemen

Albert Text (Globus Bold)

ALBERT in a royal pagea

Germania

Theme Events Staged D

Becker

FINER things open

Ain't it dreadful? Some people try to set blackletter types "all caps." Please don't!

Caxton Text
Caxton Introduces Type

Psalter Text
Festive Lights Aglow a

Trump Deutsch
Dusty Corridors Foun

Church Text ATF
The Brideshead Revisited

Chaucer Text
The Knight of Counihan's Dep

Engravers Old English
The Old Oaken Bucket au

Cloister Black Condensed
The Queen's War Jeanne M

Cloister Black
Early Printing Machine

Territorial Black
Daily News Magazine J

Territorial Shaded
Eureka Sentinel & Ruby

Munich Fraktur
Come Home for Christmas this

Graphic Text
Fancy Restaurant Opened

Wedding Text
Know All Men By Thes

Fancy Card Text
Queen Victoria Holds Court

Music Hall Text
Beautiful Decorative Effects V

Ecclesiastic
Historic Experts Can

Holland Gothic
Myth and Symbol Cre

Harlem Text
Ruby Hill Mine

Klingspor Text
German Accent Design

Gans Bold Gothic
Society Friends Go

Neptun Text
Neptune Fortuna

Chalet Text
Watchmaker Swiss

Tudor Text Italic
Mark Port Scenes

Church Text

Scribes Paint Flourish

Celebration Text

The Celebration of Marriage

Testimonial Text

University of California

Innsbruck

Easter Church Services begi

Progressive Text

Happy Times Ahead

Durer Gothic Condensed

Display of Printing Types Available

Square English

PEARL oyster raw

Rimpled Text

Old World Charm An

Mission Text Condensed

Traveling Students br

Mission Text

San Juan Capistra

Mission Text Extended

Stories of End

Morris Romanized Black

ROMAN blackletter

Sign Text

Sign Crafter

Lautenbach

Garden Chimes Dangle

Lautenbach Fancy

Decorative Towels in

Satanick Outline

Satan Gets The W

Thor

THINGS TODAY

Adrian's Titling

MISS MUFFETY

GOT A QUESTION? GIVE A CALL.
PHONE (510) 531-0353 8 AM-4:30 PM
24-HOUR FAX LINE: (510) 531-6946

DREADFUL TYPOGRAPHY

1 Certificate of Achievement

2 Certificate of Achievement

3 Certificate of Achievement

The customer specified a curve of small radius,
shown in version 1. As you can see, this gave
the illusion of smaller letters at the line ends,
which may not qualify as dreadful, but certainly
isn't esthetically pleasing. We sent along a
curve of larger radius, shown in line 2, which
the customer liked and used. If the small radius
is really necessary, it might be a good idea to
switch to a fan curve, which we show in line 3.

Freehand with Swash Initials
The East Bay Club

Freehand
The Pen is Mightier S

Rhapsody
Chateau Theory of VO

Concordia Text
The Historical Society of Mission Sa

Pencraft Text
Lectures on History of

Pencraft Text Italic
Fine Pen And Ink Works

Nicolini Broadpen
The Slowest form In Their

Ondine
FRENCH winelist in

Yucca Italic
CASTLE museum opens for

Yucca
BLACK hearted crews ravag

Zion
MOUNT Zion sunrise

Viking
GARLIC and chive

Otis Pen
SUNDAY brunch open

Zachery
Plan Of Action Starts Now Here

Zodiak
In The Light Of Moon Beams

Zealand
Kiwi Bird Shoe Polish Extinct

Monastery Text
An Informal Manuscript Hand

Zinnia
Enter At Your Own Risk!

Zola
Emile Zola Writes New Book

Silverwood Swash
Brightest Stars Given Awar

Artscript
Flowers Exhibited Today

Lys Calligraphic
Expert Fencing Progra

Zapf Chancery Medium
FRUIT stand ahead

Zapf Chancery Medium with Swash
Toy Boat Chug-Alo

Zapf Chancery Medium Italic
WRONG answering

Zapf Chancery Medium Italic Swash
Dog And Cat Rains

Pangloss
RIGHT livelihoods

Samson
GOTHIC graphics

Humbert Etruscan
HAWK falls skywar

Motto
GREEN grocers conv

Goudy Thirty
TOWER of London In

Goudy Medieval
JOUST official sport of

Codex
JOURNEY the cente

Carolus-Codex
QUILL lettering nea

Rustikalis Modernized Gothic
PERFECT goal made

Rustikalis Semibold
Mexico Becomes A habit

Rustikalis Bold
MODERN version and

Chevalier
Maurice Chevalier On

Chanceleresca Bastarda
A Chancery Hand for

Lee
MONEY the loot of all

Lee Italic
QUICK like a fox and

Lee Bold
ZEBRA wears pajama

Aurelio Extrabold
MONEY managem

Aurelio Outline
BONDS offered tod

Aurelio Shadow
HOMES inspected

Lydian
RAFTS made of canvas

Lydian Bold
LABEL manufacturer I

Lydian Bold Italic
ROSTER changes made

Lydian Bold Condensed
THEATRE engagement end

Lydian Bold Condensed Italic
SPREAD eagle formations

Lydian Cursive
Jacques Fox Wears Red Socks

Honda
MOTOR bikes repairwork

A few fonts of Classic Initials.

Blackstone Initials

ABCDEFGHIJK

Araby Initials

ABCDEFGHIKLMNOP

Engravers Initials No. 2

ABCDEFGHIJ

Engravers Initials No. 3

ABCDEFGHIJRL

Bella Initials

Old English Open Initials

ABCDEFGHIJ

Amadeus Initials

ABCDEF

Ballé Initials

ABCDEFGHIK

Dolbey Initials

ABCDEFGH

Georgian Initials

ABCDEFG

Caligraph (Dundee) Initials

ABCDEFG

Variante Initials

ABCDEFGI

Missal Initials

ABCDEH

Roberta Initials

ABCDEFGHIJ

Caxton (Abbeydale) Initials

ABCDEF

Dodge City Initials

ABCDEFG

Bradley Initials

Ben Franklin Initials

Solemnis
PRINTING EARLY

Solemnis Revised
EACH MAN HAS

Libra
IRISh house open

Monmouth No. 1
mental gymnas

Monmouth No. 2
FRIENDLY SOCIET

Scotford Uncial
WORK IN OLD AT

Hammar Uncial
uncial letter

American Uncial
STORY plotted by

Hammar Uncial Bold
Gaelic literat

American Uncial Bold
MAGIC and myths

Unciala
finnegans wake

Mosaik
GREAT CIRCLE TOUR

Diderot
MANUSCRIPT

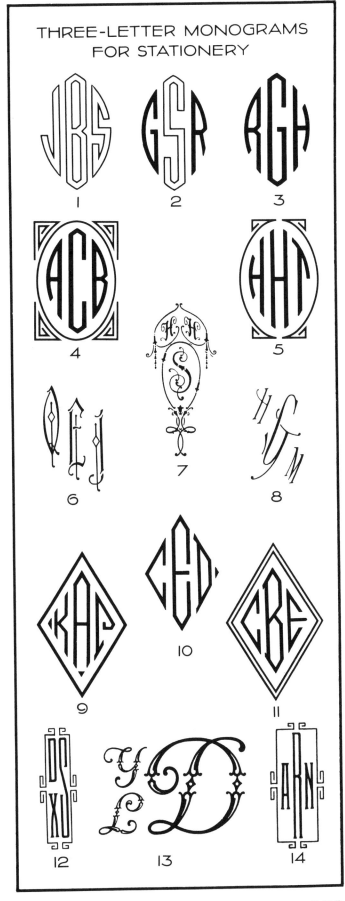

THREE-LETTER MONOGRAMS
FOR STATIONERY

OLD TIME STENCILS

A few examples of brass stencils in our archive. These were commonly used until the 1920s, when printed cartons replaced wooden shipping boxes. Our vast collection of stencil alphabets, combined with modifications, can achieve that old time look

Decibel
DECIBEL STENCIL

Nile Stencil
NILE STENCIL

Steam Stencil
STEAM STEN

Dry Brush Stencil
GHOST SIGN HERE

Victorian Stencil
VICTORIAN ST

Sports Stencil
SPORTS STENCIL

Spooks Alive
SPOOKS ALIVE 1

True Crossfire
TRUE CROSSFI

Adamo Stencil
ADAMOS

Stretch
STRETCH

Bigelow
BIGES

Blackpool
BLACKPOOL

Export
EXPORT

Stencil Bold
MASH UNIT OPER

Europa Stencil (Charette)
DRUG FORCE ME

Teachest
BOSTON TEA AND CRUMP

The stencil effect can be added to many typefaces at small cost.

Quiet Stencil
HANDLE WITH TENDER LOV

Spartana Stencil
SPARTANA TWO

Dockside
COASTAL FREIGHTER

Ragtime Stencil
RAGTIME STENCIL

Glaser Stencil Bold
FUTURA STENCIL

Stencil Bold Condensed
FIREWORKS OF CHINA

Glaser Stencil Light
EMERALD TAXICA

Stencil Outline
STENCIL OUTLIN

Dawson Stencil
DAWSON STENCIL TYPE

50 lbs. ARMY BREAD Net wt.
FROM THE
UNION MECHANICAL
BAKING COMPANY

Bank Stencil
BANK STENCI

Thayer Stencil
THAYER STENCIL

Scepter Stencil
SCEPTER WAN

Poster Stencil
POSTER STENCIL OF

Amster Stencil
THOROUGH

Banco Stencil
BANCO STENCIL TO

Hornman Stencil
HORNMAN SW

Neuland Stencil
NEULAND FROS

 ... SOLOTYPE HAS THESE GREAT TYPES, TOO!

Ancient
AVANTI STENCIL
BARN
BEIJING
BILLBOARD
BROMPTON
Cabaret Stencil
CAIRO
CALISTOGA
CLASSIC STENCIL
CONCAVE STENC
COPELY PLAZA
COURTLAND
EASTERN
EDDA STENCIL

FLOSSO
GAME PLAN
Gesh Stencil
Grocers Stencil
HORIZONTAL
INSCRIPTION
IONIC STENCIL
JENSONIAN
KEITH
LIMBO STENCIL
LIRA STENCIL
LONDON STENCIL
MORRO
MOSAIC STENCIL
Neutron

Oly Stencil
ORPHEUM
PREVIEW
SAGAMORE
SARATOGA
SERPENT
Sheetsteel
SHOALS
SPICE STENCIL
Technic
TEMPLATE
TWAIN
WOOKY HOLE
WHITELINE STENCIL

Stencil Border No. 1

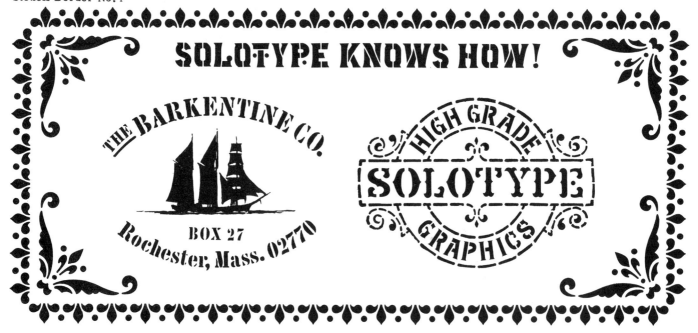

SOLOTYPE KNOWS HOW!

THE BARKENTINE CO.
BOX 27
Rochester, Mass. 02770

HIGH GRADE
SOLOTYPE
GRAPHICS

Caren Stencil
PACKAGING department office

Visa
PLASTIC money exchanges

Fortune Stencil
GAMES of chances

Import
IMPORTED products made

Inside Solotype — by Golly

Another lesson learned
by our apprentice.

Mink Stencil
MINK STENCIL FOR

British Stencil
ENGLISH IMPORTED

Unit Stencil
UNIT STENCIL WMR

Tape Stencil
TAPE STENCIL WR

Commerce Stencil
COMMERCE STENCIL

Quadrata Stencil
QUADRATA IN

Herzog Stencil
HERZOG STENCILS

Titania Stencil
TITANIA STENC

Cuba Stencil
CUBA STENCI

Import Italic
CUSTOM agents dogs

Grocers Stencil
Grocers Stencil Displa

Auriol Stencil
AURIOL stencil de

Auriol Italic Stencil
Auriol Italic Stencil

Elephant Stencil
Elephant Stencil Desig

Samoa Stencil
SAMOA Stencil Type

Morro Condensed Stencil
CONDENSED Moro Stencil

Woodcut Stencil
WOODCUT stenci

Optima Bold Stencil
OPTIMA Bold Ste

LATINS FOR ALL SEASONS

Latin Elongated
CONSERVATIVE newspaper headlin

Latin Antique Condensed
NEW YORK TIMES HEADLINE TYPE

Latin Noir Etroit
GHOSTLY figures bust out midnight an

Latin Bold Condensed
HOMES opened today

Toussant
FRONTIER DAYS!

Latin Bold
GAME changed

Latin Wide Italic (Wheat)
HARVEST wheaties

Latin Wide Outline (Vigor)
HOPES for better li

Latin Wide Shaded (Vogue)
MUSIC soothes sava

Latin Not-So-Wide
HORSE racing today for

Latin Wide
HOUSE sale today r

Chisel Wide
BIG story!

Chisel
MARCH scheduled f

Latin Open Shade
GRAVEN IMAG

Estienne
BORDEAUX that special to

Latin Bold Condensed Outline
LINE DRAWINGS

Biltmore
BUILD apartment

Clipper Latin Condensed
CANDLE maker discovel

Clipper Latin Extended
LAND grants f

Tangier Latin
DANCE company tra

Poster Latin
POSTER typographers

Mitford
MOST engagin

Moncure
MATS creating

Chagall Latin
PORTS closed aftel

Pelican Latin
DESIGN distinctive headings with

Paris Latin
HOTELS near favorite sigh

Phoenix Bounce
DANCES hot and spicy!

Petal
MUSIC institute fo

Animated Latin Bold
SHORT and tall

Potomic Latin
HOLD tight for

Our entire shop is devoted to display typography.

Niagara
BUFFALO leave union

Quorum Light
LIGHT and bright type

Quorum Book
NORMS equated with

Quorum Medium
ROMPS through time

Quorum Bold
STICK furniture show

Quorum Ultra
ULTRA bold effects

Mormon
RELIEF MEETING

Quill Casual
RELAX beside

Crazy Herold
CRAZY over horse

Animated Latin
MAGIC tricks

DREADFUL TYPOGRAPHY

1. **FRANCE**
2. **FRANCE**
3. **FRANCE**
4. **FRANCE**

One of the most annoying devices perpetuated by type designers is the extended leg on the capital R. It is guaranteed to destroy the even color of a tightly spaced line of type.

In the example above, line one is the actual nameplate as it appears on an international magazine. It is a good example of what you get when you specify "tight but not touching." Line two shows how we would have done it, with "tight optical spacing." In line three, the color is better still because we modified the leg of the R, but of course that's cheating. Finally, in line four we bite the bullet and overlap the strokes. The decision is yours, but we think line one is dreadful!

Wolf Antiqua
DANCE with wolves

Friz Quadrata
QUAKE and shake

Friz Quadrata Extrabold
TIDAL lake impro

Friz Quadrata Bold
GREAT design pr

Baker Signet
BAKER'S dozen cakes

Arrow
ROYAL obligation re

Alburtus Light
PROWLS around town

Alburtus
TONITE won't be like

Alburtus Bold
VALUES galore today

Alburtus Bold Outline
URBAN renewal ploy

Alburtus Bold Titling
GENOA BY THE SEA

National Oldstyle
AQUA farming growth

Novarese Book Italic
None But The Best S

Novarese Book
ROSES shown for

Novarese Medium
KITES flying over

Novarese Medium Italic
Forms With Errors To

Novarese Bold
OUTER space sit

Novarese Bold Italic
Kite Sails Over Cit

Novarese Ultra
HOPE springs i

Stand out in the crowd with a Solotype headline.

Eve Light
TABLE builders and cabine

Eve Bold
HOMES comfortable d

Rivoli
RIVOLI beach hotel lift

Rivoli Italic
SHARP razor blades glides

Schneidler Initials
CORPORATE MA

Weiss Initials I
WORDS ON WIN

Weiss Initials II (Lapidar)
CODES ENFORCED B

Weiss Initials II Bold (Lapidar)
THEATRE NIGHTS

Weiss Initials III
YIDDISH POETR

Rivoli Initials
ABCD
EFGHHIJKLM
NOPQR
STUVWXYZ

Columna Solid
LOST HORIZON

Columna Open
CRESCENT YAL

Weiss Bold Outline
QUIET holiday w

Weiss Roman
PIANOFORTE music of the ol

Weiss Italic with Regular Caps, Swash Caps, and terminal letters
Distinctive Styles from e m n t

Weiss Roman Bold
HAPPINESS is a successful p

Weiss Roman Extrabold
DANCING in the rainstor

Inside Solotype by Golly

Darkroom chemistry is
mixed fresh daily.

Cloister Cursive Handtooled

Private Reserve stock

Delphin I

THEORY *being basis for*

Delphin II

PLACE *still looks sam*

Meridian

BILGE empties wast

Meridian Bold

BLEAK outlook fro

Trump Medieval

MAZDA lamps fron

Trump Medieval Italic

REDHOT lovers last

Trump Medieval Semi-bold

BASES loaded from

Trump Medieval Semi-bold Condensed

SHAMED into hiding

Trump Medieval Bold

DEAL direct wi

Trump Medieval Bold Italic

GEISHA girls rev

Trump Medieval Outline

SWING into spr

Trump Gravure

HALF TIME C

Blado (Poliphilus Italic)

Venice Canal Paved Over

Arrighi (Centaur Italic)

SHINE on harvest moon

Centaur

SHADE to be made in

Cloister Extrabold Condensed

COMEDY best medicine

Cloister Oldstyle

POWER lunch at one

Cloister Bold Italic

SOUTH by southwest

Cloister Bold Condensed

FIRSTEST with mostest

Charlemange

KING OF FRANK

Charlemange Bold

EMPEROR WEST

Belwe Light

NORTH explored with

Belwe Medium

SUPER computer n

Belwe Bold

MUSIC charms to

Belwe Bold Shaded (Extra for overlapped shadows)

GAMES people play

Fiore Light

OLIVE oil factories

Fiore Light Italic

MANOR house to

Fiore Medium

UNDER the clock

Romic Bold Greyshade

SHADE your won

Romic Bold Shadow

GRAND horse bot

Romic Light

FORTS discovered

Romic Light Slope

TRAIN teachers th

Romic Medium

MINTS served afte

Romic Medium Slope

BRING plenty one

Romic Demibold

REGAL bearing is

Romic Demibold Slope

BUILD relationsh

Romic Bold

NIGHT music he

Romic Bold Slope

FORGE chain fro

*Remember,
we need time to
do our work, too.*

Trajan

ORIGINAL PRINTS

Trajan Bold

THERAPY CLASS

The Benguiat Series
AABCDEFGHIJKLMMNOPQRSTU
VWXYZ& *AABÆAEAHAKAPARAASSTT*
abcdefghijklmnopqrstuvwxyz$¢!

Benguiat Book

FROST free refrig

Benguiat Book Italic

PRAWN dishes hil

Benguiat Medium

BASED on preset

Benguiat Medium Italic

LOCKS on open

Benguiat Bold

ARBON batters

Benguiat Bold Italic

VOICE from the

SOLOTYPE **125**

Korinna Bold Outline Shadow

Add The Surprise Dimension!

Della Robbia Light

MIGHTY mouse is on

Della Robbia Medium

BROKER firms action

Della Robbia Extrabold

INTER new busines

Della Robbia Heavy

ITALIA represent

Westminster

FROST ban developed

Korinna

DANCE company to

Korinna Bold

EBONY boxes sold

Korinna Cursive Bold

PATIO living today

Korinna Extrabold

GRAND opera fron

Korinna Outline

HINDU mystic ea

Korinna Heavy

HOMES open he

Korinna Heavy Expanded

MIST rise over

Souvenir Light

REFUGE visited in wit

Souvenir Light Italic

HOMES open forever t

Souvenir Medium

FANCY clothes disp

Souvenir Medium Italic

MUSIC library open

Souvenir Demibold

CASTE system stu

Souvenir Demibold Italic

DOGMA explained

Souvenir Bold

CONGO revisited

Souvenir Bold Italic

STARS and stripe

Souvenir Demibold Outline

PAINT brush clea

Souvenir Bold Outline

WRAPS package

 GOT A QUESTION? GIVE A CALL.
PHONE (510) 531-0353 8 AM-4:30 PM
24-HOUR FAX LINE: (510) 531-6946

Swash Characters for Souvenir Bold only.

TAXES rips off

Bulfinch Oldstyle

TOURS state increas

Grasset

FORTH into sea of

Grasset Italic

GENTS furnishings of

Hollandse Light

LITHO prints dating

Hollandse Bold

HABIT worn by n

Benedictine Book

CHARD vegetables in

Benedictine

MUSIC publisherfe

Benedictine Bold

PRINT media plo

Richmond Condensed

MULES used for transporti

Richmond Bold Extra Condensed

HERDS of cattle crossed the

Richmond Bold Condensed

BROKE and hungry se

Richmond Bold

RENTS raised as r

Richmond Heavy

LIGHT sources ch

We can match more than 7,000 unusual typefaces.

Morrocan Condensed

OBJECTS for the risking

Windsor Light Extra Condensed

FOREIGN language broadcast

Windsor Light Condensed

POETIC licenses issued

Windsor Light

DAILY papers delive

Windsor Elongated

MARKETS held on weekends

Windsor Bold Condensed

SYMBOL of faith revea

Windsor Outline

COUCH potatoes

Windsor Comstock

MUCH promise

Windsor

NAME of the ga

Windsor Black

BLUES singers of

Fenice Regular

BRIGHT lights froma

Ehmke (Carleton)

ZONES of twilight mystery

Euclid

BRICKS laid end to

Chesterfield

MINKS grow while

Athenaeum

HOTEL directories from

Exeter

BUGLES and other not

Urbild

LEFTY finally made

Typo Roman

TEACH the masters qu

Invitation

BANKS that do busi

Metropolis Bold

BOATS sailing throug

Athenean Wide

TRUCKSTOP cutie pours

Royal Roman

COURT jester danc

Ruth Roman

SMOKE gets in your eye

Graybar Book

DRESS for fine dinin

Argos Aguila

BORDER crowds overwh

Argos Andromeda

LADIES club holds year

Argos Apus

RECENT reports have fi

Argos Ara

PUBLIC meeting heldt

Hess Penletter

HOMES open inspec

Polyphilus Titling

MONTREAL HOTE

Forum Titling

FIRST PRINTING

Hadriano

FINAL PRINTING

Hadriano Stonecut

GOUDY DESIGN

Announcement Roman
METHOD formulate

Announcement Italic
GARDEN toured witl

Colwell Handletter
SOME is as handson

Colwell Handletter Italic
STAGE performed by

Michaelangelo Titling
NOTES MAY BE K

Michaelangelo Bold
MICHELANGELO

Palatino Semibold Outline
FRESH garden veg

Palatino
DRINK is the down fa

Palatino Italic
TERMS of this agreemen

Palatino Italic with Swash Caps
New Art Exhibit Halls of

Palatino Medium
FRAME work almost

Palatino Semibold
HERDS of dairy cow

Palatino Black
HANDS off policy

Antikva Margaret
HORSE and bugg

Exempla
GARDEN awaiting s

Verona Humanistic
HUMAN letterforms

Signwriter's Roman
BRAINS without th

Series 18 Italic
RISKY business for

Zebra Ace
ZEBRA farms opening

DREADFUL TYPOGRAPHY

ANOTHER WINNING TEAM

Some nameless barbarian took the beautiful font known as Michaelangelo Titling and squeezed it into a parody of a typeface. Then, realizing that still greater devastation was possible, this Philistine added an offset shadow to the lettering, spacing it just far enough away to insure maximum illegibility. Dreadful typography! What bothers us most is the acceptance such work is finding in the graphics community. Will we someday be so used to bad typography that we think it is good? Makes us think of Alexander Pope's lines on vice:

Vice is a monster of such frightful mien,
As to be hated needs but to be seen;
Yet seen too oft, familiar with her face,
We first endure, then pity, then embrace.

Century Expanded

ENDOWS funds form

Century Expanded Italic

DROPS of lemon lime

Century Schoolbook

ADOBE sound syste

Century Schoolbook Italic

ABUSED and insulte

Century Schoolbook Bold

FORCED into exile

Century Schoolbook Black

BLACK flag spray

Century Schoolbook Bold Extended

CHOW manes

Century Bold Condensed

PROFITS for the millions in

Century Bold Extra Condensed

ROMANS roam countrysides

Horizon

BAGELS served within

Horizon Italic

ITALIC versions useful for

Horizon Medium

DRUGS from plantings

Horizon Bold

NAMES changed to

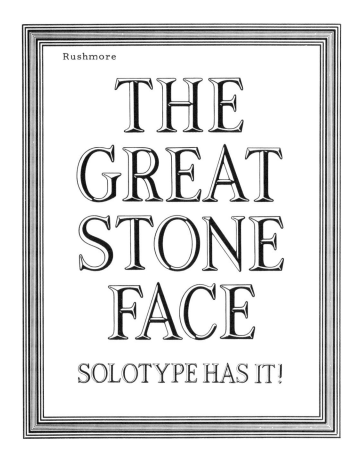

Rushmore

THE
GREAT
STONE
FACE

SOLOTYPE HAS IT!

Willow

SUNDAE flavors create

Perpetua

ROUND about now

Perpetua Bold

BASIN street blue

Perpetua Black

CLUBS from arou

Perpetua Outline

MELON raised h

Perpetua Super

SUPER typesetting



130 SOLOTYPE

Goudy Flair
FLAIR is an elusive

Baskerville Swash
FANCY parlors

Goudy Cursive
Cursive Form of Lette

Baskerville
STONE cutter wor

Goudy Handtooled Recut
CHICKS and farmer

Baskerville Italic
GREAT art lives for

Goudy Handtooled
BROTH of chickens

Baskerville Bold
FORKS and knives

Goudy Bold Outline
HUMID weather

Baskerville Thick
STUCK in the mud

Goudy Oldstyle Italic
CRAPS out early soon

Baskerville Outline
IRATE taxpayer o

Goudy Bold Italic
DRANK until goofy

GOT A QUESTION? GIVE A CALL.
PHONE (510) 531-0353 8 AM-4:30 PM
24-HOUR FAX LINE: (510) 531-6946

Goudy Extrabold Italic
GROWN healthier

Kennerly
TABLES waiting from

Goudy Oldstyle
BARKS louder than

Kennerly Bold
NIFTY design from

Goudy Catalog
PERSONAL messages in s

Goudy Bold
COMPLAINT departme

Goudy Extrabold
EARLIEST printers bui

Goudy Black
COVERED wagon trails

Inside Solotype by Golly

Credit is no problem at Solotype.
Neither are collections.

Mountie

Your Best Source for Interesting Headlines

Baker Danmark 2

SIGHT is a very gre

Trooper Roman Light

RAYON clothing sale the

Baker Danmark 4

HARD substance

Trooper Roman Light Italic

CASION demands c

Baker Danmark 6

METAL material

Trooper Roman

GREAT football games

Romana Outline

NAPOLI beckons wi

Trooper Roman Italic

MOND mine found

Romana

BIRDS watched from

Trooper Roman Bold Extended

BEARS winter sle

Romana Bold

BONES displayed of

Bernase Roman

PRODUCT developme

Ultra Romana

HOLDS tightly with

Americana Outline

PAUSE for a mom

Romana Black

SPITE fences built

Americana

CRABS season

Romana Estretcha

STRONGER than locomotive

Americana Italic

PARIS nights an

Hawthorne

ORIGIN sought for we

Americana Bold

SHARP styles ap

Hawthorne Extended

MONEY grows on tr

Americana Extrabold

CLUBS for clos

Romana Ultra Wide

TOPIC of the

Americana Black

FLASH news b

Bulmer
GHOST encounters of

Bulmer Italic
ROUND the mulberries

Bembo
POUND of rotund

Bembo Italic
DROPS everything no

Bembo Black
BEST question from

Bravour Bold
FARO games

Tiffany Light
ROADS leading far an

Tiffany Medium
BARGE traffic rises

Tiffany Demibold
PLAIN **parcels own**

Tiffany Bold
FAKES discove

Garamond Oldstyle
DANCE the night aw

Garamond Oldstyle Italic
CAMEO neckpiece wear

Garamond Bold
PURSE snatcher hits

ITC Garamond Book
LUCKY rabbit foot

ITC Garamond Bold
APRON stringer

ITC Garamond Black
BLACK horses

Garamond Outline
BONDS male closer

Concorde
FASTER aircraft flown

Concorde Italic
GREAT farms visited?

Concorde Bold
HOPES spring eterna

Berling
UPSET and mollified

Berling Italic
HOCUS pocus magic

Berling Bold
BOWLS perfect ga

There's a place in Hell for those who set Romans too tight.

Janson
DOZENS of doughnut

Janson Italic
HORDE of crazed shopper

Zapf Light
DOCK worker in a

Zapf Light Italic
SPITE fences built!

Zapf Medium
QUIET please or

Zapf Medium Italic
NICER garden or

Zapf Demibold
FROST banned

Zapf Demibold Italic
TABLE & chairs

Zapf Heavy Italic
ZAPF revisited

Zapf Heavy
COME along to

Largo Bold
GREAT ESCAPE

Cooper Oldstyle
POLITE conversing

Cooper Oldstyle Italic
PROFIT makers show

Hess Oldstyle
RAISE your hopes to

Light Litho Roman
LIGHT litho type

Light Litho Roman Italic
SLOPE for effects

Liberta Extra Bold
ROAST chicken

Stone
STONE age families

Stone Bold
MYSTIC knights of

ITC Book Bold
HOPE & glories

ITC Book Bold Swash
Cats and Dogs

ITC Book Bold Italic
KITES flyings

ITC Book Bold Italic Swash
Boys and Girls

Dartmouth
HOMES sold quickly

Dartmouth Italic
MUSIC *of the masters*

Clearface Roman Bold
RUSTY old nail wound

Clearface Roman Bold Condensed
SALUTING great ducks

Clearface Roman Thick
BROKE the record

Clearface Roman Extrabold Outline
STERN task ma

Clearface Roman Extrabold
PLANE lands at d

Aster Bold Outline
PECAN santuar

Aster Italic
INVESTOR makes finai

Aster
FLOWER fruit trees pla

Aster Bold
GRANDS entertainn

Aster Extrabold
MEXICAN mines si

Aster Black
BROKEN promise

Times Roman
BLACK knight leads

Times Roman Italic
BONES doctor in space

New Times Roman Semibold
FLOAT in parade wi

Times Roman Bold
FLATS in the city ex

Times Roman Bold Italic
POLICE union calls

Times Roman Bold Modified No. 2
GUSTO grabs nerds

Times Roman Black Italic
QUEASY made easy

Times Roman Outline
STEAM trains play

GOT A QUESTION? GIVE A CALL.
PHONE (510) 531-0353 8 AM-4:30 PM
24-HOUR FAX LINE: (510) 531-6946

Inside Solotype by Golly

Our shop is situated conveniently
to our main source of supply.

Inside Solotype by Golly

At Solotype, raises are frequent and cheerfully given.

B·O·D·O·N·I

Bodoni Open

ABCDEFGHIJKLMNOPQ
RSTUVWXYZ&
abcdefghijklmnopqrstuvw
xyz $1234567890

Bodoni Book

UNREST among kids?

Bodoni Book Italic

TIPTOE through tulips

Bodoni

POTION marketed by

Bodoni Italic

GENIUS fails scholars

Bodoni Bold

JOKER indicted with

Bodoni Bold Italic

FAMILY farm planer

Louvaine Light

GRANTS for students u

Louvaine Medium

GRAND place service

Louvaine Bold

FIRST and foremost

Bodoni Open

OPENS offices down

Bauer Bodoni

TABLE settings displa

Bauer Bodoni Italic

VOICE training school

Bauer Bodoni Bold

DISCO morality fo

Bauer Bodoni Extrabold

BAUER'S foundry

Bauer Bodoni Titling

FOREIGNERS BEI

Louvaine Eclair

MIXED doubles tennis

Andrich Minerva

PACKS of wild dogs f

Andrich Minerva Italic

PERSON needed for se

Torino Swash Italic (used with Torino Italic below)

aaA A A AABCDEE EEFGG HH HHH IJJK K KKLL MMMM MMMN NNNNNO PQRR RR STTTUU VV V VWWWWWXXYYZ a a b c d d e f f f ghh i j k kk l m mn n pq r rst t uv v v ww w xyz

Torino
DESTRY rides again fr

Bernhard Modern Bold Italic
COMBS *hair back up*

Torino Italic
CRAVE candy cigaret

Bernhard Modern Roman
BAGEL shop triples b

Roman Compressed No. 2
NARROW MINDED viewpoints in type

Bernhard Modern Italic
ITALY welcomes trade fo

Roman Compressed No. 3
CHAMPIONS inducted fame

Bernhard Modern Bold
DRIFT down mory

Roman Compressed No. 4
CARPET riders flying

Didoni
BRIGHT new star i

Modern No. 20
LAKES are drying

Egmont Medium
DIMES are high priorty

Modern No. 20 Italic
SILVER and crystal

Egmont Bold
FIELD representative

Light Litho Roman
HIKER safe after li

Craw Modern
NOTE the pro

Firmin Didot
CLASSIC reprinted l

Craw Modern Italic
MINE closed af

Firmin Didot Bold
FRENCH design rei

Craw Modern Bold
MODE of new

We take all work in turn, so order early.

Matinee
CHEFS Delightful super

Eden Light
BRIGHT ideas abound fr

Eden Bold
TRADE show exhibits

Eden Bold Titling
FEAR NOT NEW IDEAS

Corvenus Medium Italic
BASKET weavers club

Corvenus Medium
OPERAS presented or

Corvenus Skyline Italic
WINDOWS cleaned by experts

Corvenus Skyline
TOWERING skyline block view

Corvenus Bold
NIGHTS of splendor

Corvenus Bold Italic
MUSIC hath charm

Menlo
MURPHY out of style

Menlo Outline
DENTIAL lots for sa

Dominante
MISSION day ceren

Dominante Bold
MAGNET universe

Dominante Outline
DIGEST brings ord

Melior
NAILS and other kii

Melior Italic
PEACE can be costly i

Melior Demibold
NIGHT stalker found

Melior Bold Outline
PLUTO dog planet

Melior Bold
GRAND panjandru

Melior Bold Condensed
MODEL agency open

Vandenhoughten
PERSON resident a

John Alden
MOBILE races and

Venezia Keystone
HEROES brave and

Grouch Swash
And To You We Say

Grouch
SAUTÉ light with

Domino
STORY made th

Kompakt
RAILS built m

Wilshire
TYPES made for

Eightball Outline
DRAW cartoon

Eightball
BILLIARD parlorn

Primus
HEADS tails

Sphinx Italic
MYSTIC reads l

Sphinx
BRIDGE spans d

Encore
AIRSHIP Ride to the

Encore Condensed
MERCHANT Never Question

Laureate
SPECIAL from this

Ibarra
SPANISH printers and

Howland
STORMY night and creepy too

Howland Open
STEAK and eggs over medium it

Harrington
IRON balconies of Or

Ludgate
BRIGHT student f

Gazebo
MAP of atlantis

Inside Solotype by Golly

Our apprenticeship program is
the envy of the industry.

Fat is always with us.

The beginning of display types as we know them was the "fat face," shown by various English typefounders early in the 1800s. Robert Thorne, the inventor of this style, also gave us the three-dimensional effect, an outline letter with a heavy shadow, exemplified in Thorne Shaded. This type is nearly two centuries old, and is still popular in advertising.

Many of the fat face styles are latter day designs, but some are genuinely old. Thorowgood has been with us since 1821, but Ultra Bodoni is from 1928. The relative newcomers are Pistilli and ITC Fatface. There are a number of condensed and extra condensed versions of the fat face, too. Ultra Bodoni Extra Condensed, Bodoni Campanile, and Onyx, to name just a few.

Pistilli Roman Swash
FRENCH and Italian

Pistilli Roman
NORTH lights display fr

Pistilli Roman Extra Heavy
BUSTING through muck

Pistilli Roman Bold Slope
ROASTED to perfection

Pistilli Roman Outline
SANDLOT playgrounds

Normande Italic
YOKES of service

Didi
QUAIL preserve from

Normande
WORSE for ear

Didoni
CRUEL and human

Normande Outline
BEACH invader

Didoni Bold
DROPS body flu

ATF Nubian
FANTASY world of films

Troy
HORSE jumpers beware

Surf
RUTHLESS typographers

Reef
UNDERWATER DANG

Onyx
MODERNISTIC variation olde

"Mommy, my tummy hurts!"

Bodoni Campanile
BEDROCK Historical Societies

Bodoni Bold Condensed
PURPOSE of main lette

Ultra Bodoni Extra Condensed
BRIDGE associations to

Ultra Bodoni
ULTRA boldness

Ultra Bodoni Italic
RADIO progran

ITC Fatface
PRESLEY lives again

Firenze
FLAIR and fancy

Ruler
GRIST mill opens

Trio
BLIND mice runs

Rose
DOZEN flower cut

Marto
FRENCH DESIGNS

Thorne Shaded
ABCDEF
GHIJKLM
NOPQRST
UVWXYZ
&12
34567890

Tom's Roman
TASK oriented plans

Thorowgood Roman
HOPE springs up

Thorowgood Italic
DRUMS bangs

Thorowgood Italic Modern Swash
Shop at Home b

Caslon lives on forever.

New Caslon Black Swash
SWASH LETTERS PO

New Caslon Black Swash
Freedom of design thro

New Caslon Black
CONQUER obstacles with

Wilshire
OPTIC nerves bad

Caslon Shaded
PRINT demands man

Caslon 224 Bold
CREAM of mush

Caslon Openface
GROUSE game birds

Caslon 224 Book
OBTUSE triangle do

Caslon Black
NOBLE jesture mad

Caslon 471 Italic Swash
Helping to Improve the Look of Advertising

Caslon 471
CASTOR oil dosage

Caslon Bold Condensed
HOSTAGE of love taken

Caslon 471 Italic
PAST events help in future p

Caslon Bold
RAINS wash bridg

Caslon 540
PAUNCH developed

Caslon Bold Italic
MEDAL for heroes

Caslon 540 Italic
REDACT proclamation

Caslon Oldface Heavy
MAINS break caus

New Caslon
SPACE evenly or die!

Caslon Ad Bold
FREAK show leaves

New Caslon Italic
FORMS printed by f

Milan
MOTOR city blues

Donna

Greatest Type Show On Earth!

Rainbow Roman

DESIGNS in Demand FOR Better TYPOGRAPH

Radar Roman

DESIGNS in Demand FOR Better TYPOGRA

Racer Roman

DESIGNS in Demand FOR Better TYP

Ranger Roman

DESIGNS in Demand FOR Better TY

Robin Roman

DESIGNS in Demand FOR Better T

Raven Roman

DESIGNS in Demand FOR B

Rodgers Roman

DESIGNS in Demand FO

Riviera Roman

DESIGNS in Demand F

Racine Roman

DESIGNS in Demand

Regeant Roman

DESIGNS in Demand

Rex Roman

DESIGNS in Demand

Regal Roman

DESIGNS in Demand

Rapid Roman

DESIGNS in Deman

Whale Roman

DESIGNS in Dem

Realm Roman

DESIGNS in Deman

Ruth Roman

DESIGN in Dem

Rich Roman

MONEY here today

Zenith Roman Inline

BEST tricks are

Inside Solotype by Golly

Sexual harassment is not tolerated here.

Bluto Swash

More Than Just A Pretty Face

A B C D E F F G H I J K K L L M N O P Q R R S T The U V W X Y Z &

Goudy Heavyface Condensed Italic Swash

BOATS for sale with rad

Goudy Heavyface Condensed

FRUIT market open

Goudy Heavyface

MILES from no

Goudy Heavyface Italic

GREAT are thin

Cooper Black

CLEAR and bol

Cooper Black Italic

CAROS while pr

Cooper Black Italic Outline

HAREM tours dai

Cooper Black Outline

OFTEN used fo

Cooper Black Contour

BINGO game rai

Cooper Highlight

LIGHT of the new

Super Cooper

ENTER into the

Hinkle Black

BANJO favorites p

Stephania Bold

THIRD time chare

Stephania Outline

CARES all seem to

Robur Decorated (Cabaret)

PRINT a good line

Robur Woodgrain

HOMES open and

Robur Black Condensed Inline

EXCITE old automobile f

Robur Black Condensed

POINT has place in typ

Robur Black Condensed Italic

CLOWNS be sent inside

Robur Black Inline

DANCE in search

Robur Black

LOGS on request l

Robur Black Italic

BLACK as night

Solotype Adds the Surprise Dimension!

INFORMATION ON SPECIAL EFFECTS STARTS ON PAGE 203

ROYAL

TAKE AIM WITH NEW QUICKSHOT JOYSTICKS

IT'S MERRY CRISPNESS

HOLDSTER

GOT A QUESTION? GIVE A CALL.
PHONE (510) 531-0353 8 AM-4:30 PM
24-HOUR FAX LINE: (510) 531-6946

CREATIVE DIRECTIONS

CHAMPIONSHIP SEASON

High Velocity Football

FRENCH RIVIERA

Bookman Demi Modern

DEATH and taxes

Bookman Demi Modern Swash

Eat Drink And I

Bookman Contour

TOPS and bottom

Bookman Bold ITC

DROPS by late

Bookman Bold Swash ITC

Bank Of No M

Bookman Bold Italic ITC

WORKS hardly

Bookman Bold Italic Swash ITC

Get The Joy Off

Bookman ATF

PRANK played for

Bookman Italic ATF

DUNCE hat fittings

Bookman Bold ATF

GRAND staircase

Bookman Bold Italic ATF

MONEY means tim

Bookman Bold Italic Swash ATF

Take It With A Gr

Bookman Bold Outline ATF

SOBER judgement

Bookman Bold Outline Swash ATF

Fancy Letter Im

Meola Bookman, the Ultimate in Swashes!

There is a small additional charge for matching swash characters to your layout. See price list.

ABCDEFGHIJKLMNOPQRSTUVWXYZ&&&&The
abcdefghijklmnopqrstuvwxyz aaabbcddddddeeeeffffgg ghh
hhhhbiiijj jkkkkk kk klllllmmmmnnnnnoopbpqprrrsssttt
uuvvv wwwxxxxxxxyyyzzzz 1234567890 1234567890 !?
AAAA ABBCCCD DEEEE FFFGGHHH
IIJJKKKKKKKKKLLLLLMMMMMMMMNNN
NOOPPQQQ QQRR RR RRRRSSSSTTTU
UUUUVVVVVVVWWWWWWWXXX XYYYZZ ()

Trying to identify a typeface? Fax us a sample, and let us try.

Superba Bold Condensed
SUPERB square serifs

Ernie
DOUBLE your fun

City Light
GAMES played in toda

Aquarius 2
LIGHTER faces work well

City Medium
MATCH cancelled for l

Aquarius 4
SEANCE with departed o

City Bold
LOADS of people gat

Aquarius 6
READY for distributione

City Bold Outline
DREAM from tomorr

Aquarius 7
ZODIAC sign reading

City Black
POLES used by pho

Aquarius Outline
FIRST with most in go

Aquarius 8
GREAT morning ideas f

Aachen Bold
COMBS designed fo

Waltz
DEBUTANTES night out dancing

Worcester
SAUCE for steak and poultr

Woody
MUSKRAT clubhouses

Texan
CHAINSAW recreational

Look to Solotype for Special Effects

Tower
TREMENDOUS popularity of

Karnak Black Condensed Italic
CARPET manufacturer

Stymie Obelisk
REALIZE capabilities early in life a

Memphis Medium Condensed
MEMPHIS revisited thro

Stymie Hairline
DERBY winner charg

Lubalin Graph Extra Light
FRANCE comes in

Stymie Light
LANDS dedicated to

Lubalin Graph Book
HASTE may be th

Stymie Medium
CAMEL jockey stay

Lubalin Graph Medium
ENJOY sporting v

Stymie Bold
FAMED fighter pla

Lubalin Graph Demibold
DAVID met with i

Stymie Extrabold
SAILS on the hori

Lubalin Graph Outline
GOLD bricks sit

Stymie Black
IMAGE important

Lubalin Graph Bold
BLANK tapes for

Waring
MARTIANS invade planetarium

Westgate
GUARDS protect against

Wand
MAGIC rabbit trickster

Hellenic Wide
EGYPT pyramid or

Craw Clarendon Condensed
RESCUE from the clu

Clarendon Contour
SHOW falling me

Craw Clarendon Book
BASE with load

Consort
MOIST soil causes

Craw Clarendon
LEGAL proced

Consort Bold
ROCK bottom ic

Craw Clarendon Outline
PLANT doctor

Clarendon Light (Haas)
MATH studentl

Cushing Light
BETEL nuts package

Clarendon Bold (Haas)
FORM and such

Cushing Medium
TEACH us how to lea

Fortune Light
ATOR pilots craf

Cushing Bold
SPACE capsule encou

Fortune Bold
BOAT teaches

Cushing Extrabold
LAKES emptied six

Fortune Bold Italic
MOST amazing

Cushing Outline
PAIRS of ancient st

Fortune Extrabold
RULE of the

Ridge
DRIVEN over the edge

Clarendon Special
BRUSHED with famous

Walnut
YOUNG armadillo rest

Warden
PARDON me please!

Raleigh
ZEROS essential int

Raleigh Bold
PRINT for profit at

Egyptian Bold Condensed Outline
EVOKES memories fr

Egyptian Bold Condensed
PUNCH your headline

Egyptian Bold
MEDIC creek open

Egyptian Bold Extended
SOFT shout g

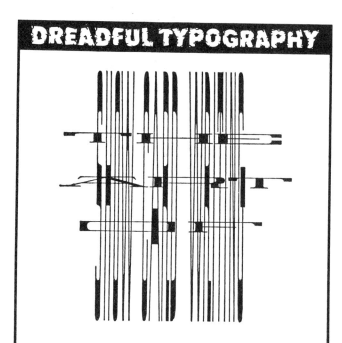

DREADFUL TYPOGRAPHY

This would be dreadful typography if it was a headline you were supposed to read at a glance. Actually, it is an optical trick. Tilt the page away, view the lettering at an angle, and it becomes readable. We see a lot of "over-squeezed" type these days thanks to modern electronics and bad judgement. We think it is far better to use a type designed as a condensed face. We know they are hard to find, but Solotype offers dozens.

Skin and Bones
ROLES reveal fears in

Arpad Light
GREAT humorist and

Arpad Bold
STOCK clerk fired in

Arpad Outline
OFTEN reprimands

Italia Book
KITES soar overhead

Italia Medium
TABLE models are

Italia Bold
BOWLS cherries g

Beton Bold Outline
TYPES vary in heigh

Beton Bold
HEART trusts mind

Beton Bold Condensed
RADIO program sha

Beton Extrabold
CHINA opens tall

Datilo Light
CAMEL riders we

Datilo Black
DAIRY cows rei

Schadow Antiqua
AFTER the rain sto

Schadow Werk
POWER failure stops ci

Schadow Antiqua Semibold
HARE to race con

We can stretch, squeeze and curve type to your specifications.

Schadow Antiqua Bold
MAJOR changes e

Cheviot
CHASE elusive one

Schadow Antiqua Bold Condensed
MANIACS hold cocktail

Contact Bold Condensed
PARISIAN friends visiting

Whitin Black Condensed
CARDS dealt honest

Contact Bold Condensed Italic
WESTERN recipes publis

Whitin Black
SING a career in

Contact Bold Condensed Outline
SWITCH engine directo

Whitin Black Extended
SUBJECT to further delays

Chiswell
JOAQUIN MILLS

Walnut
CRACKS open easy with

Egyptian Expanded Open
TRIPS arranged

Egyptian Expanded
DROPS accounts

Lambada
EXPAND YOUR

Cheltenham Oldstyle Condensed

SHAMROCK stars lipsync

Cheltenham Oldstyle

MOANS heard coming fr

Cheltenham Bold Ultra Condensed

TRAVELING with a dog name cha

Cheltenham Bold Extra Condensed

SHADOW boxer loses fight wit

Cheltenham Bold Condensed

PEOPLE talk of the future as

Cheltenham Bold

GIRLS swim meet cance

Cheltenham Bold Italic

SANDS of the desert

Cheltenham Bold Extended

FOUR fishing boa

Cheltenham Outline

ROSES in bloom are w

Cheltenham Bold Condensed Outline

HOMINY served nightly w

Cheltenham Bold Extended Outline

GRAIN alcohol p

White Friars

GUARD on parad

Clarendon Special

HON telegra

Egizio Medium Condensed

COURTLY manners and

Egizio Bold

OYSTER shucks

Egyptian 505

DICTION modern

Egyptian 505 Bold

BLUES guitar rec

Egyptian 505 Outline

PLATE silver wi

Jenson Bold Condensed B

QUANTUM leaps and bounds out

Jenson Bold Condensed

PANDORA'S mystery box

Jenson Agency Light

ICING with family an

Jenson Agency Medium

CAGES made of softi

Jenson Agency Bold

RING on the evil of

Jenson Agency Extrabold

RADIO stations pl

Mastodon

SOUTH tribes pla

Book Jenson Bold

EAGLE soaring t

The Kabels

Bernhard Gothic Light
POKES along sloth like

Bernhard Gothic Heavy
SHORE patrol duties

Bernhard Gothic Extra Heavy
BEARS in forest sits

Bernhard Deco
ROCKIES ROAD TO

Fino
DRAMA world plays a r

Fino Medium
MODERN decorative

Washington Extra Light
MOVIES are your best entertain

Washington Light
PYGMIES growing larger daily the

Washington Medium
SCHOOL days golden rule da

Washington Black
OPENS and closes every da

Kabel Inline (Zeppelin)
PICAS measure six to an in

Kabel Outline
MONEY talks forev

Kabel Light
SMOKER beats statistician

Kabel Medium
MAGIC presentation of

Kabel Bold
MAGIC presentation of

Kabel Extrabold
KITES fly overhead

Kabel Medium Condnesed
RECIPES for a happy marri

Kabel Bold Condensed
THESPIAN stages comeba

GOT A QUESTION? GIVE A CALL.
PHONE (510) 531-0353 8 AM-4:30 PM
24-HOUR FAX LINE: (510) 531-6946

Kabel Heavy
HIDES are first dried

Salut

Check With Solotype!

Britannic
DOPEY dwarf drug

Britannic Italic
CHOPS and cuts

Britannic Bold
BUGLE blowings

Britannic Outline
GENT search e

Corbett
FIGHT scheduled

Corbett Condensed
FAMILY members talk abo

Admiral
DELAWARE protectio

Salut
To Pay The Debts

National Map Shaded
GEOGRAPHIC MAPS

Allingham
FUDGE PUDDING COOK

Fedder Bold Italic
NIGHT and daze

Koloss
COLOSSAL events cast shadows and

York
Be sure to ask
about types not shown
in this catalog.

We have well over 7,000
uncommon alphabets
in our collection—
and perhaps we have
the one you want.

York
CROPS starting de

York Bold
SHOCK disbelief an

York Black
FILMS rated on bas

Valiant
JOUST with knight ride

Jana

DREAMER invents greater

California Grotesk Medium

TOURS start every day at

California Grotesk Bold

JUMBO shrimp sale now

California Grotesk Black

LAST one in is a rotte

California Grotesk Outline

GOLDEN state outlined

Matador Bold

APPLES are nature's whiskbroom

Matador Outline

FRUITS and vegetables get you g

Ibsen Light

BORNE aloft on wings f

Ibsen

BOTCH jobs should be

Ibsen Outline

BRAKE shop opens on m

Ibsen Outline Biform

Biform variation He

 GOT A QUESTION? GIVE A CALL.
PHONE (510) 531-0353 8 AM-4:30 PM
24-HOUR FAX LINE: (510) 531-6946

Ibsen Contour

BONUS offered extra

Futura Display

MOTHS damage price

Othello

SPEARE festival held h

Othello Outline

TRAGEDY and comedy!

Semi-Stark

MAJOR changes in transp

Stark

GOTHIC type faces mos

Permanent Massive (with descenders)

SOMETHING for every

Permanent Massive (without descenders)

SOMETHING for every

DREADFUL TYPOGRAPHY

1,000 Tested Money-making Markets For

We find it hard to believe anyone would like type run together as in the dreadful example above, taken from a book in our library. (We blocked out the bottom line to protect the guilty.) Kiss-kerning, as this affectation is called, needs a delicate touch, and is usually best dispensed with altogether. It may have its place in some logo work, but we have yet to see the headline that was improved by it. Even if you insist on kiss-kerning, we may still require a note from your mother saying that it's OK.

Peignot Bold with Special Effects Shadow added

Great Special Effects From Solotype

Neil Bold

LORD of the fries ea

Daphne

Daphne Gardens

Neil Bold Outline

SNAKE in the grass

Serpentine Light

SNAKE in grasp

Ritmo

BUCK stops over the

Serpentine Medium

DUSTY trailers

Pascal

CLEAN and shine servi

Serpentine Bold

MUSIC mighty

Optima Outline

DANCE contest win

Serpentine Bold Italic

CURE ailment

Optima

HOAXER loses license

Inverserif Outline Italic

COBRA strikes

Optima Italic

BLOCK party given ho

Inverserif Outline

LENTIL soup disl

Optima Semibold

HINDU mystic night

Inverserif Light

DENTAL work most ex

Optima Bold

LEMON product o

Inverserif Regular

HOARD money for

Peignot Light

QUAKE warning broac

Inverserif Heavy

PATIO decora

Peignot Medium

FARMS well known or

Dill Light

THING always del

Peignot Bold

CHARM is the virtu

Dill

RAGE and retri

Globe Gothic Extra Condensed
GLOBAL travel for worldly sojo

Globe Gothic Light
KIPPERS with champa

Globe Gothic Normal
SELDOM heard stori

Globe Gothic Bold
ROBUST constitution

Globe Gothic Outline
WINDY city visitors le

Globe Gothic Extended
HELP mains e

Radiant Bold Extra Condensed
GUIDANCE CENTER for delinquent dogs

Radiant Bold Condensed
SORCERY apprenticeship exam

Radiant Bold
PLANE lands safely af

Radiant Heavy
PHONES connecte

Tempor Medium
BEIGE carpets show

Tempor Bold
LEACH installed plu

Matthews
FISH talk from ne

All Solotype headlines are edited for even color.

Clearface Gothic
DRINKS served quickly

Clearface Gothic Bold
PRINTS found after b

Clearface Gothic Extrabold
MAGIC conclave vani

Clearface Gothic Outline
DOGMA explained ic

Polypheme Condensed
RADIUM glows in the darl

Precis Bold
DETROIT automative firms

Rodin
TRICKS invented for

Florentine Light
QUIET must be observ

Florentine Bold
PARSON weds cou

Cadence
SCRAP drive helpin

UNUSUAL SANS SERIFS
TO STIR YOUR CREATIVE JUICES

There's more to life than Helvetica! Among these modern, stylish sans serifs you may find just the touch you need to break the "look-alike headline" habit. (And if the job really calls for workhorse gothics — like Helvetica — we've got 'em all.)

Tamil Outline
DANGER no entry

Tamil Light
TOPAZ stones are ve

Tamil Medium
CABIN for sale or tra

Tamil Demibold
ENTER through sic

Tamil Bold
DEMON worship ep

Tamil Black
BANJO picker plu

Tamil Heavy
PRIME location f

Antique Olive Outline
GIBSON girls dra

Antique Olive
OLIVER twists arm

Antique Olive Italic
BOXER shows am

Antique Olive Narrow
CAPITOL press confe

Antique Olive Medium
HOTEL detective

Antique Olive Bold
CROWD gather

Antique Olive Black
FRIED shrimps

Antique Olive Black Extended
FAT freds c

Antique Olive Black Italic
OAT bran ca

Antique Olive Nord
POUR milk

Film Titles?

Sure, we do them all the time — on paper for reflective copying, and on Kodalith for backlighting.

Tell us what you need. Solotype knows how.

Corporate Gothic

THE BORED CHAIRMAN

Microgramma

WOK ON WILDSIDE

Eurostile Outline

HANG them high

Microgramma Extended

YOU DIRTY R

Eurostile Bold Shaded

PLAIN types are

Microgramma Bold

MORONIC COW

Earth

earthdays

Microgramma Bold Extended

TOP DOGGY

Eurostile Contour

COLD shiver

Microgramma Outline

SHOUT LOUDLY

Handel Gothic Light

BLAND foods serv

Eurostile Light Extended

BEST service

Handel Gothic

BOXER shows mat

Eurostile Condensed

CROWNS heads tonigh

Modula Light

SUGAR growing o

Eurostile

BROW beating is no

Modula Medium

BARON invites em

Eurostile Extended

BOAT rentals

Modula Bold

MODEL children a

Eurostile Bold Condensed

RUSTED pieces may hav

Modula Extrabold

PAST present ar

Eurostile Bold

RADIO plays favo

Bolt Bold

FIRST day of mon

Eurostile Bold Extended

FATS may us

Blackjack

CARD SHARP

Jay Gothic
SHAPE the future with of

Jay Gothic Outline
SAVED by the bell whichr

Jay Gothic Bold
BREAD and cakes for dini

Topic Dimension
TOWERS toppled explos

Topic Outline
CLOSED for vacation in

Informal Gothic
INFORMAL AFFAIRS DRE

Peignot Condensed
MADAME CURIE AND HER

Marcos Face
FRIED chicken and po

Stabile Outline
TRAIN for vacat

Stabile Fineline
FAVORITE actress returns

Stabile Light
CAPTIVATING ideas in typo

Stabile Demibold
BLENDING colors for gre

Stabile Extrabold
HONDURAS mahogany o

All our headlines are edited by hand for even color.

Fat Albert
SHAKE well and into

Fat Albert Outline
LIVES saved thanks

Fat Albert Shadow
OVERLAND with noted

Hess Neobold
FROZEN DELIGHTS ABOUI

Checkmate
RACES begin at

Ad Lib
SIDED propositic

Inside Solotype — by Golly

Some of our staff moonlight.

Add the Surprise Dimension with Solotype!

Pastel
ABALONE DIVERS

Genny
ORGAN grinder plays

Copperplate Gothic Light
BUILT ON TRADIT

Weigand's Ad Bold
DIRECT advertisings

Copperplate Gothic Medium
JOIN THE GROU

Harper
HARPS and flowers sent with

Copperplate Gothic Wreath
HOLIDAY DECOR

Steelplate Gothic Shaded
CRAB MARKET

Copperplate Gothic Winter
COLD FRONT

Contrary Bold
CONTRARY WISDOM

Copperplate Gothic Wasp
WHITEBREAD

Thermo 300
THE STRANGE

American Gothic Medium
GAMES cancelled

Mitchell
PRINTING SE

American Gothic Bold
GIRLS badminton

Weiss Medium Gothic
DEVICE designed pr

Wilson Gothic
BOWL decorate

Weiss Bold Gothic
GUARD discovers le

Copperplate Gothic Wave
OCEAN surfer

Newtext Regular
DREAM dates

Copperplate Gothic Whiz
FAKE chees

Newtext Demibold
DOCK of the ba

Copperplate Gothic Washington
CHOP down tre

Windsor Gothic
DOCTORS ambulance vic

Many of the typographic revivals popular today started at Solotype.

Marylebone
GLAMOUROUS HAT

Gorton Condensed
GORTON CONDENSED

Alphabet Soup
WARD'S GARDEN CENT

Moon Black
ARTIST and model for

Cycle
CLING now popula

Moore Combo
COMBINE elementary

Blippo Light
WHERE will you find such

Bubble Light
BLOWING soapy water

Blippo Bold
DIETS prove harm

Bubble Dubble
ELEMENTS of typograph

Blippo Black
ALTER route to go

Bubble Shadow
CHEWING gum sticks

Blippo Outline
GRADE taken rom

Bauhaus Light
FESTIVE parties held

Harry Thin
ORDER to restore privc

Bauhaus Medium
HEROIC patriot from

Harry Heavy
GUEST speaker clam i

Bauhaus Demi
BRIDGE tournament

Harry Fat
MARKS show angle

Bauhaus Bold
AZURE skies beckon

Harry Obese Squeezed
DOUBLE standard h

Bauhaus Heavy
GREAT mysteries of

Harry Obese
SHARK watch ef

Chubby

ROUND ON THE ENDS

Not So Chubby

PORK LIKE SUBS

Marianna Black

HOGS brick hut

Frankfurter Highlight

HIGHLIGHTS FO

Frankfurter

RED HOT FRANKS

Frankfurter Chubby Outline

CHAMPAGNE OF

Frankfurter Lo-cal

MOVING TARGET

Frankfurter Heavy Outline

CHEWING SNAX

Too Much Clear

MAKE YOUR OW

Too Much Shadow

BUMP IN THE NIGH

Too Much Opaque

FAT BLACK TYPI

Rolling Extra Bold Outline

POSTS for fenc

Rolling Extra Bold

RENTS due on t

Formula Naught

BREAK windows pu

Formula One

BLOCK party given

Benguiat Gothic Book

NOSE hair unsightly

Benguiat Gothic Medium

FLEA bitten varmint

Benguiat Gothic Bold

FOWL ball chicken

Benguiat Gothic Heavy

CROCK pot full of

Cut-in Medium

Can't find it?
Check with us!

This catalog doesn't show our entire library. Thousands more in the vault.

Frisko
MENTAL garden plant

Tasmin Light
PATCH plaster with flour and wa

Tasmin Medium
HOARY jokes never die haunt

Tasmin Bold
BEACH blankets offered for

Casablanca Light Condensed
HAPPINESS guaranteed absolutely

Casablanca Medium Condensed
RADIANT complexion assured in

Capone Light
REMARK if you should ag

Capone Medium
SHOWN last fall undern

Windemere (Ludlow Gothic)
AMAZON river exists yet

Ronda Light
NATURE lovers unite fo

Ronda
LUXURY home builder

Ronda Bold
FORTUNE telling taug

Soul Light
LAGER brew sold only t

Soul Medium
HONED for sharpness a

Soul Bold
LEAFY bowers maintai

Soul Outline
DEVICE patented thor

✳✳✳✳✳✳✳✳✳✳✳✳✳✳✳✳✳✳✳✳✳✳✳✳✳✳✳✳✳✳✳✳✳✳✳✳

Paprika
KARMA watcher p
Alternate letterforms for Tabasco and Paprika
AHJKLMNRUVWY hkmnsvw

Tabasco Light
DANCE held last nigh

Tabasco Medium
SECRET recipe flops t

Tabasco Bold
MOVIE makers local

Novel Gothic Light
GREAT music of an

Novel Gothic Medium
TYPE designer prin

Novel Gothic Bold
SHORT story nov

Lincoln Gothic
MODERN HEADLINE TYPES

Serif Gothic Light
TUBA players blow it

Serif Gothic Regular
SEATS made of hard v

Serif Gothic Bold
GUSTS of wind hampe

Serif Gothic Extrabold
ROCKS around clok

Serif Gothic Heavy
FORTH coming prec

Serif Gothic Black
CRUDE attitude r

Serif Gothic Bold Outline
BENDS are a divers w

Serif Gothic Open Bold
RULES to be broken

Advertisers Gothic Light
CREATIVE directors

Advertisers Gothic Condensed
RADIOS pump up the jam

Advertisers Gothic Outline
RADIO showsw

Advertisers Gothic
SOLVE others poi

Avant Garde Gothic Extra Light
COMBS manufactur

Avant Garde Gothic Book
LIGHTER typefaces

Avant Garde Gothic Medium
PRINTS stationeries

Avant Garde Gothic Demibold
KNOWS no bounds

Avant Garde Gothic Bold
BOLD typography

Avant Garde Gothic Book Condensed
SICKER than mongrels

Avant Garde Gothic Medium Condensed
BRIGHT lights dazzles

Avant Garde Gothic Demi Condensed
EATING right for health

Avant Garde Gothic Bold Condensed
SELECT the right type

Frisko
MENTAL garden plant

National Map
GEOGRAPHIC MAPS

Review Gothic
ISLANDS of the sout

 LOOK TO SOLOTYPE FOR HARD TO FIND HEADLINE TYPES!

Galaxy Gothic

THE MILKY WAY galaxy of chocolate nougat

Gay Gothic

SLIGHT touches in types

Gable Gothic

BROADCASTING music and news everyd

Globe Ace

COVERS the earth over

Garfield Gothic

GARFIELDS presidential houses

Gyro Gothic

RINGS around collar

Giant Gothic

GOLIATH upset by underdog

Gala Gothic

PARTY hearty tim

Gamma Gothic

ALPHABETA gamma soup test

Glenlake Gothic

FLOATS atop glenlake

Gazette Gothic

CRUISER ship take off late

Goddess Gothic

VENUS Beauty girl

Grant Gothic

GENERAL the union army

Eden Ace Italic

GARDEN of temptations

Garnet Gothic

GARNET crystal glea

Eagle Ace Italic

EAGLE receding hair

Gaucho Gothic

GAUCHO cowpokes

Earl Ace Italic

DUKES of earl rigs

Ginger Gothic

GINGER ails whis

Echo Ace Italic

ECHOS vibrating

Raleigh Gothic

ELEGANT STYLES DISPLAYED AT SOLOTYPE!

Eddy Gothic

SLANTED for your pleasu

Easter Gothic

EASTER parade started

Event Gothic

DEATH of salesman

Evans Gothic

SPORT car name hal

Entry Gothic

ENTRY stage left

Electro Gothic

SHOCK tabloid rages

Elm Gothic

PRICE slashing

Envoy Gothic

SEND diplom

Encore Gothic

ONE MORE A

Eclipse Gothic

DARK SIDE

Binderstile Medium

RUBICON river flow easy

Binderstile Bold

SARDONIC laughter hed

Binderstile Heavy

WASHING dirty linen w

Inserat Grotesk

GREAT BALL fire bound

Enge Wotan

ROARING Twenties wild

Gill Sans Bold Extra Condensed

CHANCED on romancing

Permanent Headline

KNUCKLE sandwiches

Designer Raleigh

SIR WALTER RALEIGH TOBACCO CAN

Gaspipe Gothic

KGB SPIES ON THE CIA

Gem Gothic

ROCK HUNTS

Jersey

HARD TO FIND OCTIC TYPES!

Poster Gothic Condensed

RAILROAD TRACKS

Stanford

QUESTOR

Agency Gothic

LAND IS BRIGHT WESTWARD!

Time Machine

THE FUTURE PAST

Agency Gothic Open

NATURE HAS GIVEN US TWO EAR

Energy Inline

GREAT MOMENT IN

Quote

GAME show loses i

Charger Rimmed

NEW ICE CREAM LA

Irwin

HOSPITAL ERN

Charger Outline

TRAVELERS RETURN

MAZE & DAZE
GAMES

Charger Bold

COMPUTER SCIENCE

Charger

MAGNIFICENT FLYINC

Octic Extra Condensed

BADMINTON TOURNEYS

Machine

PRINTING AND THE MI

Octic Condensed

EINSTEIN'S THEORY OF

Machine Medium

KNOWING WHEN YOU C

Octic Regular

CENTRAL TIME ZON

Machine Bold

HELP! THE MACHINES A

Sar Modern

ATOMIC powethouse open

Octic Extended

EIGHT SIDED TYPES

Yagi Link Light

STICKS TO YOU A

Yagi Link Double

BRIGHT & BOUNCY

Yagi Double

MYSTERY HOUSE

Yagi Bold

BALLET COMPANY

Yarra

DESERT FLOWERING

Cirkulus

metro after hour

Mossman

RIGHTEOUS TEAR 3

Busorama Light

RENT A FLAT IN BLOOMSBU

Busorama Medium

DISC JOCKEY OF THE YE

Busorama Bold

PROGRAM CONFEREN

Avanti

SAFETY FIRST ANI

Burko Circle

RECORDING COM

Burko Bounce

OUTER SPACE MS

Interface (Stop)

HOUSE PUBLISHER

Earth

EARTH DAYS

Eagle Bold

WHERE MAGIC

EAGLE BOLD

ABCDEFGH
IJKLMNOPQR
STUVWXYZ

NRA
MEMBER
U.S.
WE DO OUR PART

1234567890

Futura Inline

PRIZE WON BY CO

Simplex Light

case alphabets

Simplex Bold

basic enthusias

Marvin

OMNIBUS TOURING

X-Ray Bold Open
X-RAY device

X-Ray Bold
DEALS closed

Ballot Box
STRIKE workers!

Victory Bold Open
OPERETTA melodies

Victory Bold
MYSTERY programs

Beware! Young man, don't swear. Swearing never
was good for a sore finger, It never cured the
rheumatism nor helped draw a prize in a lottery.
It isn't recommended for liver complaint. It isn't
sure against lightning, sewing machine agents, or
any of the other ills which beset people through life.
There is no occasion for swearing outside a news-
paper office, where it is useful in proof-reading and
indispensably necessary in getting forms to press.
It has been known also to materially assist the editor
in looking over the paper after it is printed. But
otherwise it is a very foolish and wicked habit.
— Source unknown.

Dance Band Light
ABCDEFGHIJKLN

Dance Band Medium
ABCDEFGHIJKLN

Dance Band Bold
ABCDEFGHIJKL!

Lulubelle
SALON HAIRSTYLES BY

Lulubelle Outline
EGG CREAM IN A CUP

Lulubelle Bold
STARSHIP ROAMING

Providence Bold
HOSPITAL ZONE

Flash Idea Open
MANY chosen

Parnel Product Medium
SERIOUS moneys

High Catz
DECK chairs

Global Fineline
LONE rides on

NOT Glasster A CURVE IN A CARLOAD!

Will Light
BRIGHT studies

Vacation Bold
OPENS tonight in

Vacation Bold Outline
BRIDGE game for

Victory Bold Open Shadow
VICTORY program

Victory Bold Shadow
SHADOW typefac

United Bold
GUIDES publisher

United Bold Outline
RADIO studio list

Herald Square
EXACT details of the job

Will Bold Open
FROST bites

Will Bold
VERDI opera

Princetown Outline
PEP TALKS

Sweatshirt Bold
SWEAT SOCK

All Star
VARSITY RAG

Overaction Open
DEVILISH JOKE

Imprint Serif
HEAD COACHES

Model Square Serif Open
RISK FACTO

Youth Medium
STANDARD method

Killington Open Highlight
KITCHEN cabinets

Model Sans Serif Open
EACH MONTH

Ricardo's Special
STUDENT M

An up-to-date price list is always available on request.

Futura Fargo
SALUTARY effect demonstrate

Futura Flyer
GREATER paychecks now

Veranda
PORCH swings built o

Vellum
GENIUS welcome

Veteran
FORM functions

Van Dyke
OPERA guild opens

Futura Light
CHILD care growing in po

Futura Light Oblique
SLANT can either be for

Futura Book
CRIME control squad or

Futura Book Oblique
UNSAFE at any speed

Futura Medium
MEDIC on duty at clinic

Futura Medium Condensed
SERVICE begins when you open

Futura Medium Oblique
ITALIC faces are great p

Futura Bold Condensed
CRAPS players gamble

Futura Demibold
MONEY is never ther

Futura Bold Condensed Oblique
ZONES of twilight lands

Futura Demibold Oblique
ITALY welcomes visit

Futura Extrabold Condensed
FORCES meet resista

Futura Bold
NAMES have to ch

Futura Extrabold Condensed Oblique
BEARS and grandma

Futura Bold Oblique
HABIT has been do

Futura Extrabold
BONDS mature in

Futura Extrabold Oblique
MAJOR quake ro

Eras Light
PEOPLE forget soon

Eras Book
WOMEN in graphic

Eras Medium
PARTIES given daily

Eras Demi
SPEND more time

Eras Bold
CROW about us

Eras Ultra
KITES designed

Eras Outline
SOUND system

Eras Contour
BIRD song tap

Granby Extra Light
CLUBS open early on w

Granby Light
LIGHT faces must be s

Granby
HORSE ranch stall p

Granby Outline
RACES begin tw

Granby Elephant
NOW is the time

Folio Bold Condensed
FLAVOR packs may pro

Folio Light
LIGHT and dark imag

Folio Medium
FAITH in one creati

Folio Bold
FATS in your sho

Folio Extrabold
HARPS are won

Folio Outline
SAFE dependa

Gill Sans Light
RECLUSE shuts out worl

Gill Sans
LEAVE your things and e

Gill Sans Bold
CATCH the wind fori

Gill Sans Bold Condensed
BREAD prices continu

Gill Sans Extrabold
DOMES of silenc

Gill Kayo Outline
NORTH pole tr

Gill Kayo
SOME like it to

The Univers Series

Univers 39
LINE WORKERS cease production after forem

Univers 49
RAINBOW hues available in printing and other l

Univers 47
FRAME work requires knowle

Univers 48
EFFORT must be expelled in firs

Univers 59
RAGTIME band makes back

Univers 57
RACKET busters succe

Univers 58
RADIAL tires now the g

Univers 67
LEVER action most p

Univers 68
MAKER of toy airplan

Univers 77
RADIOS blast airwave

Univers 57 Outline
ZATION and how to co

Univers 83 Outline
ECRU towels off

Univers 45
FRAME builder retires t

Univers 46
HOUSE cleaning has l

Univers 55
BARKS are not alwa

Univers 56
CARRY the load as f

Univers 65
POETS hold first ex

Univers 66
DARES make exc

Univers 75
RIFLE shots hear

Univers 76
POLICY prohibit s

Univers 53
GRIP the side of

Univers 63
HELP wolf crie

Univers 73
JURY refuses

Univers 83
KEEP your th

Yes, we have Helvetica!

Helvetica Bold Italic Modified

Helvetica Thin
SHAKE roofs installed

Helvetica Light
FASCIST government

Helvetica Light Italic
SPENT cartridges are

Helvetica
ROUGH rider show

Helvetica Italic
RUSTY nail found in

Helvetica Medium
SHIRT lost in wash

Helvetica Medium Italic
SHIFT gears with c

Helvetica Semi Demibold
HOSTEL for hostile

Helvetica Bold
BRONX cheering

Helvetica Bold Italic
PANZER division

Helvetica Italic Modified
SIGN with a bit w

Helvetica Ultra Black
LUBED and grea

Helvetica Ultra Compressed
SANFORIZED for nominal charge

Helvetica Bold Condensed
REMIT payments promptly to

Helvetica Extra Compressed
BIRDNEST soup of lark pits

Helvetica Extrabold Condensed
REGAL robes display the

Helvetica Compressed
MOSQUITO night raid

Helvetica Rounded Medium
GROUND round bef

Helvetica Showcard
YOGA bear new guru t

Helvetica Showcard Italic
FOXES quick brown

Helvetica Regular Condensed
BLANKETS whole region

Helvetica Regular Extended
SQUAD car chas

MOCHA drink

Helvetica Extrabold Extended
ROAD loads

Standard Light
FORCE of numbers in

Standard
HOPES and desires

Standard Medium
HOSTEL travel guid

Standard Bold
CAUGHT in the act

Standard Extra Light Extended
SOME other day

Standard Light Extended
BEST effort from

Standard Extended
PARIS is calling t

Erin
POINT our lights

News Gothic Extra Condensed
CURMUDGEON DUCK grumpy quack fowl

News Gothic Condensed
HANKERS to be chief again!

News Gothic
MODEST yet conceited

News Gothic Bold
NUDGES with elbow

Quick Gothic Condensed
JACK be nimble jack quick

Grotesk No. 9
WARTS from frog lips

Grotesk No. 9 Italic
EXTRA savings for yo

Venus Light Condensed
FOUNTAINS improve environment for

Venus Bold Condensed
DESERTED tropical island found

Venus Extrabold Condensed
DOLPHINS do it on porpoise

Venus Medium
PRINT for fun at home

Venus Medium Italic
CRAZY photograph

Venus Medium Extended
DRUG seminars

Venus Bold
CLONE produced in

Venus Bold Extended
MORE money

Venus Extrabold Italic
TOPSY just growed

Venus Extrabold Extended
PLANETS of the lost limbs

Aurora Grotesk
ACTION packed adventur

Anzeigen Grotesk
ADVERT leading trade a

Impact Outline
SHIPS crew in trou

Impact
SHARP edges may be

Permanent Headline
MONSTROSITIES manufactur

Permanent Headline Open
PAINS caused by nervous tension

Alternate Gothic No. 1
RACING stripes painted on mode

Alternate Gothic No. 1 Italic
FRENCH painter arrives for lect

Alternate Gothic No. 2
RECITES poems for enterta

Alternate Gothic No. 2 Italic
REASON wins out every tim

Alternate Gothic No. 3
ORANGE flavored soft drin

Alternate Gothic No. 3 Italic
AUTHOR questions playh

Maigret
PLEASE do not tease the animals

New and old faces arriving everyday at Solotype.

Sans Serif Condensed Italic
BROAD avenues found

Franklin Gothic Extra Condensed
MODELS no longer require

Franklin Gothic Condensed
HOPE springs eternal

Franklin Gothic Condensed Italic
HAPPEN at the old plant

Franklin Gothic
OPENS new gifts

Franklin Gothic Italic
PLATE glass wind

Franklin Gothic Wide
DUCKS are daf

Franklin Gothic Wide Italic
SHORT order h

Charter Oak
DRAFT beer tap

Old Gothic Bold Italic (Doric Italic)
CHART solicite

SOLOTYPE HAS IT!

Postcard Light

GAME OVER

Postcard Dark

POWER PLAY

Overlapping the shadows
doubles the price.

Richfield

THE HOUSE UP HILL

Figgins Shaded

NO ABSINTHE

Sacramento

STOP AHEAD FOR FALL SAVINGS

Forum One

ADVENTURE TOUR PLAN

Forum Two

MARKET REPOR

Regina

QUEST FOR THE KNOWN

Stereo

STEREO ART

Fat Shaded

RIGHT OF WAY ALWAYS

Thorne Shaded

DIMENSIONA

Stack

VERTIGO AWARE

Premier Shaded

PHOTOGRAPHIC ESSAY P

Elongated Roman Shaded

THE ABC BOOK FOR ADULTS

Block Dimension

THIRD DIMENSION

Bullion Shadow

GOT TO BE TOUGH

Telegram Open

MORAL GAMES AND OBJEC

Riccardo

FRED AND ETHYL

Kickapoo

KICKAPOO INDIAN

Gill Shadow

STATION MASTER

Orplid

TWENTY-SIX MAGIC

Sans Serif Shaded

TREASON AND PLOT

Uncle Bill

SMOOTH SHAVIN

Shadowland
SHADOWS

Submarine Shaded
SUBMARINE EXHIBIT FOR

Caslon Shaded
PRINT demands man

Hunter
THE STORY ANCIENT

Castellar
THE GIN GAME

Castor
CASTOR POLLUX

Comstock
COPIES quicklr

Comstock Condensed
MINERS get the shaft!

Univers 59 Contour
HOMINY grits for breakfast!

Univers 57 Contour
BATHS installed today

Philadelphia Contour
CAFE SOCIETY GOSSIP

Serif Gothic Open Shadow
THEATRE programs

Korinna Open Shadow
PRINTS auctioned

Whistle Dropshadow
WHISTLE BLOWS AT DAWN

Double Vision
TWICE as nice but

Narciss
LIGHT of the sprir

Mirabeau with Small Caps
Buy The Horse A

Mirabeau with Lowercase
Regency Period Lives

Souvenir Sans Embossed
SHINY surface int

Augustea Inline
ELECTRIC BILLS IN

Antique Roman
ELEGANT appearances

Delphian Open
PAGES FILLED WITH

Contura
RADIO days visited

Goudy Open Italic
BINGO parlor open

Goudy Open
EMPTY promise in

Buxom Angular

OUTLINES & SHADOWS

BRINGING THE THIRD DIMENSION TO TYPOGRAPHY

Profil

PREDICTIONS

Pioneer

PLAIN STYLE EXHIB

Invisible

CLAUDE RAINS

Pioneer Bounce

SAME DESIGN With

Profile Shadow

CARGO SHIP

Franklin Open Shade

THE SHADOW KNOWS

Umbra

WATCH ME PULL RO

Diebold

LOCKS OPENED QUICK

Rambler

**HARMONIOUS TYPES
75 New Volumes**

Flippo Outline Shaded

PUBLIC auctio

Quail

REMEMBER THE FIFT

Flippo Solid Shaded

BLANK spaces

Echo

SCHOOL SWEATER WI

Buxom Angular

LOOK TO SOLOTYPE

Bronze

CARVED IN STONE

Buxom Condensed

BABY ARBUCKLE TYPE

Nugget

THREE-DIMENS

Buxom

PLAN INSTITUT

Neon Deepshadow

THE RAILROAD L

Venice
USEFUL SHADOWED TYPES

Monument
QUADS ON LOGS

Helvetica Shaded
SHADOW knows you

Hadriano Stonecut
GOUDY DESIGN

Cursiva Iberica
Coffee Shop open all nite

Mona Lisa
STOLEN design reforms

Viking
VIKING long ship oar

Burlington
CITIES of magic call to

Victory Casual Shaded
VICTORY at sea worlds

Valor
SWORD of valors

Vertex
HIGHEST point reached

Van Dyke Shaded
BEARDS trim shapely

Venture
VENTURES into dark shadows

Vanity
VANITIES sold wholesale

Viola
STRING sections

Vermont
ACTIONS speak louder

Vessel
BOATS capacity

Voyage
VOYAGE around them

Venetian Casual Shaded
VENETIAN blinds hung

Vatican Shaded
VATICAN city tour

Vodka
VODKA gimlets ice

Vigil
KEPT vigilanc

Volt
CHARGE of electric

Video
VIDEO tapes

Vim
ACTIVE energies

Graphique
NARROW TYPES THAT DON'T LOOK SQUEEZED

Looking Glass Outline
DISCO dancing ta

Whedon Outline
DESIGN wins the day for

Outline Gothic Condensed
PROBLEMS resolved neatly

Livermore Outline
One Tally Mark begins

Modern Outline Condensed
MODERN outline condensed

Pluto Outline
KEYLINE for color

Helvetica Bold Condensed Outline
MONTAGES of carp images

Helvetica Italic Outline
SCOTER quacks up

Helvetica Medium Outline
OMNIBUS singles

Helvetica Bold Outline
DEALS out card

Helvetica Bold Outline Italic
ROMPS through

Helvetica Bold Outline No. 2
CORNY joke tol

Contour Gothic No. 1
LINES FORMING ATO

Eightball Outline
CHALK cuestix

Double Trouble
DOUBLE TROU

Wurstell Outline
WURSTELL OUTLINE

Univers 83 Outline
FORTY thieves?!

Publicity Gothic Outline
QUIET zones of

Bloc
DANGER SIGNS

Heavy Outline Condensed
CAUTION DON'T DROP A

Brush Sans Outline
MASTER SLEUTH

Brush Sans Rimmed
MYSTERY WRITE

Incline (Extra cost for overlapped shadows)
INCLINED PLANES

Inflation
ANOTHER SOLOT

Trump Medieval Outline
SWING into spr

Korinna Outline
HINDU mystic ea

Windsor Outline
COUCH potatoes

Univers 57 Outline
ZATION and how to co

Univers 83 Outline
ECRU towels off

City Bold Outline
DREAM from tomorr

Aquarius Outline
FIRST with most in go

Arpad Outline
OFTEN reprimands

Othello Outline
TRAGEDY and comedy!

Inverserif Outline Italic
COBRA strikes

Inverserif Outline
LENTIL soup dish

Neil Bold Outline
SNAKE in the grass

Charger Outline
TRAVELERS RETURN

Matador Outline
FRUITS and vegetables get you g

California Grotesk Outline
GOLDEN state outlined

Ibsen Outline
BRAKE shop opens on m

Ibsen Outline Biform
BiFORM variation HE

Permanent Headline Open
PAINS caused by nervous tension

Impact Outline
SHIPS crew in trou

Folio Outline
SAFE dependa

Eightball Outline
DRAW cartoon

Britannic Outline
GENT search er

Rolling Extra Bold Outline
POSTS for fenc

Too Much Clear
MAKE YOUR OW

Frankfurter Chubby Outline
CHAMPAGNE OF

Frankfurter Heavy Outline
CHEWING SNAX

Spartana Outline
FACES OF THE PA

Basso Outline
CAMCORDER SHOTS

Anonymous Outline
ANONYMOUS OUTLINE

Kobe Open
WINTER BLUNDERLAND SKI

Futura Black Outline
MOCK turtle soup

Veronica Open
TICKET SALE FROM

Quaint Open
ENTER THIS CONTEST

Souvenir Demibold Outline
PAINT brush clea

Souvenir Bold Outline
WRAPS package

Stencil Outline
STENCIL OUTLIN

Latin Bold Condensed Outline
LINE DRAWINGS

Elefante Outline (Domingo)
MASQUE tonight at the ol

Latin Wide Outline (Vigor)
HOPES for better li

Automation Outline
NEW INTEGRATED CI

Igloo Outline
ALASKA MORGAN I

Block Outline Shadow
STOP watching

American Typewriter Outline
GONE foreverm

Ben Franklin Open
GREAT earth feature

Graffito Outline
CAMP sites foun

Jolly Roger Outline
PRICES remain high

Bradley Outline
CHRISTMAS magazine co

Satanick Outline
Satan Gets The W

Viking
GARLIC and chive

Aurelio Outline
BONDS offered tod

Calcutta
ANTIQUE FURNI

Jay Gothic Outline
SAVED by the bell whichr

Topic Outline
CLOSED for vacation in

Roberta Outline
ROBERTA in outline

Columbus Outline
FRESH fish today

Soul Outline
DEVICE patented thor

Serif Gothic Bold Outline
BENDS are a divers w

Serif Gothic Open Bold
RULES to be broken

Veranda
PORCH swings built o

Vellum
GENIUS welcome

Veteran
FORM functions

Eras Outline
SOUND system

Granby Outline
RACES begin tw

Gill Kayo Outline
NORTH pole tr

Hacker Outline
COUNTRY BUMP

Mandarin Outline
JUST HOLLOW M

Optima Outline
DANCE contest win

Globe Gothic Outline
WINDY city visitors le

Clearface Gothic Outline
DOGMA explained ic

Tamil Outline
DANGER no entry

Olive Antique Outline
GIBSON girls dra

Eurostile Outline
HANG them high

Microgramma Outline
SHOUT LOUDLY

Fat Albert Outline
LIVES saved thanks

Stabile Outline
TRAIN for vacat

Blippo Outline
GRADE taken ron

Advertisers Gothic Outline
RADIO showsw

Columna Open
CRESCENT YAL

Erratick Outline
BUYING houses

Negrita Outline
POINT out benefits

Virile Open
FAVORITE art nouveau perio

Epitaph Open
WHITEWASHED ROOM

Mansard Outline
GREAT ARCHITECTS

Santa Claus Open
A FLYING REINDEER

Washington Antique Open
GREATEST SHOW

Davida Bold Outline
HOLIDAY DECORS

Weiss Bold Outline
QUIET holiday w

Farringdon Outline
FARRINGDON MACHINE

Alburtus Bold Outline
URBAN renewal ploy

Latin Wide Shaded (Vogue)
MUSIC soothes sava

Van Dyke
OPERA guild opens

Belwe Bold Shaded (Extra for overlapped shadows)
GAMES people play

Bubble Shadow
CHEWING gum sticks

Davida Bold Shaded
NEW YEAR PARTIE

Woodcut Shaded Initials
SHADED INITIAL

Cartoon Bold Shaded C
OCTOBER TRAVEL

Spartana Shaded
BLADES OF STEE

Anonymous Shadow
AESOP WAS FABULOUS IN

Aurelio Shadow
HOMES inspected

Eurostile Bold Shaded
PLAIN types are

Too Much Shadow
BUMP IN THE NIGH

Fat Albert Shadow
OVERLAND with noted

Bookman Bold Outline Swash
Fancy Letter Im

Bookman Bold Outline
DERBY hats wor

Times Roman Outline
STEAM trains play

Howland Open
STEAK and eggs over medium it

Menlo Outline
DENTIAL lots for sa

Clearface Roman Extrabold Outline
STERN task ma

Aster Bold Outline
PECAN santuar

Dominante Outline
DIGEST brings ord

Melior Bold Outline
PLUTO dog planet

Egyptian 505 Outline
PLATE silver wi

Cheltenham Outline
ROSES in bloom are w

Cheltenham Bold Condensed Outline
HOMINY served nightly w

Cheltenham Bold Extended Outline
GRAIN alcohol p

Stephania Outline
CARES all seem to

Cooper Black Italic Outline
HAREM tours dai

Cooper Black Outline
OFTEN used fo

Garamond Outline
BONDS male closer

Palatino Semibold Outline
FRESH garden veg

Baskerville Outline
IRATE taxpayer o

Goudy Bold Outline
HUMID weather

American Outline
PAUSE for a mom

Romana Outline
NAPOLI beckons wi

Egyptian Bold Condensed Outline
EVOKES memories fr

Lubalin Graph Outline
GOLD bricks sit

Craw Clarendon Outline
PLANT doctor

Beton Bold Outline
TYPES vary in heigh

Dare to be Different with Solotype!

INFORMATION ON SPECIAL EFFECTS STARTS ON PAGE 203

BLUE RIDGE RANGERS

NICHE

YOU ARE BEING WATCHED

NEW ORLEANS RAGTIME

PREHOLIDAY

COMING SOON

THE CIRCUS is coming to town!

RIVER PARK

GOT A QUESTION? GIVE A CALL.
PHONE (510) 531-0353 8 AM-4:30 PM
24-HOUR FAX LINE: (510) 531-6946

HIDDEN FLORIDA

SUNFLOWER SEEDS

W-R-RONG!

SPORTS KOOLERS

Here are a few ornaments to fill in the blanks!

GREAT TYPE!

Showboat

◆ ◆ ◆ ◆ ◆ ◆ ◆ ◆ ◆ ◆ ◆

Bellery Condensed
FRENCH character types

Coral Inline
DELIGHT the audience

Carolus
BERLINGS TYPE

Carolus Medium
QUESTION BOX

Conway
THINK OF SOLOTYPE

Cupola
GARDEN bowers for

Jason
SOUND SIMPLE MONEY-SAVING

Trio
FASHIONS in typography change

Paris Light
FALL PREVIEW SHOPPING DANCE

Paris Bold
FRENCH POODLE KISS ON FAT LIP

Wonderland
ALICE'S adventures in Wonderla

Marla
TOGA PARTY TONIGHT SHEETS OPTI

Extra Condensed Title No. 12
WHY DID THE CHICKEN CROSS THE ROAD?

Headletter No. 2 Keystone
MONEY SITUATION Rates Unfavorable to Stock Brok

Shadow
SCHOOL OF DESIGN II

Privat
Private Lives Shown

Robards
FORMER EXECUTIVES GATHER FORTY ACCOUNTS OUT OF

Thurston
PERFECT strings for max

University Roman
FRATERNAL brothers

University Roman Bold
SHOW cards from the

Greeting Monotone
METRO transit provid

Greeting Monotone Bold
BOLD version from

190 SOLOTYPE

CHECK WITH SOLOTYPE FIRST—WE MAY HAVE IT!

Albatross Medium
Albatross Demi Bold
Albatross Bold
Albatross Extra Bold
Albatross Heavy
Badger Light
Badger Medium
Badger Heavy
Baker Signet
Baker Signet Medium
Baker Signet Bold
Baker Signet Black
Brittany Extra Light
Brittany Light
Brittany Medium
Brittany Bold
Brittany Extra Bold
Callorte Light
Callorte Medium
Callorte Demi
Callorte Bold
Callorte Extra Bold

Casablanca Light
Casablanca Medium
Casablanca Bold
Continental
Continental Italic
Continental Black
Corinthian Light
Corinthian Medium
Corinthian Bold
Corinthian Bold Condensed
Corinthian Extra Bold
Crillee Light Italic
Crillee Italic
Crillee Extra Bold It.
Cursillo Light
Cursillo Medium
Cursillo Bold
Cursillo Extra Bold
Cursillo Black
Dynamo Medium
Dynamo
Dynamo Condensed

INDEX BEGINS ON PAGE 232

A GREAT CAST OF CHARACTERS AT SOLOTYPE

Delta Medium

Delta Bold

Erbar Light

Erbar Medium

Erbar Demi

Erbar Bold

Erbar Extra Bold

Eurocrat Regular

Eurocrat Medium

Eurocrat Bold

Express Light

Express Medium

Express Bold

Express Ex.B

Gill Sans Black N'veau

Glasgow Serial 1

Glasgow Serial 2

Glasgow Serial 3

Glasgow Serial 4

Glasgow Serial 5

Glasgow Serial 6

Glasgow Serial 7

Gotwick Sans

Granby Elephant Cond.

Granby Elephant Cd. It.

Granby Hippo

GREEN GRANBY

Guinness Demi Bold

Guinness Bold

JOCUNDA

Johnston Nouveau Light

Johnston Nouveau Med.

Johnston Nouveau Md. It.

Johnston Nouveau Med Cond.

Johnston Nouveau Bold

Johnston Nouveau Bd It.

Johnston Nouveau Bd Cd.

Litera Light

Litera Regular

Litera Medium

Litera Heavy

Montreal Serial 1

Montreal Serial 2

Montreal Serial 3

THOUSANDS MORE WHERE THESE CAME FROM

Montreal Serial 4

Montreal Serial 5

Montreal Serial 6

Montreal Serial 7

Optykos Light

Optykos Light Italic

Optykos Light Condensed

Optykos Light Cond. Italic

Optykos Bold

Optykos Bold Italic

Optykos Bold Condensed

Optykos Bold Cond. Italic

Pinto Lightline

Pinto Medium

Pinto Heavy

Placard Bold Condensed

Poppl Laudatio Light

Poppl Laudatio Regular

Poppl Laudatio Med

Poppl Laudatio Bold

Rivington Extra Light

Rivington Light

Rivington Regular

Rivington Medium

Rivington Bold

Ronda Light

Ronda Medium

Ronda Bold

Roslyn Gothic Medium

Roslyn Gothic Bold

Sally Mae Light

Sally Mae Medium

Sally Mae Demi

Sally Mae Heavy

Salzburg Serial 1

Salzburg Serial 2

Salzburg Serial 3

Salzburg Serial 4

Salzburg Serial 5

Salzburg Serial 6

Salzburg Serial 7

Treacle Light

Treacle Medium

Treacle Bold

INDEX BEGINS ON PAGE 232

WE MAKE HEADLINES EVERYDAY AT SOLOTYPE

Aachen Medium

Aachen Bold

Accolade Light

Accolade Light Italic

Accolade Medium

Accolade Bold

Andgear Light

Andgear Medium

Andgear Bold

Appleyard Regular

Appleyard Semi B

Appleyard Extra B

Argonaut Light

Argonaut Medium

Argonaut Bold

Argonaut Extra Bold

Artcraft Regular

Artcraft Medium

Artcraft Bold

Artcraft Black

Augustea Serif Medium

Augustea Serif Bold

Aurelio Light

Aurelio Medium

Aurelio Bold

Aurelio Extra Bold

Aurelio Black

Barcelona Book

Barcelona Medium

Barcelona Bold

Barcelona Heavy

Bauer Text Light

Bauer Text Regular

Bauer Text Medium

Bauer Text Demi

Bauer Text Bold

Bauer Text Ex. Bold

Bell Roman

Bell Roman Italic

Bellini Original

Bellini Semi Bold

Bellini Ex. Bold

GOT A QUESTION? GIVE A CALL.
PHONE (510) 531-0353 8 AM-4:30 PM
24-HOUR FAX LINE: (510) 531-6946

DON'T SEE IT? WE MAY HAVE IT ANYWAY!

Bramley Light
Bramley Medium
Bramley Bold
Bramley Bold Condensed
Bramley Extra Bold
Bridger Medium
Bridger Bold
Bridger Extra Bold
Bridger Black
Brighton Light
Brighton Light Italic
Brighton Medium
Brighton Bold
Britannia
Britannia Light
Britannia Medium
Britannia Demibold
British Light
British Medium
British Demibold
British Bold
British Extra Bold

British Black
Candida
Candida Italic
Candida Medium
Caxton Light
Caxton Light Italic
Caxton Book
Caxton Book Italic
Caxton Bold
Caxton Bold Italic
Caxton Bold Condensed
Caxton Extra Bold
Caxton Ex Bold It
Caxton Ex Bd Cond
Centaur Light
Centaur Regular
Centaur Medium
Centaur Bold
Centaur Extra Bold
Claridge Regular
Claridge Bold
Claridge Black

INDEX BEGINS ON PAGE 232

Clarion

Clarion Mini

Clarion Medium

Clarion Bold

Clarion Jumbo

Cochin Roman

Cochin Italic

Cochin Bold Roman

Cochin Bold Italic

Cochin Black Roman

Cochin Black Italic

Congress

Congress Italic

Congress Medium

Congress Bold

Congress Heavy

Denby Light

Denby Medium

DeRoos Bold

Detroit Light

Detroit Medium

Detroit Bold

Devinne

Diethelm Cursive

Eagle Light

Eagle Medium

Eagle Bold

Eagle Extra Bold

Eastern Souvenir Light

Eastern Souvenir Medium

Eastern Souvenir Bold

Edwardian Light

Edwardian Light Italic

Edwardian Medium

Edwardian Med. Italic

Edwardian Bold

Edwardian Bold Italic

Edwardian Ex Bold

Edwardian Ex Bd It

Ehrhardt

Ehrhardt Semibold

Ehrhardt Extra Bold

Ehrhardt Ultra

Elizabethan

Elizabethan Condensed

Elmont Light

Elmont Medium

Elmont **Bold**

Elmont **Extra Bold**

Embrionic 55

Embrionic 85

Erasmus Extra Bold

Ernesto Exeter

Falstaff

Fiesta Medium

Fiesta Medium Italic

Fiesta Bold

Fiesta Bold Italic

Flamenco

Flamenco Bold

Folkwang

Fournier Roman

Fournier Italic

Fry's Baskerville

Galliard Roman

Galliard Italic

Galliard Bold

Galliard Bold Italic

Galliard Black

Galliard Black Italic

Galliard Ultra

Galliard Ultra Italic

Gargoyle Regular

Gargoyle Italic

Garth Graphic

Garth Graphic Italic

Garth Graphic Condensed

Garth Graphic Bold

Garth Graphic Bold It.

Garth Graphic Bold Cond.

Garth Graphic Ex Bd

Gazebo

Goudy Italian Serial 1

Goudy Italian Serial 2

Goudy Italian Serial 3

Goudy Italian Serial 4

Goudy Italian Serial 5

Goudy Lavenham Bd

INDEX BEGINS ON PAGE 232

IF YOU DON'T SEE IT IN OUR CATALOG, ASK!

Goudy Super
Graphis Extra Bold
Grassmere Extra Light
Grassmere Light
Grassmere Medium
Grassmere Heavy
Hadfield
Henrietta Medium
Henrietta Bold
Henrietta Bold Condensed
Horley Old Style
Horley O.S. Medium
Horley O.S. Bold
Hotspur Light
Hotspur Medium
Hotspur Bold
Hotspur Extra Bold
Imprint
Imprint Italic
Imprint Bold
Italian O.S. Bold
Italian O.S. Extra Bold

Italian O.S. Ultra Bold
Jaeger Antiqua Light
Jaeger Antiqua Reg
Jaeger Antiqua Bold
Jaeger Antiqua Ex B
Jersey Regular
Jersey Medium
Jersey Bold
Jersey Extra Bold
Joanna
Joanna Italic
Joanna Medium
Joanna Bold
Joanna Extra Bold
Lavenum Goudy Light
Lavenum G Bold
Lavenum G Ex Bd
Leamington
Leamington Italic
Leamington Medium
Leamington Bold
Leamington Black

Lectura

Lectura Bold

Lothario

Lothario Medium

Lothario Bold

Lothario Extra Bold

Lothario Ultra Bold

Lynton Light

Madison Antiqua Light Cond.

Madison Antiqua Med Cond

Madison Antiqua B

Minster Medium

Minster Bold

Minster Extra Bold

Minster Medium Condensed

Minster Bold Condensed

Minster Extra Bold Cd

Monkton Regular

Monkton Medium

Monkton Bold

Monkton Medium Italic

Monkton Bold Italic

Nantucket Light

Nantucket Medium

Nantucket Bold

Nantucket Black

Nevada Serial 1

Nevada Serial 2

Nevada Serial 3

Nevada Serial 4

Nevada Serial 5

Nevada Serial 6

Nevada Serial 7

Omega

Omega Demibold

Omega Bold

Omega Extra Bold

Omega Ultra Bold

Packhard Light Packhard

Paddington

Palana

Penman Light

Penman Medium

Penman Bold

INDEX BEGINS ON PAGE 232

Pilgrim Serial 1
Pilgrim Serial 2
Pilgrim Serial 3
Pilgrim Serial 4
Pilgrim Serial 5
Plantin 110
Plantin 110 Condensed
Plantin 110 Cond. Italic
Plantin Bold Condensed
Pontecorvo Light
Pontecorvo Light Italic
Pontecorvo Bold
Pontecorvo Bold Italic
Pontecorvo Bold Condensed
Pontecorvo Bold Cond Italic
Poppl Laudatio Bold Cd
Poppl College 1 Regular
Poppl College 1 Medium
Poppl College 1 Bold
Poppl College 2 Regular
Poppl College 2 Medium
Poppl College 2 Bold

Poppl Pontifex
Poppl Pontifex Italic
Poppl-Pontifex Med
Poppl-Pontifex Med Cd
Poppl-Pontifex Bold
Proteus Light
Proteus Medium
Proteus Bold
Proteus Ex Bold
Quadriga Regular
Quadriga Medium
Quadriga Bold
Quadriga Extra Bold
Raleigh Light
Raleigh
Raleigh Medium
Raleigh Demibold
Raleigh Bold
Raleigh Extra Bold
Range Solid
Rio Grande Light
Rio Grande

HUNTING FOR HARD-TO-FIND TYPE? CALL SOLOTYPE!

Rockwell Light

Rockwell Light Italic

Rockwell Medium

Rockwell Medium Italic

Rockwell Bold

Rockwell Bold Italic

Rockwell Extrabd

Rockwell Medium Condensed

Rockwell Bold Condensed

Salisbury Bold

SAXON SOLID

Schneidler Old Style

Schneidler O.S. Bold

Seagull Light

Seagull Medium

Seagull Bold

Seagull Black

Seneca Regular

Seneca Italic

Seneca Medium

Seneca Bold

Seneca Extra Bold

Shelley

Sherborne, Light

Sherborne, Medium

Sherborne Bold

Sterling Light

Stratford

Stratford Italic

Stratford Bold

Stratford Black

Tempo Heavy Condensed

Tempo Black Condensed

Tempo Black

Titus Light

Titus Medium

Vendome

Vendome Italic

Vendome Condensed

Vendome Bold

Vendome Bold Italic

Vendome Black

 GOT A QUESTION? GIVE A CALL.
PHONE (510) 531-0353 8 AM-4:30 PM
24-HOUR FAX LINE: (510) 531-6946

Verona
Verona Italic
Verona Bold
Verona Extra Bold
Veronese
Veronese Semibold
Veronese Bold
Walbaum
Wandsworth
Wandsworth Bold
Wandsworth Bold Cond
Warlock Medium
Warlock Heavy
Warlock Ultra
Williams Sans Medium
Westin Light
Westin Regular
Westin Bold
Worcester Round
Worcester Round Italic
Worcester Round Medium
Worcester Round Bold

Clova
Clova Medium
Clova Heavy
Column Book
Column Italic w/Swash
Comenius Light
Comenius Light Italic
Comenius Medium
Comenius Bold
Gatting Medium
Gatting Semi Bold
Gatting Bold
Jugenstil
Knightsbridge
LATIMER TITLING
LEPRECAUN
Murrpoint
Obliq Light
Obliq Medium
Rialto
Springfield Bold
WEISSACH

INDEX BEGINS ON PAGE 232

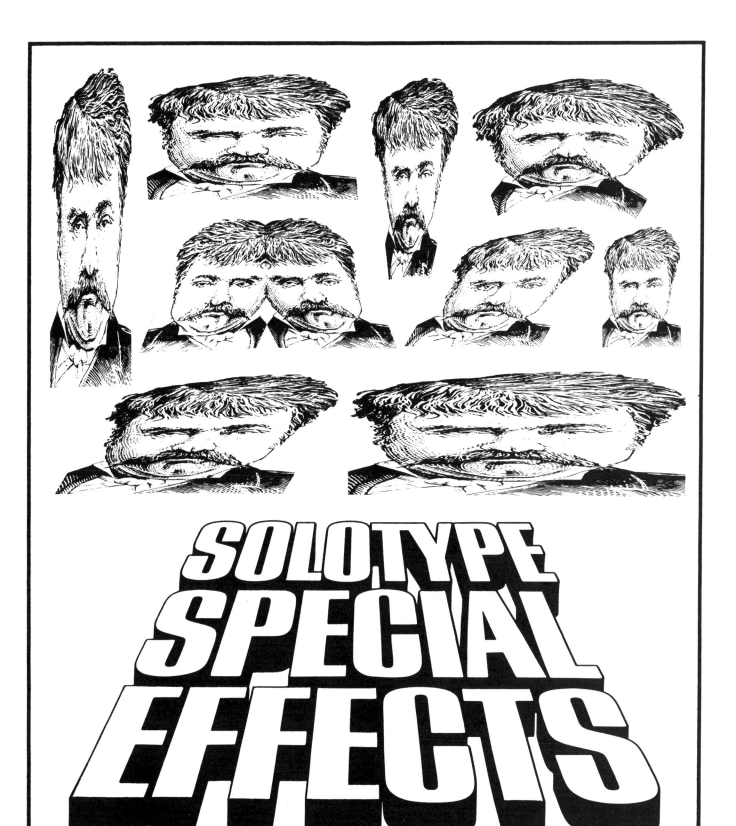

SOLOTYPE SPECIAL EFFECTS

A Catalog of Type Tricks for Graphic Designers

STOCK SERPENTINE CURVES

A SOLOTYPE KNOWS HOW!

B SOLOTYPE KNOWS HOW!

C SOLOTYPE KNOWS HOW!

D SOLOTYPE KNOWS HOW!

E SOLOTYPE KNOWS HOW!

F SOLOTYPE KNOWS HOW!

G SOLOTYPE KNOWS HOW!

H SOLOTYPE KNOWS HOW!

I SOLOTYPE KNOWS HOW!

J SOLOTYPE KNOWS HOW!

K SOLOTYPE KNOWS HOW!

L SOLOTYPE KNOWS HOW!

M SOLOTYPE KNOWS HOW!

N SOLOTYPE KNOWS HOW!

O SOLOTYPE KNOWS HOW!

P SOLOTYPE KNOWS HOW!

Q SOLOTYPE KNOWS HOW!

R SOLOTYPE KNOWS HOW!

S SOLOTYPE KNOWS HOW!

T SOLOTYPE KNOWS HOW!

Plumb curves are plumb useful

Plumb curves are so called because the vertical strokes of the letter remain vertical, or plumb, while the horizontal strokes faithfully follow the curve. Notice that in our process all letters retain their original width and never look pinched. We have standard arcs of every radius, plus the special serpentine shapes shown at the left. Custom curves following your layout can also be provided where no standard curve will fit. (No extra charge, but allow an extra day.) Although any curve is theoretically possible, extremely small radius curves may distort some of the lettering to an undesirable degree.

Some examples of customers' ideas brought to life

1

A small radius gives the illusion of smaller letters at the ends.

4

This curve was so extreme we had to cut a custom cam for our equipment.

2

The lower line was done as a mirror image curve of the upper line.

5

This was a custom curve to tuck up under an arch on the layout.

AMERICA'S FAVORITE
FOR OVER 50 YEARS

3

Each line of a multi-lined curve will match the others perfectly.

DOUBLE AGED
FOR EXTRA SMOOTHNESS

6

Note that this effect is produced with two entirely different curves.

Waving the flag

An entire copy block can be curved at one time for the one price, giving great opportunities to do something different with the layout. Note how easily the straight copy was prepared for the waving flag at the right.

When money's tight,
Levi's could be just the
bait you need.

7 Tight money doesn't stop women from buying clothes. But it does turn their attention from frills to basics. They're looking for value. Basic styles. Solid construction. Which is exactly what Levi's does best. Classic jeans, shirts and jackets built to last an extra season. Which is probably why Levi's has always outsold the market when times got hard. And why we expect our newest lines to sell out fast. Buy the name your customer trusts. It's the best lure you can get.

When your customers are looking for value,
you should be looking to Levi's.

8

Here's how others use plumb curves

Plumb curves are easy to use, always attractive, and a virtual necessity in much label work. The examples below only hint at the possibilities. We've always like the enlarged end letters ("Spudkins"), and usually paste them on after curving the rest of the line. The word "Naturals" at the bottom was first treated as an Elastograph to swell out the ends. Tricks, tricks, tricks.

LEVI STRAUSS & CO.
9

MADE BY GRANNY GOOSE
100% NATURAL
10

BankAmericard
11

12

13

14

Arcs and Dips

Curves of any radius are possible, though exceptionally small radii may not produce a pleasing result. Shown here are the most popular.

AA
SOLOTYPE KNOWS HOW!

BB
SOLOTYPE KNOWS HOW!

CC
SOLOTYPE KNOWS HOW!

DD
SOLOTYPE KNOWS HOW!

EE
SOLOTYPE KNOWS HOW!

FF
SOLOTYPE KNOWS HOW!

GG
SOLOTYPE KNOWS HOW!

HH
SOLOTYPE KNOWS HOW!

JJ
SOLOTYPE KNOWS HOW!

Any curve can be flopped to give the exact opposite curve. Thus, the curves above will also produce dips.

We can save you money

When ordering plumb curves, you may include as many lines of type as will fit in a space 80% as deep as the lines are long. If the lines are 10 inches long, for instance, you can stack up 8 inches worth of lines. Remember, though, lines must be perfectly centered if they're not all the same length. Lines placed upside down will give the exact opposite curve.

SEE US AT THE SHOW
LIMITED TIME OFFER
SA
GIF

SEE US AT THE SHOW
LIMITED TIME OFFER
SALE·SALE·SALE
GIFT GIVING SPECIALS

Fan-tastic curves for a tighter look

The advantage of fan curves over type assembled by hand on a curved baseline is the tighter, more cohesive look of the line. Each letter becomes a wedge, with vertical strokes aligned along the radials, and the horizontal strokes following the curve. This eliminates the excess space that otherwise would occur between letters, and lets the line flow smoothly. Curves may be arcs, dips or serpentine of any radius, just so long as they are segments of a circle.

In an arc of large radius like the one above, the wedge-shaped distortion is barely discernable. Arcs of smaller radius produce considerable distortion, as in the "Triumphal Arches" heading on this page. Outer lines will become wider, inner lines narrower, as necessary to fill the space.

Line art of any kind can be curved with surprisingly good results, lending itself to unusual, eye-catching layouts.

Got a question? Give a call: (510) 531-0353.
Fax: (510) 531-6946.

We do fan curves of any radius

The examples below illustrate a variety of ways in which our customers have used fan curves. We thought the curved coupon was an interesting idea. Not sure just how the public reacted to it though. "Salsa Flammante!" took advantage of the top-weighted design of a type called Japanette.

BAY TO BREAKERS
1

THE RISE & FALL OF THE MOUSTACHE
2

NAME _____ AGE
ADDRESS _____
CITY _____
STATE _____ ZIP
3

INGREDIENTS: CULTURED GRADE A PASTEURIZED MILK AND CREAM, WATER, NONFAT MILK, SUGAR, CHERRIES, CORN SYRUP, MODIFIED CORN STARCH, PRESERVED WITH 1/10 OF 1% OF POTASSIUM SORBATE AND SODIUM BENZOATE. NATURAL FLAVORS, GELATIN, ARTIFICIAL COLOR, CITRIC ACID, SALT, ARTIFICIAL FLAVOR, SODIUM METAPHOSPHATE (A WHIPPING AGENT) © 1979 MANUFACTURED BY KNUDSEN CORP., LOS ANGELES, CA 90011
4

¡SALSA FLAMMANTE!
5

RETURN COUPON NOW!

RETURN COUPON NOW!
6

206 SOLOTYPE

A

B

C

Fan curves to fit tapered containers

If you've ever tried to prepare curved art work to fit a tapered container, you know how tough it can be. An easier approach is to assemble the art to the correct width and length, and leave the curving to us. We'll need to know the radius (measured at the center of the package, top to bottom). See "Finding the Radius," below right. Accuracy is essential. If you don't want to deal with measuring the package, send it to us and we'll do it for you.

How to prepare your copy

Measure the length of the label area around the top-to-bottom center point of the package. Then measure the depth of the label area. Your pasteup should fit that area. Do not make any allowances for curvature. Our magicians will take care of everything.

Finding the radius

The only safe way to check the radius is to cut a piece of paper to fit. Measure the curve or send us the paper.

D

Package Art

These are cylindrical perspectives made to fit into existing line drawings of packages. Send us a label or pasteup and a photocopy of the art to be filled.

LOOKING
UP

LOOKING
HEAD ON

LOOKING
DOWN

Wrap your dreams around a cylinder

The important feature of the wraparound look, aside from the curvature, is the diminished width of the lettering at the edges. Extremely lightweight types are not recommended for this treatment, as the end letters may disappear entirely.

Cylinder wraparounds, the long way

F

THAT'S A WRAP!

G

E

There are many imaginative ways cylinder wraparounds can be used. Think of them as lettering on a stick of dynamite, a bottle of bourbon or a can of anything. Solotype can make it happen.

Damned if you do, damned if you don't

There are only two methods to choose from when putting type into a circle, and yet the choice is often a tough one.

A photo circle distorts the type, making each letter wedge-shaped, and giving a tighter, smoother appearance to the job. But if the diameter is small and the type is wide, the distortion of the letters is quite obvious.

A studio circle, which imitates what you might do by pasting the letters around a curved baseline, leaves the letters undistorted, but gives the line a loose look. If the type is wide or the diameter small, there is a noticeable roughness to the effect.

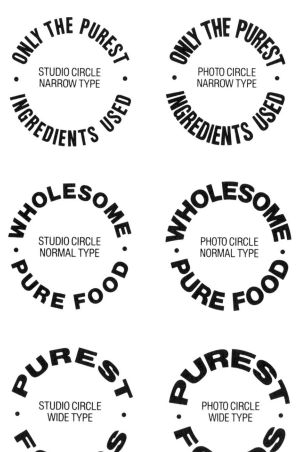

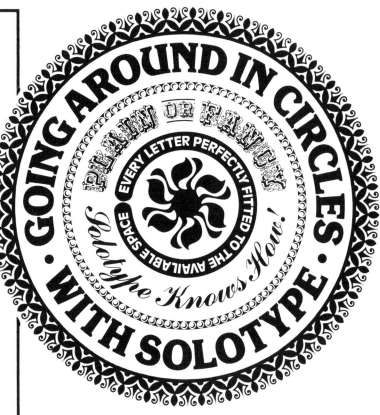

Perfect circles every time

A good photo circle is a joy to behold. Each letter is perfectly fitted to the wedge-shaped space allotted to it. We can work from your type, or from type we set, though if a great deal of small type is involved it will probably be more cost effective for you to supply it. We can add any combination of concentric rules at remarkably small cost.

How do you want to break your copy?

When you want to specify the starting and stopping point of a line of type on a circle, referring to numbers on the clock can be a handy way. Want your line of type to start at nine, go over the top, and end at three? 'Nuff said.

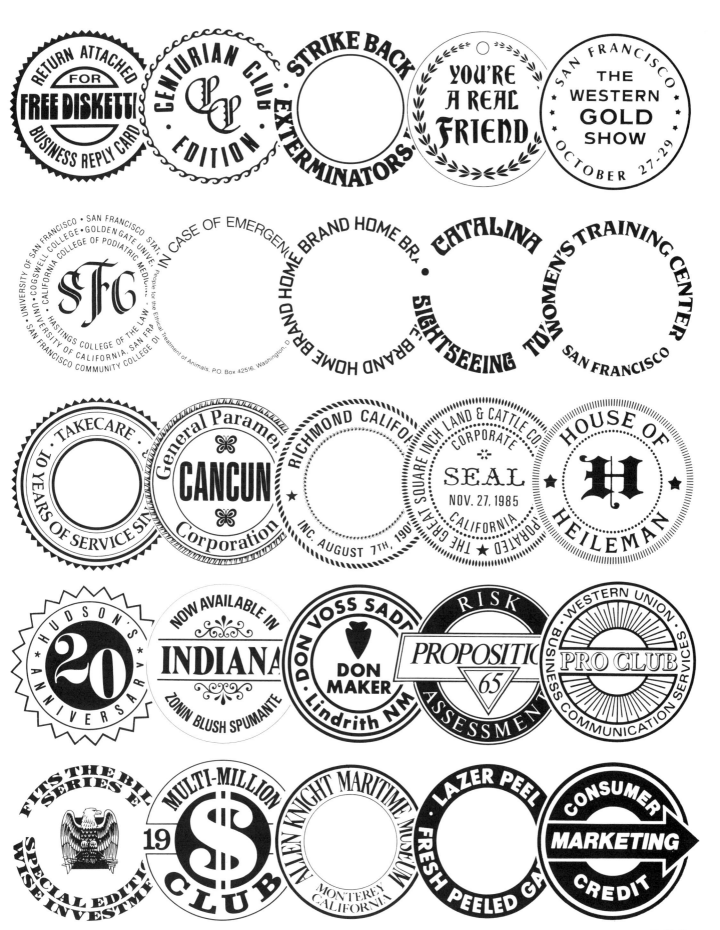

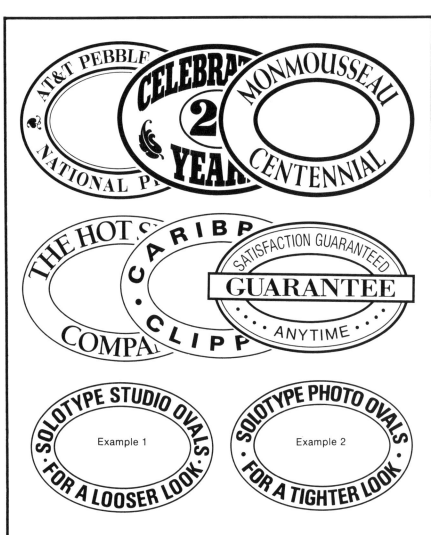

Typographic ovals

Setting type to fit an oval is more difficult than setting it to fit a circle. Takes longer, costs more. Ovals may be specified by the degrees marked on standard templates, or by giving us the height and width. Preparing concentric oval borders can be quite costly, so talk to us before ordering.

Soloflex ovals

These are simply photo circles of the type that have been squeezed into ellipses. Any amount of squeeze is possible. The type becomes narrower across the short axis of the oval, adding a surprise dimension to the job. (But, then, perhaps you'd rather not be surprised.)

Eccentric sphere

Here's a cute trick. (The type, not the girl!) We ran the type as a photo circle, then treated it as an off-center sphere. Must have sold at least two of these in the last quarter century.

SPHEROIDS are spheres that have been extended or condensed in a separate operation.

OVERALL PATTERNS work well because we take pains to center the design elements carefully.

TOTAL COVERAGE of a sphere is the result of totally filling the circular area when setting type.

Here are some swell ideas...

In the examples below, the typesetting on the left produced the results on the right. Note that complete coverage of the sphere requires typesetting that completely fills a circular area. All caps carries the effect better than caps and lowercase.

A single line becomes a swelled line.

THE NEW SOLOTYPE SPECIAL EFFECTS CATALOG *THE NEW SOLOTYPE SPECIAL EFFECTS CATALOG* G

Fill the circle to cover the sphere.

SOLOTYPE SPECIAL EFFECTS CATALOG *SOLOTYPE SPECIAL EFFECTS CATALOG* H

A square of type gives you a barrel effect.

Solotype Special Effects *Solotype Special Effects* J

Scripts and slopes don't work very well.

K

Overall patterns are a cinch to prepare.

L

THERE'S SOMETHING FISH·EYE GOING ON HERE!

Get on the ball with Solospheres

Spheres are produced with the aid of an uncommonly short focal length lens ground with slight aspheric distortion to heighten the effect. Proper copy preparation is essential. If the entire sphere is to be covered with type, the type must fill an equivalent circle. This may mean changing the wording or varying the type size on a different line.

Use these graphs to design your own sphere

A layout on the left can be copied to the right, giving a fairly good idea of what the sphere will look like.

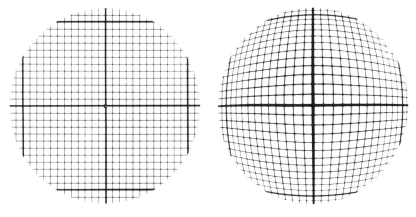

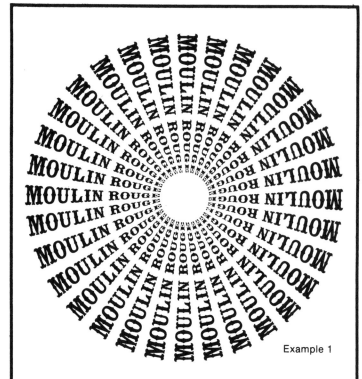

Example 1

The windmill effect

This is a nice effect achieved through a combination of techniques. First we taper the type with a Soloflex straight taper (see right), then we step-print it on our circular step-and-repeat machine. (Not many of those around!) The result is an effective, almost irresistable design.

The vortex effect

This is the windmill made with a curved taper instead of a straight one. Same price, different effect. Lines can curve in either direction.

TYPE: We recommend all caps, but do as you please.

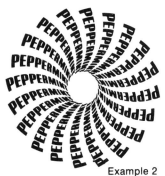

Example 2

Perpendicular fan curve

This is the standard fan curve with the type placed perpendicular to the curve, rather than sitting firmly on it. Curve can be any radius, with type any size you specify. When designing, think of each line of type as the spoke of a wheel.

Perspectives and tapers

Good perspectives are the product of long experience, good typographic judgment and highly specialized equipment. The process is time-consuming, and therefore costly. We are always happy to quote firm prices on specific work.

As with all our special effects, we do this work the old way, optically, because we believe it is the best way. On the next three pages we show typical examples of perspectives selected from the many hundreds that we have done.

When other special effects are combined with perspectives (outlines, shadows, shading, etc.) it is often necessary to do these separately after the perspective is completed.

SOLOTYPE DOES PERSPECTIVES THE RIGHT WAY =

The example above is a perspective as it would be handled by a typical photo copy service. Letters at the small end are pinched and hard to read, color balance is bad.

SOLOTYPE DOES PERSPECTIVES THE RIGHT WAY =

At Solotype, we first modify the copy by a process called "alterizing," so that in the final perspective color balance is even and readability is improved.

Good perspectives are a vanishing art

We do this work the old way—optically—which we think is the only way.

HOUSE SHARKS

ADVENTURES IN THE COMPILER LIBRARY

BIG 2-DAY SALE

Human history is, in essence, a history of ideas—and vision. In all areas of human endeavor it has been vision—both individual and collective—that has tested the limits of our reality, expanded the boundaries of our imagination, and challenged our assumptions of what is possible.

What is vision? It is simple and clear, but compelling and in-spiring. It is challenging, and invariably focused on excellence. It is the picture of where we as individuals or as a company are headed, and the beacon that guides us to the future we want to create.

Above all, vision is our license to dare to be different and better. It is the dream that moves us individually and as an organization to the highest levels of performance.

At Citicorp Savings, our vision is to be the best financial organization in California. How? By being the best place to work and the best place to bank.

LEGENDS

BLIND BLIND

THE MANUFACTURERS EQUIPMENT COMPANY

BLITZ WEINHARD BREWING

PERSPECTIVE $ ON THE ECONOMY

THE SECRET TO DETECTING STOCK MARKET TURNS

GOT A QUESTION? GIVE A CALL.
PHONE (510) 531-0353 8 AM-4:30 PM
24-HOUR FAX LINE: (510) 531-6946

TIME LIFE VIDEO

Peterbilt Parts

Peterbilt Service

GALAXY FORCE

Solotype perspectives are made optically

Good perspectives take time—please allow plenty.

TOP COPS

100 %
SATISFACTION
GUARANTEED
IN WRITING

AMAZING
MARLBORO
MUSIC
VIDEO

COUPON COUNTRY

PREMIUMS

HEARTWARD
Homes where the heart is...

ROBIN
has LANded

Curvacious typography from Solotype

We're always glad to quote prices—give us a call.

X from OUTER SPACE

YOU, TOO, CAN MAKE MILLIONS WRITING TABLOID HEADLINES!

THE BEST OF CRIME & DETECTIVE

The True Story of Hollywood's Most Shocking Crime
The Murder of Thelma Todd

THE SAVEUS AVIS TEAM

RUMOR OF AN ELEPHANT

LONG FLY BALL

TRIPLE ROCK

DEAD PAN ALLEY!

I'M A CHEERLEADER
OFFICIAL DRESS SET

Gilding the Lily

Elastographs must start out as solid lettering. Once the curve is produced, however, it can be given any of our usual cosmetic treatments.

A

OUTLINING an Elastograph gives you an opportunity to fill in with color. Most of the shadow effects can be applied too.

B

CONTOURING is a good effect to add when designing a logo. Case contours tie the entire word together.

C

SHADOWS seem like a natural for logo work. The vanishing-point shadow shown here works quite well.

The basic shapes

EL-1 ELASTOGRAPHS	EL-10 ELASTOGRAPHS
EL-2 ELASTOGRAPHS	EL-17 ELASTOGRAPHS
EL-3 ELASTOGRAPHS	**Double Curve Elastographs:**
EL-4 ELASTOGRAPHS	EL-11 ELASTOGRAPHS
EL-5 ELASTOGRAPHS	EL-12 ELASTOGRAPHS
EL-6 ELASTOGRAPHS	EL-13 ELASTOGRAPHS
EL-7 ELASTOGRAPHS	EL-14 ELASTOGRAPHS
EL-8 ELASTOGRAPHS	EL-15 ELASTOGRAPHS
EL-9 ELASTOGRAPHS	EL-16 ELASTOGRAPHS

Other shapes are possible.

SOLOTYPE ELASTOGRAPHS

There are two secrets to producing good looking Elastographs: Pre-distort the type on a letter-by-letter basis so the final product will be even in color; and secondly, don't attempt the impossible. We are often sent roughs in which letters have been left out. If you can't work it out in pencil, we probably can't do it in type. Remember, all Elastographs are made from solid type. Any outlines or shading must be added later.

TEAMWORK TEAMWORK

JOE BOXER BATMAN

HANDBONE CALIFORNIA

GRATEFUL DEAD

CHAMPIONS THE WATCHED POT NEVER BOILS

WESTERN DAYS

UNDERWEAR BRIDGES

Elastographs are a swell design tool

BIG BUSTER
The Original
ATTENTION-GETTER

VYNL★FLEX

JULY JAMBOREE

BePrepared

ADVENTURES

GREAT
TASTING
GRAINS

BINGO PARLOR

CONTROVERSIAL Games, Inc.

TERRIFIC

SUPERBURGER
THE HEAVYWEIGHT CHAMP

PRODUCTIONS

VALENTINE'S DAY

SQUEEZE

JOE BOXER

FREEDOM

ROYAL

BALLGAME!

Everything you need to know about

INLINES, ONLINES AND OUTLINES

Any solid lettering or design can be photo-converted to an outline of any weight, or to an inline or online of appropriate weight.

AN INLINE follows the inside edge of the letter. Thin strokes will close up. Outside corners remain sharp, inside corners are rounded. Works well on bold types, poorly on lighter ones.

AN ONLINE follows the edge of the letter partly inside and partly outside. Thin strokes may close. Inside and outside corners are both rounded, but to a lesser degree than on inlines and outlines.

AN OUTLINE follows the outside edge of the letter. All strokes remain open. Outside corners are rounded, inside corners remain sharp. Lettering should be spaced to allow for the outline.

Solotype Solotype Solotype Solotype

How to order outlines

First, read the column at the left and look at the examples below to determine what you need. Ordinary lightweight outlines like these usually look better if the letters are spaced so the outlines don't touch or run together. If you are going to fill in with color, we can make a color trapping spread overlay at the same time we make the outline for half the outline price.

EXAMPLES OF INLINES

Solotype Solotype Solotype Solotype

EXAMPLES OF ONLINES

Solotype Solotype Solotype Solotype

EXAMPLES OF OUTLINES

Solotype Solotype Solotype Solotype

DESIGNS can be inlined, onlined or outlined just as easily as lettering.

Fat Outlines At Thin Prices

Fat outlines are a big help

No matter what the type, fat outlines seem to give it a designer look. These are always made around the outside of the letter so the lines run together. Perfect for logos and dramatic headlines. We can't think of any problems to warn you about. Fat outlines are one of the easiest-to-use design tools we offer. You can specify the line weight you want, or choose the effect you want from the examples.

Example 1

Example 2

Example 3

Example 4

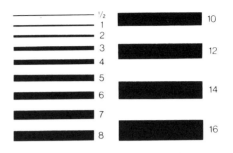

How to space your type

For fat outlines you space the type normally. For thin ones, when you don't want the letters to run together, you must space the type accurately according to this formula: Space equals two times the line weight, plus the desired white space. (If you don't want to deal with this, perhaps we should set the type.)

Outlines

TABLE OF LINE WEIGHTS

½
1
2
3
4
5
6
7
8

10
12
14
16

Heavier weights as necessary.

RELATIVE OUTLINE WEIGHTS

A Solotype!
B Solotype!
C Solotype!
D Solotype!
E Solotype!
F Solotype!
G Solotype!
H Solotype!
J Solotype!

Solotype!
Solotype!

a = a
a = a

GARBAGE IN, GARBAGE OUT!

In today's world of desktop publishing, we see a lot of type that is less than perfect. Rough edges will reproduce in all of our optical processes. Since you are paying us to do a good job, we urge you to start with good type.

Example 1

Case Contours

Example 2

Case Contours

Case contours tie it all together

One of our production people said it best: "Everything looks better with a contour line around it." Just about. A contour line differs from an outline in that it is spaced away from the letter. The letter remains solid, and the white space between the letter and the contour can be any amount desired. The weight of contour can be as heavy as you like. Thin contours are sometimes used as die lines for cutting. We can furnish the contour separate from the lettering on an overlay at no extra charge. Just ask. If you need square corners on your contour, see "Squaring the Corners" on page 221.)

Your lettering, our contours

Drawing good contours is one of the most time-consuming studio jobs we know of. Why do it? Let us put a perfect line around your lettering, free from heartbeats and white paint. If time is money, then this is a bargain.

Our customers do beautiful lettering. We do beautiful contours.

CHAMPS

CHAMPS

Separate or together?

When a contour encases all the letters in one clump, we call it a "case contour." When each letter is contoured without joining its neighbor, it is said to be "individually contoured." Individually contoured letters must be spaced with great accuracy. Sometimes it is easier to space them very loosely, contour them, then cut them together at the drawing board.

TORTIES

TORTIES

TORTIES

Separated for color

When we make the contour it is separate from the lettering, so it's no problem to give them to you separately instead of combined. You have to ask for it that way, however, as normally we print them together in place on one sheet. (If you'd like both, separate and together to expand your choices, the extra cost is the cost of a stat.)

Heavy contours

This is a great design tool for high impact headlines, as well as certain kinds of logo work. Remember, we can make the white space and the contour line as thick as you would like.

You're surrounded!

Solotype case contours

Below are a few examples of our day-to-day contouring. The packaging field in particular seems to like what we do.

1 ORIGINAL SHOESTRING POTATOES

2 SPORTS ALMANAC

3 FISH

E E

Squaring the corners

The outlining and contouring process always rounds the corners. Usually this is quite acceptable, and sometimes—as in the case of Fat Outlines—is desirable. If, however, your project requires outlines with square corners, the only answer is retouching at the drawing board. We've learned a few tricks about this, and it goes pretty fast. Give a call if you'd like to discuss it.

4 COLOR-STIKS

5 Otis Spunkmeyer

6 DRINK BLITZ

Multiple contours

Presumably there is no limit to the number of contours that can be added to a line of lettering or a design. All it takes is money. Each contour must be added as a separate operation. In the "Color-Stiks" example the round corners that naturally occur were left as part of the design, but in the "Blitz" headline, the corners were squared at the drawing board.

7 The Grapevine

10 Hearts

8 National Institute

9 Muir Station Office Park

11 Red Raspberries

Contours with shadows

Here's another great effect if you want to make ordinary type look extraordinary. Any type becomes an instant logo when you add a contour with a shadow. Most shadows are to the right and bottom, but there's no law saying that you have to do it that way. The white space between the type and the contour can be as much or as little as you like, and the shadow can be of any depth or direction. Several lines can be done on one sheet for the one price, but all will have the same amount of shadow.

Solotype Shadows and Shading

With our facilities and techniques we can produce almost any combination of lines and shadows, breaking them up onto overlays for color if required. Send us a copy of your layout or a sketch of the general effect, and be amazed.

SOLOTYPE

The sundown shadow

This is another somewhat more costly effect than most. We reproportion the type, angle it, flop it, screen it, and finally combine everything on one stat.

REFLECTIONS
in Rhythm

Reflections

The idea of reflecting type in water comes up from time to time. This is one answer. Like the "Sundown shadow" above, it requires several steps to achieve. The depth and direction of the reflection is totally controllable.

Original

SOLOTYPE EFFECTS

Invisible Letter Shadow

SOLOTYPE EFFECTS

Full Shadow Below (See page 223 for ANGLE and DEPTH)

SOLOTYPE EFFECTS

Full Shadow Above (See page 223 for ANGLE and DEPTH)

SOLOTYPE EFFECTS

Hard-edge Shaded Type

SOLOTYPE EFFECTS

Graduated Internal Screen

SOLOTYPE EFFECTS

Two-way Shadow

SOLOTYPE EFFECTS

Heavy Detached Shadow

SOLOTYPE EFFECTS

Sundown Shadow

SOLOTYPE EFFECTS

Solid Offset Shadow (Above or below, any angle)

SOLOTYPE EFFECTS

Outline-on-Outline Offset Shadow

SOLOTYPE EFFECTS

Lazy Shadow

SOLOTYPE EFFECTS

Top-and-Bottom Shadow

SOLOTYPE EFFECTS

Outline Offset Shadow (Above or below, any angle)

SOLOTYPE EFFECTS

Fineline Detached Shadow

SOLOTYPE EFFECTS

Vanishing Point Shadow

SOLOTYPE EFFECTS

Prismatic Shadow

SOLOTYPE EFFECTS

Retrograde Shadow

SOLOTYPE EFFECTS

ANGLE OF SHADOW

A ANGLE B ANGLE

C ANGLE D ANGLE

E ANGLE F ANGLE

G ANGLE H ANGLE

RELATIVE DEPTH OF SHADOW

Solotype!

Example 2

Solotype!

Example 3

Solotype!

Example 4

Solotype!

Example 5

Solotype!

Greater depths available.

VULCAN FORGE AND MACHINE CO.
OF SAN JOSE, INC.

The American Gold Standard

FIRST NATIONAL BANK OF OBAN

THE CIRCUS CLUB OF AMERICA

Church Organists Guild

Solotype
Banknote
Shading
makes you
look rich,
rich, rich!

Some shady deals from Solotype

SOLOTYPE

ORANGE

SWEETS

HOLLYWOOD

H. WEINHARD

Gold Effect

Wax Effect

Bronze Effect

Stainless Effect

Solotype bas reliefs:

It's the old *trompe-l'oeil* trick: Place some screens out of register to produce highlights, give them shadow, and fool the eye into thinking it sees a third dimension. It's a good way to add color to a job without actually adding color. The screens we use are coarse enough to reproduce well as line art at 100%. We recommend that all bas reliefs be produced at or near the size they will ultimately be used.

When ordering, specify style by screen names above: Gold, wax, bronze, stainless.

How to prepare your copy

Medium to bold weights of type are recommended, as light weight types don't produce the illusion. Set normal or loose, not tight. A border is absolutely necessary. Use bold, simplified art elements, as high detail will not carry the effect properly.

The look of a carved sign

It's the bas relief trick again, but this time using screens made from actual pieces of wood. The effect is heightened by using appropriate type faces (bold with blunt, rounded serifs, or anything bold with a hand-carved look). The irregular border in "Hawaiian Crafts" is a nice touch.

This original was used to produce the bas relief plaque at the left.

WOOD CARVING EXHIBIT

October 8-10

GOT A QUESTION? GIVE A CALL.
PHONE (510) 531-0353 8 AM-4:30 PM
24-HOUR FAX LINE: (510) 531-6946

Complete layouts of art and type can be sloped, but certain design elements may be adversely affected. In the diagram above, the circle becomes an oval and the rectangle becomes a rhomboid. If this matters, perhaps the original undistorted art can be cut in to the modified layout.

EXAMPLES OF ITALIC SLOPES 1 TO 30 DEGREES OFF THE VERTICAL.

CHAMPION 1° *CHAMPION* 16°
CHAMPION 2° *CHAMPION* 17°
CHAMPION 3° *CHAMPION* 18°
CHAMPION 4° *CHAMPION* 19°
CHAMPION 5° *CHAMPION* 20°
CHAMPION 6° *CHAMPION* 21°
CHAMPION 7° *CHAMPION* 22°
CHAMPION 8° *CHAMPION* 23°
CHAMPION 9° *CHAMPION* 24°
CHAMPION 10° *CHAMPION* 25°
CHAMPION 11° *CHAMPION* 26°
CHAMPION 12° *CHAMPION* 27°
CHAMPION 13° *CHAMPION* 28°
CHAMPION 14° *CHAMPION* 29°
CHAMPION 15° *CHAMPION* 30°

Working the angles

A word or phrase can be sloped both left and right, then cut and assembled on the drawing board to form the angle effects shown above. The examples are all produced with a 30° slope. Both slopes–italic and contra-italic–can be produced for just one-and-one-half times the price of a single slope.

The weight shift mystery

Every process used for sloping type—optical or electronic—introduces an odd shift in the weight of the lettering. This is particularly noticeable in the diagonal strokes, as in the cap R shown here. The weight shift is usually acceptable in slopes to 30°, but may be objectionable beyond that point. Sometimes simple retouching will solve the problem.

Sloped headlines

Standard italic slopes of 12° can be made at the time we set the type at no additional charge. Greater (or lesser) slopes must be produced by a separate optical process. Slopes to 30° give good animation to a headline. Beyond that distortion of letterforms might be undesirable.

Get a new slant on things
Get a new slant on things
Get a new slant on things
Get a new slant on things

Precision italic slopes

If you were to ask us just how precise "precision" is, we'd have to say "right on." There's nothing worse than sloping a line to fit an angled space, then finding it to be a degree or two off. At Solotype we've got equipment to do this job right. If you provide us with accurate specifications, you get accurate slopes.

Want to try several slopes?

We've got a good deal for you. We charge the first slope at full price, and each additional slope from the same negative at half price. A good deal when you want to try a logo at various angles.

Pisa revisited

Yes, we could even straighten the leaning tower of Pisa if you sent it to us as art work. Works the other way, too. Send us a picture and we'll put a bit of action in it with a simple slope. A useful technique.

ANGLE OF SLOPE

Parallelograms, rhomboids and squeehawkies

An old printer friend of ours brought by a paragraph of type to be made into a parallelogram, but his instructions were to "make it sort of squeehawkie to fit this space." We know what he meant. We looked up the terms, and this is what we found:

Parallelogram. A quadrilateral with opposite sides parallel, and therefore equal.

Rhomboid. Having the shape of a rhombus, an equilateral parallelogram having its angles oblique.

Squeehawkie. Not in the dictionary, but if you use it we'll assume you want us to make your type fit the space.

Entire blocks of copy can be sloped to fit a rhombic shape like this one. The slope may be of any angle within reason, with the type leaning forward or backward. We know how!

Entire blocks of copy can be sloped to fit a rhombic shape like this one. The slope may be of any angle within reason, with the type leaning forward or backward. We know how!

Entire blocks of copy can be sloped to fit a rhombic shape like this one. The slope may be of any angle within reason, with the type leaning forward or backward. We know how!

Entire blocks of copy can be sloped to fit a rhombic shape like this one. The slope may be of any angle within reason, with the type leaning forward or backward. We know how!

Entire blocks of copy can be sloped to fit a rhombic shape like this one. The slope may be of any angle within reason, with the type leaning forward or backward. We know how!

Entire blocks of copy can be sloped to fit a rhombic shape like this one. The slope may be of any angle within reason, with the type leaning forward or backward. We know how!

Entire blocks of copy can be sloped to fit a rhombic shape like this one. The slope may be of any angle within reason, with the type leaning forward or backward. We know how!

WANTED!

Alert Advertisers to reap the

REWARD

of Solotype Special Effects.

Old type for new?
Solotype knows how!

Creating Antique Effects

We've analyzed hundreds of old posters to learn what makes them look the way they do, and are prepared to imitate the effect on your type or ours. We call the technique "antique." To achieve the flavor, choice of type is important, with a great mix of styles and unsophisticated layouts. Poor presswork gave a somewhat ragged quality to old type, which we can imitate with our specially-made diffusers. (Less or no roughness on the small type, more on the large type.) Damaged corners and other imperfections in the type, added by means of our special screens, complete the effect.

Rubber-stamp effect

There is a quality about rubber-stamped impressions that is difficult to capture with screens alone, so we have developed some additional techniques. Some suggestions if you seek an authentic effect: use loosely-spaced old fashioned grotesks or romans, nothing stylish or up-to-date. Butted borders, not mitered, with the joints showing.

AA **SOLOTYPE EFFECTS**

BB **SOLOTYPE EFFECTS**

CC **SOLOTYPE EFFECTS**

DD **SOLOTYPE**

EE **SOLOTYPE**

FF **SOLOTYPE**

HH **SOLOTYPE**

solotype is your best source of hard-to-find headline types

GOT A QUESTION? GIVE A CALL.
PHONE (510) 531-0353 8 AM-4:30 PM
24-HOUR FAX LINE: (510) 531-6946

Original art (center) is lengthened to 133% (left) and widened to 147% (right). All elements are reproportioned uniformly throughout.

Precision reproportioning of ads and art

Line art and entire mechanicals can be reproportioned quite successfully within reasonable limits. One dimension can be changed without changing the other, or both dimensions can be changed, but not in proportion to each other. Every element within the piece will change in exact proportion. If pictorial elements suffer from the distortion, they can often be reinserted from the original layout, leaving just the type in reproportioned form.

Distortion:

Changes in proportion are noticeable in the distortion of geometric shapes. In the diagram below the original is shown condensed (left) and extended (right). The circle becomes an ellipse, the angled box becomes a rhomboid, and vertical line weights are changed.

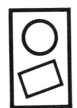

Precision reproportioning of headlines
Precision reproportioning of headlines
Precision reproportioning of headlines

When it is necessary to fit a specific letter height and line length, we can reproportion the type precisely. Most styles can be condensed up to 20% and widened up to 30% without seriously affecting the integrity of the design, and some will stand much more than that. (See examples in box at right). Monotone styles such as Avant Garde or Futura suffer the most as the vertical stroke weight changes in proportion to the condensing or extending. Thick-and-thin styles, such as Optima and most romans, reproportion well.

Take a squint at these distortions

Avant Garde and Times Roman are reproportioned below to an exteme degree so that you may see what happens at different percentages. Note that the angle of italic changes.

50% Distortion
75% Distortion
100% Distortion
150% Distortion
200% Distortion

50% Distortion
75% Distortion
100% Distortion
150% Distortion
200% Distortion

50% *Distortion*
100% *Distortion*
150% *Distortion*

Your Ideas Become Reality at Solotype

THESE FINISHED PIECES STARTED OUT AS CUSTOMERS' ROUGH IDEAS.

DIFOLATAN FOR BLUEBERRIES

WILLAMETTE VALLEY — THE ORIGINAL 100% WHOLE WHEAT BISCUIT MIX

SPRING STYLE & BEAUTY SHOW

Kate at the Castro — The Best of Katharine Hepburn

Old Sacramento Citizens and Merchants Association
INAUGURAL BALL
Saturday, January 30, 1982
8:00 p.m. till 2:00 a.m.
ADMIT ONE
The Railroad Exchange Building
1115 Front Street, Old Sacramento

H. WEINHARD — DOUBLE AGED FOR EXTRA SMOOTHNESS — CREAM ALE — NET WT. 12 FL. OZ. — IRELAND BRAND

AMERICANA NOTES — 16 Folders — 16 Envelopes — MANUFACTURED BY THE PAPER PALACE, COLUMBIA, CALIFORNIA

ALL TURKISH TOBACCO — TURKISH TROPHIES — S. ANARGYROS' NEW TURKISH CIGARETTE — 10 FOR 10¢

THE TRAVEL SHOPPE — 1242 PARK STREET ALAMEDA, CALIF. 94501 — PHONE (415) 865-5542

MADE IN W. GERMANY — NT. WT. 2 OZS. — MILK CHOCOLATE — © WORLD COMMERCE, DISTRIBUTORS — VACAVILLE, CALIFORNIA 95688

SCOTT LAMP CO. — APPROVED — SURGEON'S LAMP — SAN FRANCISCO, CALIF.

Ye Olde Original — Calendar Log & Tidal Graph

The chief mischief-makers at Solotype

DAN X. SOLO
PROPRIETOR

DONALD WONG
TYPESETTING

DONNA LANDON
PRODUCTION

DIANE SOLO
BILLING

MACK FRAGA
CREATIVE ART

BONNIE GUINEE
ACCOUNTING

GUIDO & ROCCO
COLLECTIONS

TOMMY HARRIS
MAINTENANCE

LANCE SCHROEDER
MAKE-UP

INDEX

Edrick 94
Edwardian Clarendon 10
Edy Gothic 167
Egiziano Wood 29
Egizio 152
Egmont 137
Egyptian Bold 150
Egyptian Bd Cd Out 187
Egyptian Expanded 151
Egyptian 505 152
Egyptian 505 Out 187
Ehmke (Carleton) 128
Eightball 139
Eightball Outline 182
Eleanora 51
Electra Clara 54
Electro Gothic 167
Electronic 70
Elefanta 44
Elefante 45
Elefante Outline 184
Elefont 53, 83
Elephant Stencil 119
Elegance 96
Elite 102
Elizabethan 196, 197
Elm Gothic 167
Elmo 18
Elmont 197
Elvira Bold Italic 103
Embrionic 197
Emperor 42
Empire 7
Emporia Gothic 6
Encore 139
Encore Gothic 167
Energy Inline 168
Enge Wotan 167
Engravers Bold
Engravers Bd Shade 62
Engravers Initials 114
Engravers Old Eng 110
Engravers Roman 64
Engravers Text 108
Engrossing Script 97
Entry Gothic 167
Envoy Gothic 167
Epitaph 15
Epitaph Open 186
Eras 173
Eras Outline 185
Erasmus Extrabold 197
Erbar 192
Erbar Initials 23
Erin 176
Ernesto 197
Ernie 147
Eros Text 109
Erratick 43
Erratick Outline 186
Estienne 120
Estro 83
Euclid 128
Eureka 27, 34
Eurocrat 192
Europa Stencil 117
Eurostile 159
Eurostile Bd Shade 186
Eurostile Outline 185
Evans Gothic 167
Eve Initials 67
Eve 123
Event Gothic 167
Excelsior 44
Excelsior Script 96
Excelsis 29
Exeter 128, 197
Explosion 60
Export 116
Express 36
Express No.2 192
Express Script 102
Ex Con Title No.12 190

Facade Bold Cond. 36
Falstaff 197
Fanal Script 101
Fancy Card text 110
Fancy Celtic 13
Fanfare (French) 50
Fanfare (German) 57
Fanfold 77
Fantail 10
Fantan 72
Fantasie Artistique 42
Fantastic 53
Fantasy No.4 67
Fargo 19
Farringdon 28
Farringdon Outline 186
Fashion 15
Fat Albert 160
Fat Albert Outline 185
Fat Albert Shadow 186
Fat Cat 48
Fat Face 141
Fat Shaded 178
Fata Morgana 61
Fatima 75
Faust Text 109
Fearless 30
Fedder 154
Fenceline 67
Fenice Regular 128
Ferdinand 14
Festival 54
Fieldstone 61
Fiesta 197
Figaro 100
Figgins Shaded 178
Fillet 77
Film 77
Fingal's Cave 45
Fino 153
Fiona 35
Fiore 125
Firebug 60
Firehouse Gothic 31
Firmin Didot 137
Firenze 141
Fists 33
Flag Initials 75
Flamenco 197
Flamo 60
Flash 94
Flash Idea Open 170
Flemish Condensed 53
Flemish Wide 43
Flex Ribbon 101
Flintstone 82
Flippo 180
Flirt 11
Florentine 157
Florist 17
Flosso 118
Focus 59
Folio 173
Folio Outline 183
Folkwang 197
Formula 163
Fontanesi 22
Forester 57
Forte 102
Fortunata 102
Fortune 149
Fortune Stencil 119
Forum I and II 178

Forum Titling 128
Foster Gothic 47
Fournier 197
Fox 100
Fractured Typewritr 71
Franconia 44
Frankenstein 69
Frankfurter 163
Frankfurter Out 183
Franklin Gothic 177
Franklin Openshade 180
Frednel 50
Fredricksburg 9
Freedom 200 85
Freehand 112
French Kate 81
Frisko 164, 165
Friz Quadrata 122
Frolic 33
Fry's Baskerville 197
Fry's Ornamented 19
Fulton Sign Script 101
Funhouse 23
Futura Black 49
Futura Black Out 184
Futura Display 155
Futura Inline 169
Futura Script 101
Futura Series 172
Futura Stencil 117

Gable Gothic 166
Gabrielle 99
Galadrielle 50
Gala Gothic 166
Galaxy Gothic 166
Galena 17
Gallia 50
Galliard 197
Game Plan 118
Gamma Gothic 166
Gans Bold Gothic 110
Garamond 133
Garamond Outline 187
Gardenia 26
Garfield (Shaded) 63
Garfield Gothic 166
Gargoyle 197
Garland 67
Garnet Gothic 166
Garth 197
Gaspipe Gothic 167
Gaston 101
Gatting 202
Gaucho Gothic 166
Gauloises 10
Gay Gothic 166
Gazebo 139
Gazebo 197
Gazelle 13
Gazette Gothic 166
Gazette No.5 26
Gem Gothic 167
Genny 161
Gentry (Cicero) 16
Geometric 23
Georgian Initials 114
Gesh Stencil 118
Gettysburg 35
Giant Gothic 166
Giftwrap 66
Gilbey 28
Gill Kayo Outline 185
Gill Sans Blk Nouv 192

Gill Sans Bd Ex Cd 167
Gill Sans Series 173
Gill Shadow 178
Gillies Gothic 100
Ginger Gothic 166
Gingerbread 14
Giraffe 55
Giraldon 46
Gismonda 51
Gladiate 13
Glaser Stencil 117
Glasgow 192
Glass Art 50
Glasster 171
Glenlake Gothic 166
Global Fineline 170
Globe Ace 166
Globe Gothic 157
Globe Gothic Out 185
Globus Bold 109
Gloria 99
Glorietta 11
Gloriosky 102
Glossy Script 86
Glyptic Bold Shaded 18
Goddess Gothic 166
Godiva 42
Go Fish! 68
Golden Era 36
Gold Rush 21
Goldwyn 14
Gone with the Wind 22
Goodfellow 32
Gorton Condensed 162
Gothic Tuscan Cd 39
Gotham City 82
Gotwick Sans 192
Goudy Bold Outline 187
Goudy Heavyface 144
Goudy Italian 197
Goudy Lavenham 197
Goudy Medieval 113
Goudy Open 179
Goudy Series 131
Goudy Super 198
Goudy Text 108
Goudy Thirty 113
Grab Bag 82
Graffito 94
Graffito Outline 184
Granby 173, 192
Granby Outline 185
Grand Wood 38
Grandiose 26
Grandmother 9
Grange 53
Grant Antique 20
Grant Gothic 166
Graphic Text 110
Graphique 182
Grasset 127
Grassmere 198
Graybar Book 128
Grecian 29
Grecian Cd Fineline 33
Grecian Extra Cd 27,33
Grecian Extra Wide 38
Grecian No.6 35
Grecian Shaded 36
Greco 84
Greco Adornado 84
Greeting Card Cas 100
Greeting Monotone 190
Greystoke 62
Gridiron Script 86
Griswold 44
Grocers Stencil 118
Grock 49
Grog 69
Groovey 57
Grotesk No.9 176
Grouch 139
Grubstake 36
Guggenheim 48
Guinness 192
Gumball Bold 58
Gutenberg 12
Guttenberg Gothic 108
Gypsy 19

Gypsy Rose 22
Gyro Gothic 166

Haas Ideal 7
Hacker 83
Hacker Outline 185
Hadriano 128
Hadriano Stonecut 181
Halftone 62
Hallmark Script 96
Halo Script 105
Hamlet Script 104
Hammar Uncial 115
Hampton Script 105
Handel Gothic 159
Hanover 98
Hansa (Boomerang) 46
Hansa Gothic 108
Hardy Script 105
Harem 73
Harlech 44
Harlem Script 105
Harlem Text 110
Harlequin 19
Harmony 48
Harmony Script 104
Harper 161
Harper Script 104
Harquil 73
Harrington 139
Harry 162
Harvard Script 105
Hatfield 198
Hauser Script 101
Havana Script 104
Hawarden Italic 101
Hawthorne 132
Hawk Script 105
Haymarket 39
Haywood Script 105
Headhunter 69
Headletter No.2 190
Headline Script 105
Hearst 85
Heather Lightface 13
Heather Wood 29
Heavy Outline Cond 182
Hedgerow 67
Hellenic Wide 148
Hellhouse I and II 69
Helven 24
Helvetica 175
Helvetica Outline 182
Helvetica Shaded 181
Hemlock Script 104
Henrietta 198
Herald Square 171
Heraldic 18
Herb Shop 74
Hercules 45
Hercules Brush 104
Herold 45
Herold Extra Cond 7
Herzog Stencil 119
Hess Neobold 160
Hess Oldstyle 134
Hess Penlettr 128
Hibernia 9
Hickory Script 104
Hidalgo 24
High Catz 170
High Tech 70
Highland Script 104
Hillside Script 105
Hilton Script 96

GOT A QUESTION? GIVE A CALL.
PHONE (510) 531-0353 8 AM-4:30 PM
24-HOUR FAX LINE: (510) 531-6946